ALL THE BEAUTY AT HAND

A BRIEF HISTORY OF HIRMER PUBLISHERS

ALL THE BEAUTY AT HAND

A BRIEF HISTORY OF HIRMER PUBLISHERS

Edited by Thomas Zuhr

HIRMER

CONTENTS

THE PUBLISHING HOUSE

BIBLIOGRAPHY

A FUTURE WITH BOOKS — AN ORIENTATION

Thomas Zuhr

Just what is an art book? A screenplay, a string of beads, an image sequence with a soundtrack, the dramatic staging of a series of works? In recent years, the art book has increasingly evolved into a prestige product, or better, an object of desire—that, at least, is the impression gained if one considers the many book concepts by or about artists and the continual emergence of new art-book publishers. Yet each player in the market is subject to the same, ever-changing market rules, just as individuals must now bow to the requirements of a modern and fast-paced society. Publishers aiming to produce valuable examples of book art must be prepared to print multilingual editions, commission innovative and readable texts, insist on up-to-date design and high-class typography, obtain the finest possible reproductions, and invest in elaborate bindings and papers of different textures and colors—all of which have now become a welcome matter of course.

For the distribution of such books, publishers are more than ever dependent on the brick-and-mortar book trade. One notes that more and more museums are establishing their own in-house booksellers. Aside from such outlets, there are specialists who provide attractive mail-order service, and internet sources guarantee postage-free delivery in record time—but without the recommendations and qualified descriptions that are so valuable.

The indispensable intermediaries between publishers and the book trade continue to be the publishers' sales representatives, who are not only our most important advisers in determining titles and cover designs, but also help us establish selling prices and suggest the proper wording of advertising copy. They draw on their wealth of experience when proposing the right communication strategy, and are severe critics in matters of content descriptions and selling points. They are in daily contact with retailers both in big cities and the provinces, promoting their publishers' programs.

In today's production of art books, communication between all of a project's participants is a special challenge. Communicating with an international network of authors under the direction of one or more editors, who are frequently also museum directors, heads of institutes, or chairs of foundations, is no longer a rarity but increasingly the rule. For highly qualified publishing staff, time zones and language barriers are now hardly perceived as obstacles. And as for design, it needs to be clarified whether the project in question is to be given to an internationally known book designer or established advertising agency or entrusted to an in-house graphic designer.

If the publishing project is planned to coincide with an exhibition or the opening of a new museum, coordination of the entire production is generally handled by the publisher, including a precise monitoring of deadlines. Such major projects frequently suffer from deadline pressure, owing to complicated loan contracts and the heavy involvement of authors and curators. Nevertheless, the ultimate motivating factor to ensure that an exhibition catalogue or an opening publication is published on time is a love of art.

Contemporary artists often like to oversee the process themselves, lenders of works contribute their own ideas with regard to layout, and administrators of artists' estates wish to communicate to the public their knowledge and experience. Thus the challenge for publishing colleagues is how to balance the often differing notions of these parties so as to realize them in book form with no loss of momentum or content.

Copyright protections have to be coordinated and the quality of color reproduction verified with the artists themselves, their offices, their legal heirs, or museum colleagues.

In addition to a superior, sound, and readable text, the highest possible quality in the reproductions is a major goal for both editor and publishing house alike. Committed as we are to the tradition of Max Hirmer, we occasionally find it advisable to commission new photographs of an entire collection. For reproductions, the publisher is wholly dependent on available photos, and only rarely can these be compared against the originals. As for reproduction quality, the production manager is dependent on the capabilities of offset, that is to say, four-color printing with oil and water, the range of which is constantly improving thanks to the "Made in Germany" printing press industry.

Not only should the printed result be oriented toward the colors of the individual works, but the entire color spectrum, contrasts, halftones, and tiniest details should be reproduced as close as possible to the original. The challenge for the responsible book designer is how to ideally place each motif in the layout, showing the object in the proper detail or its actual size, and to be sure that a picture is complete, including the artist's signature.

Book layouts are frequently likened to a melody or a composition that is meant to cast a spell over the listener from the first bar to the final chord. Only when each double-page spread presents readers with a feast for the eyes, whetting their appetite more and more, has the

spend our available time learning about whatever sparks our interest, enables more communication, and promotes participation in cultural life.

The world's knowledge currently doubles every five to ten years, so knowing something about Leonardo da Vinci or the Bruegels, for example, can actually serve as a welcome anchor.

It is therefore only logical that books should serve as aids to orientation in the future as well. Increasingly, they are becoming repositories of society's long-term memory, strengthening communicative skills, and enhancing the individual's cultural and social competence. For many, a Sunday museum visit has taken the place of church attendance, just as reading and studying in an analog book is gaining in importance as opposed to the omnipresent digital offering.

The combination of text and illustration, of essay and color plate, or rather the art book's special way of visualizing information, can look forward to a bright future, for it will continue to provide modern and comprehensive answers to more and more questions and satisfy the increasing thirst for knowledge. This is especially so given how the assertion that pictures have greater emotional power than words is more than ever valid in our visually sated society.

Also, it is known that creativity and inspiration can be enhanced not only in managers by regular museum visits and enjoyment of art. The art book provides these pleasures at home every day—qigong for the eyes and the spirit.

At a time when faith in one's future, in our case in the printed book, is so precious, it is especially important for us to set a standard for well-made printed matter. We also think of our work as a craft, as a commitment to quality, with the best partners and the most reliable resources. With its staff, its experience, and its passion for the art book, Hirmer Publishers will continue to stand for precisely such quality in the future.

Aenne and Albert Hirmer

PROF. DR. MAX HIRMER, THE FOUNDER

Max Hirmer was born in Straubing on March 14, 1893, the only child of the bookseller and later publisher Max Hirmer and his wife, Berta. In 1903 the family moved from Straubing to Munich.

Max Hirmer developed a yearning for the South and Mediterranean art and culture even as a boy, thanks to a year's schooling in Arco, on Lake Garda. After his Abitur exams, he first studied archaeology and art history, but since research trips to other countries were impossible for several years because of the First World War, he subsequently turned to natural science. He received his doctorate in Munich in 1917 and his postdoctoral habilitation soon afterward. From 1922 on he was first assistant at Munich's State Botanical Institutions, and in 1928 became a professor of botany at Ludwig-Maximilians-Universität. His scholarly work was concentrated in the fields of paleobotany, morphology, and plant phylogenesis.

In 1936 the National Socialists found it necessary to dismiss him for "political intransigence" and a "respect for foreign scholarship bordering on high treason." After the Second World War, he declined a reappointment to his former professorship and instead embarked on his "second life" as a publisher, writer on art history, and archaeologist with a camera. This relegation in Max Hirmer's personal story was put right, with a certain irony, in 1963 on the occasion of his 70th birthday, when he was awarded the Commander's Cross of the Order of Merit of the Federal Republic of Germany precisely for, of all things, his services to promoting international collaboration between publishers. This was followed in 1979 by the Bavarian Order of Merit.

On June 24, 1948, just four days after the monetary reform, Aenne and Max Hirmer established the Gesellschaft für wissenschaftliches Lichtbild mbH (Society for the Scientific Photographic Image), which in 1952 was renamed Hirmer Verlag München. Only shortly before, they had been approved as publishers by the American military authorities. Since paper was still rationed—allocations were based on prewar usage—their publishing activity in the first two years was mainly concentrated on the publication of single postcards and series of cards on the South German Baroque, as well as church guides. Thanks to his deep love of photography, already practiced intensively as a scientist, he was able to produce all the images for his publications himself, and he also wrote the introductory art-historical texts.

The logos of the Gesellschaft für wissenschaftliches Lichtbild and Hirmer Verlag München

For three decades, Max Hirmer combed the cultural landscapes of the eastern Mediterranean, as well as those of Spain, France, and Italy, capturing in photographs of documentary quality what survives of the creative heritage of the past. All his photographs, taken with a large-format camera, served the sole purpose of viewing works of art without resorting to tricks or striving for effect. Until 1977 he had taken most of the photographs seen in the now-classic Hirmer monographs himself; from the early 1960s on, he was joined by his daughter, Irmgard Ernstmeier-Hirmer, and his son, Albert Hirmer.

These books were an avowal on the part of the publisher and photographer, who worked out the topics together with the chosen authors, in order to be able to do justice to them from an illustrative and a scholarly point of view in book form. The texts had to be well researched and written for a broad public; highest quality, in materials as well as illustrations, was the standard for Hirmer books. This traditional policy reflected the publisher's responsibility to scholars, general readers, and art lovers for their content. After Max Hirmer's death on April 17, 1981, Irmgard Ernstmeier-Hirmer and Albert Hirmer continued the publishing house according to these very same guiding standards. Aenne Hirmer also took an active role in the firm as an editor well into the 1990s.

From its founding until 1988, the publishing house's corporate shares were all in family hands. Then, in order to allow expansion of the firm's base and make possible the promotion of art books, whether in art journals or newspapers, the Weltkunst Verlag GmbH, a full subsidiary of Axel Springer AG, was taken on as an additional shareholder, and, as an additional director, Jürgen Kleidt, who continues to serve as an advisor to this day. In the following years, the group grew to include the Weltkunst Verlag, the Deutscher Kunstverlag, the Philipp von Zabern, Dietrich Reimer, and Gebr. Mann publishing houses, and the Deutscher Verlag für Kunstwissenschaft.

In 2003 Axel Springer AG sold Weltkunst Verlag GmbH, and thus its share in Hirmer Publishers and these other

Max Hirmer

Pharaohs), *Echnaton und die Armanazeit* (Akhenaten and the Amarna Period), and *Sesostris. Ein* ägyptischer *König in Mythos, Geschichte und Kunst* (Sesostris. An Egyptian King in Myth, History, and Art). The year 1953 saw the publication of the volume *Barockkirchen zwischen Donau und Alpen* (Baroque Churches between the Danube and the Alps), written by Norbert Lieb and with photographs by Max Hirmer—a work that was published again and again in revised editions and remained on the list for more than 50 years.

With the publication in 1953 of *Griechische Vasen der reifarchaischen Zeit* (Greek Vases of the Late Archaic Period), Hirmer's first work on classical art, the foundation was laid for international collaboration with other publishers. In that same year, the book received considerable attention at the Frankfurt Book Fair, where it was greatly admired—above all for its enlarged detail photos—and it became the first of many Hirmer publications to win the "Most Beautiful Book" award. This also led to an association with Béla Horovitz at London's Phaidon Press. Profoundly impressed by the work on Greek vases, in a phone call one Sunday afternoon, he ordered—sight unseen—10,000 copies of a book planned for 1955: *Ägypten. Architektur, Plastik, Malerei in drei Jahrtausenden* (Egypt: Architecture, Sculpture, Painting in Three Thousand Years). The program of large monographs had thus been set. The book had been produced in response to Max Hirmer's personal interest, and without any prior market research—if there even was such a thing at the time. Apparently, books on subjects determined solely by the publisher's engagement struck a proper nerve, for though several of the following titles were met with considerable skepticism on the part of the book trade, they turned out to be highly successful, in that they opened up new realms to a broad public. The first edition of the Egypt book appeared not only under the Phaidon imprint, but also those of Flammarion in Paris and Sansoni in Florence. It remains the publishing house's most successful book to date, with a print run of well over 250,000 copies. After Béla Horovitz's early death in 1955, Thames & Hudson, the publishing house founded by Walter Neurath, became Hirmer's London collaborator. That connection led to contact with Fritz Landshoff, the European representative of the New York publisher Harry Abrams, which would become our American partner and publish many of Hirmer Publishers' large monographs.

The success of the Egypt volume was followed by other monographs rich in content and scope on the art of

subsidiary companies, to a group of investors who in 2008 resold Hirmer Verlag to Klassik Radio AG, Augsburg. With that transition, the Hirmer family withdrew from the company.

Since April 1, 2011, the sole owner of Hirmer Publishers GmbH has been the publisher Dr. Dirk Ippen, owner of the *Münchner Merkur*, *tz*, and other regional newspapers. Since 2009, the company director has been Thomas Zuhr, who has long-standing and extensive experience in the art-book business.

THE "BIG HIRMER VOLUMES"

In 1950/51 the range of Hirmer products expanded beyond postcards and church guides to books and catalogues on South German subjects from the Middle Ages to the Baroque, all of them with Max Hirmer's photographs. These were followed from 1952 on by the first publications about more distant cultural complexes, beginning with photo card series and books by Kurt Lange: *Pyramiden, Sphinxe, Pharaonen* (Pyramids, Sphinxes,

antiquity and early history: *Fünf Jahrtausende Mesopotamien* (Five Thousand Years of the Art of Mesopotamia), *Die Kunst der Hethiter* (The Art of the Hittites), and *Kreta und das Mykenische Hellas* (Crete and Mycenae), the latter expanded in 1973 to include the famous finds on Thera. Two volumes were devoted to Early Christian and Byzantine art.

A main focus in the publishing program in the 1960s and 1970s were the various books on Greek art, its separate genres and local peculiarities: on sculpture, vases, and coins, on the art of the Western Greeks, and finally on temples and shrines—Gottfried Gruben's handbook on architecture, produced in a mere eight months, became the standard German-language work and appeared in a number of repeatedly revised editions—even in a small-format edition in the "Travel and Study" series. As contributions to the narrative picture arts, the five richly illustrated volumes by Karl Schefold on the stories of the Greek gods and heroic sagas are deserving of mention, as are Erika Simon's major study *Die griechischen Vasen* (Greek Vases) and her books *Die Götter der Griechen* (The Gods of the Greeks), *Die Götter der Römer* (The Gods of the Romans), and *Augustus*, each of which was republished in numerous editions.

Published in 1965, *Spanien. Kunst des frühen Mittelalters vom Westgotenreich bis zum Ende der Romanik* (Early Medieval Art in Spain) was the first of the Hirmer books devoted to medieval art. It was followed in 1968 by Otto Demus's *Die romanische Wandmalerei* (Romanesque Mural painting) and in 1969 by Willibald Sauerländer's *Gotische Skulptur in Frankreich* (Gothic Sculpture in France), both of which also appeared in French and American English editions. That such a highly reputed house as Flammarion would celebrate its 100th anniversary with the 1974 volume *Paris Monumental*, with photographs by Albert and Max Hirmer, can be considered a homage to and an insight into their joint publishing work. Other books to emerge from this consistently developed subject area were Bernard Rupprecht's *Romanische Skulptur in Frankreich* (1975; Romanesque Sculpture in France), Ursula Mendes's *Bronzetüren des Mittelalters* (1983; Bronze Doors of the Middle Ages), and, as a richly documented overview, *Die gotische Architektur in Frankreich. 1130–1270* (1985; Gothic Architecture in France. 1130–1270), with texts by Dieter Kimpel and Robert Suckale. The volume *Deutsche Kunst der Romanik* (German Art of the Romanesque), with a text by Anton Legner and in the planning since 1976, was published in 1982. After

the fall of the inner-German border, a new edition was given the more accurate title *Romanische Kunst in Deutschland* (Romanesque Art in Germany).

A focal point in the publisher's program from the early 1990s on was the series on Italian art. Joachim Poeschke wrote the four volumes on sculpture of the Middle Ages and the Renaissance in Italy: *Romanik* (1998; Romanesque), *Gotik* (2000; Gothic), *Donatello und seine Zeit* (1990; Donatello and His World), and *Michelangelo und seine Zeit* (1992; Michelangelo and His World), the latter two also published by Abrams in New York.

Citadelles in Paris, Abbeville in New York, and Panini in Italy bought the foreign language rights to the large monographs on Italian frescoes: *Die Giottozeit* (2003; The Age of Giotto) by Joachim Poeschke; the three volumes on the early Renaissance (1996 and 1997) and the Baroque (2007) by Steffi Roettgen; the book on the High Renaissance and Mannerism by Julian Kliemann and Michael Rohlmann (2004), and subsequently, Joachim Poeschke's *Mosaiken in Italien 300–1300* (2009; Italian Mosaics 300–1300). In addition, Hirmer published a number of books on Italian painting and architecture, some of which Hirmer had originated itself, others taken over from other houses, such as *Die Villen des Veneto* (Venetian Villas) and *Die Paläste Venedigs* (Venetian Palaces). Finally, the two volumes *Große Kathedralen des Mittelalters* (2002; Great Cathedrals of the Middle Ages) and *Klöster in Europa* (2004; Great Monasteries of Europe), both authored by Bernhard Schütz, proved to be outstanding international successes thanks to their concept of providing a wide range of topics and remarkably reader-friendly texts. They were published in several English-language editions by Abrams and Abbeville, New York, in French by Citadelles, Paris, in Italian by Jaca, Milan, and even in Russian by Slovo, Moscow.

Whereas the publishing program originally focused on antiquity, sculpture, and architecture, comprehensive studies on easel painting came to be added over time. The first large-format study was Erich Steingräber's *Zweitausend Jahre europäische Landschaftsmalerei* (1985; Two Thousand Years of European Landscape Painting). The year 1994 saw the publication of Hans Belting and Christiane Kruse's *Die Erfindung des Gemäldes. Das erste Jahrhundert der niederländischen Malerei* (The Invention of the Picture. The First Century of Netherlandish Painting), a book that set new standards in both methodology and design. Between 1998 and 2009, Hirmer's potential was again displayed internationally in a series of genre-

specific volumes: Sybille Ebert-Schifferer's *Die Geschichte des Stillebens* (1998; Still Life. A History) was followed in 2002 by Andreas Beyer's *Das Porträt in der Malerei* (Portraits. A History) and in 2006 by Nils Büttner's *Die Geschichte der Landschaftsmalerei* (*Landscape Painting. A History*). Finally, in 2009, Karl Schütz subjected *Das Interieur in der Malerei* (The Interior in Painting) to an investigation that was illustrative in several respects. A temporary end to the celebrated tradition of "big Hirmer volumes" was marked in 2010 by Werner Hofmann's *Phantasiestücke. Über das Phantastische in der Kunst* (Fantasy Pieces. On the Fantastic in Art), which would be the last major effort of that author's prolific life's work.

Mention must also be made of a singular work from the more recent history of the house: *Die großen Schnitzaltäre. Spätgotik in Süddeutschland, Österreich und Südtirol* (2005; Carved Splendor. Late Gothic Altarpieces in Southern Germany, Austria, and South Tirol), with a text by Rainer Kahsnitz and photographs by Achim Bunz, a book that brought the works closer to the reader than viewers standing before the huge and mostly cordoned off originals could ever manage to see. This achievement was honored by a large print run and editions licensed from Hirmer by Thames & Hudson and Getty Publications.

COLLABORATION WITH MUSEUMS AND SCIENTIFIC INSTITUTIONS

In the 1970s, tendencies began to emerge that had drastic consequences for the relationship between art studies and specialist publishers. For one thing, the increasing business in image and reproduction rights began to eat up available funds for independent book production. And given the quality-related increase in production costs, this development could not in the long term be compensated for by retail prices in bookstores. Researchers were therefore required to look for new ways to publish in place of the traditional, publisher-financed books, and found the necessary opportunity to publish their findings in exhibition catalogues. Given the demand for high-quality production and editorial expertise, Hirmer Publishers very soon became a proven partner of many museums both at home and abroad.

The house had had its first experience with this kind of publishing, always special in terms of organization, in 1950, for the Munich exhibition *Ars sacra. Kunst des frühen Mittelalters* (Ars sacra. Art of the Early Middle Ages). Both that catalogue, whose 154 pages now seem quite modest, and the one that followed in 1966, *Meissner Porzellan 1710–1810* (Meissen Porcelain 1710–1810), went out of print even before the close of their respective exhibitions. In the 1980s this type of publication became a truly lasting component of the publishing program, one that has long since come to be taken for granted. With it came a variety of subject matter that would have been inconceivable without the collaboration of so many creative minds: the titles listed in this bibliography, representing the entire spectrum of the field, provide some idea of the breadth of range. And for a long time, it has been artists themselves who have sought collaboration with the publishing house and in their own way added accents to the content horizon in the history of its publishing.

Along with the publications primarily intended for broader audiences, there are also scholarly series on special subjects in the realms of archaeology and art history, as well as catalogues raisonnés and catalogues of public collections. The Bibliotheca Hertziana in Rome, the Deutsches Archäologisches Institut, and the Deutsche Forschungsgemeinschaft have been among the house's longtime collaborative partners.

The fact that the public has come to regard Hirmer Publishers as both an ambitious and a highly reliable institution is due not least to its willingness to compile catalogues raisonnés—a thankless and laborious task. In 1996 it published Matthias Eberle's *Max Liebermann. Das Werkverzeichnis der Gemälde und Ölstudien* (Max Liebermann. The Catalogue Raisonné of the Paintings and Oil Studies), a book that contributed solid information to the contemporary discussion of looted art. It was followed two years later by the two-volume *Paula Modersohn-Becker 1876–1907. Werkverzeichnis der Gemälde* (Paula Modersohn-Becker 1876–1907. Catalogue Raisonné of the Paintings) by Günther Busch and Wolfgang Werner. In 1999 and 2003 Steffi Roettgen's exhaustive researches on Mengs, far exceeding the demands of the standard catalogue raisonné, were published in two volumes as *Anton Raphael Mengs. 1728–1779. Werkverzeichnis und Monographie* (Anton Raphael Mengs. 1728–1779. Catalogue Raisonné and Monograph). In 2011 Aya Soika's *Max Pechstein. Das Werkverzeichnis der Gemälde* (Max Pechstein. The Catalogue Raisonné of the Paintings) became the most recent contribution to this field of publishing so important to scholarship and the art trade.

Munich, 2013

BREATHING NEW LIFE INTO ANTIQUITY — PHOTOGRAPHY AS AN ACT OF VISUALIZATION

Niklas Maak

We did not discover antiquity in Italy or Greece. We did not stand in front of the Temple of Apollo in Corinth, did not stumble by chance upon the sleeping Maenads in Taranto's Museo Nazionale. We encountered these works for the first time as children in books—in the large, heavy tome *Die griechische Kunst* (Greek Art), for example, on whose cover a piercing eye appears to be gazing out of a dark face into the distance and within at the same time. The book was first published by Hirmer in 1966, and since then, generations of art students have come to refer to it simply as "the Boardman," after one of its authors, John Boardman. In it, art historians find everything they need to know about Doric temples of the 5th century BC, about proto-geometric art, severe archaic sculpture and high Hellenistic form, about Kritios and the sculptor Phidias, about Zeuxis of Heraclea or Praxiteles, or the order of the columns at the Temple of Aphaea on Aigina. The child leafing through the book discovered—in addition to an elegant postcard that could be sent to Hirmer Verlag, Marées-Strasse 15 in Munich, to request a publisher's catalogue—something altogether different: the gateway to a sunken continent, a mysterious world of body fragments, glittering treasures, and eyes intensively gazing back at him from remote millennia. The child did not study the site plan of the Agora, of course, which is also included in this standard work, preferring instead to stare at the exquisite drapery folds exposing the body of the Maenad. The coverlet had slipped off her body during her sleep, as if it had simply become too warm for the peacefully slumbering Maenad as she embraced her pillow. The photograph not only pictures a figure, it conjures up a whole feeling; looking at it, one feels the heat of a summer night in Apulia. Hirmer photographed the Temple of Poseidon at Cape Sounion against an unusually dark sky, so that the volumes of the light marble columns are particularly prominent. He shot Pergamon's theater against the hazy, expansive horizon of an equally sweltering landscape that seems like an echo chamber: one can almost hear the sound echoing in this expanse.

Max Hirmer, born in 1893, was a professor of botany in Munich until he was removed by the National Socialists. After the Second World War, he came to be known above all for his precise, scholarly documentation, for photographing the confident-looking kouroi in Munich's Glyptothek not only from the front, but also from the side and the back, so as to provide an impression of the entire figure. Leafing through the books today, one marvels at the incredible diligence, the enormous effort with which, be-

ginning in 1952, Max Hirmer catalogued entire museum collections, lugging his camera through the great museums of the world like a botanizing box, taking thousands of photographs, writing up file cards, sorting negatives, and thereby documented cultural treasures that for millennia have managed to defy, at least up into our own time, the most varied forces of destruction. When one looks through the standard work *Fünf Jahrtausende Mesopotamien* (Five Thousand Years of the Art of Mesopotamia), from 1962, and sees the small limestone statuette, created toward the end of the 4th millennium BC, of an orant from the Temple of Abu at Eshnunna, one has to wonder whether it is still safely preserved in Baghdad's National Museum, where Hirmer photographed it, or whether, like so much stolen from that museum in the turmoil of war after 2002, it has been misidentified as an excavation find from Syria and swallowed up into the international trade in looted art. In that same volume, one also finds photographs in which Hirmer captured excavation sites in panoramic landscape pictures that easily compete with the elegiac documentary landscape photography of the Düsseldorf School.

But it is something else that makes his photography so special. His pictures do not merely document, they bring objects to life. Hirmer did not picture antique terracottas, marble torsos, and ruins in the dull, neutral style familiar to us from reference books, but reawakened them in an almost haunting way. One looks at a photograph and hears the actors' voices, feels the heat of an evening on the Ionian seacoast without ever having been there: a warmth emanating from the year 130 BC.

What did summer feel like back then? The clothing was different, the food did not taste the same, the goblet one drank from, the colors of things were not like those of today. Even so, the buildings and figures in these pictures seem vital and present, as if they had managed to leap over what Lessing called the "nasty trench" of the millennia. The astonishing energy of these pictures enable us to visualize the past, yet it is not only the close-ups that bring objects nearer to us. The mother with her two children in the gold-glass portrait medallion in Brescia, painted in the 4th century AD, gazes at us out of heavy-lidded but engaging eyes as if she had been born in the 20th century—inconceivable that she was alive when Goths annihilated the Roman army at the Battle of Adrianople.

Hirmer's choreography of shadows plays an essential role in his photographs. The Japanese writer Jun'ichirō Tanizaki once wrote: "Like a phosphorescent stone that

glows in the dark but in the light of day loses all charm as a jewel, without the effect of shadows, there is no beauty." Hirmer appears also to have sensed this: the body of a crouching Aphrodite, the elongated rectangle of a temple facade partly dissolve into darkness, and it is precisely this hint of mystery—in which the figure comes close to resembling a living torso and the structure that of a ruin—that stirs the imagination. What could be there in the dark? Writing about the Belvedere Torso, the philosopher Jacques Rancière said that the history of art "could be thought of as the story of the metamorphoses of that mutilated and perfect sculpture, perfect because it is mutilated, for in the absence of a head and limbs, it is forced to generate multiple new bodies."

Hirmer not only photographed these bodies, he vitalized them. Antiques appear to revive in the play of shadow, as in the legend of the studio of the sculptor Pygmalion. The artist's intention to visualize a person is ultimately realized in a photograph that appears to restore vitality to these figures approaching us across the millennia. In Hirmer's photograph of the head of a girl from Chios, her features are captured in a sfumato-like haze, her lips appearing to open imperceptibly the moment one looks away.

It is pictures like these that burn into the subconscious and that one takes along on later travels to ancient sites. What one experiences on the Acropolis or in the Capitoline Museums is the same as what one felt looking at the photographs. In another context, Diderot wrote: "You were here before you entered and you will still be here after you have left." This is also true of our view of antiquity. Hirmer, the master of photographic visualization, was likewise aware of this paradox.

SUBLIME BEAUTY WITHIN ONE'S REACH — HIRMER'S ANTHOLOGY OF ITALIAN WALL PAINTING

Gottfried Knapp

If ever there were art books that obviated the need to travel to see for oneself the masterpieces illustrated in them, then it is the five, huge, full-color volumes on Italian wall painting published by Munich's Hirmer Verlag between 1996 and 2007. Their discriminating selection of works by proven scholars of the respective eras and their deft guidance through the highly complex motivic structure of these picture cycles leading to the most telling details more than compensate for any experiences or insights one could possibly have garnered on visits to the originals. On the superbly printed pages of these five books, readers get closer to the frescoes than they possibly could in their actual locations. Furthermore, the wall and ceiling paintings in the color photographs are perfectly illuminated—in a way that would never be permitted in the conservationally sensitive interiors of those churches and palaces.

To achieve such extraordinary visual quality surpassing the haphazard illustrations of previous books, the publisher had all the presented frescoes newly photographed by specialized professionals. At first, this was entrusted solely to Antonio Quattrone, a specialist in the reproduction of works of art and under contract to a number of museums and publishing houses. He was later joined by his Italian colleague Ghigo Roli. And for the volume on the Baroque period, the two centuries between 1600 and 1800, in which the art of wall painting was almost completely supplanted by the newer medium of ceiling painting, the work was assigned to no fewer than five different photographers.

The first volume is devoted to wall painting of the Giotto era, and so leads from the beginnings of post-Romanesque fresco painting in Rome around 1280 by way of Giotto's exquisite paintings in Assisi and Padua to Siena, San Gimignano, Pisa, and the churches of Florence, where some of the cycles most important for the further development of this art form were created. The book was written by Joachim Poeschke, whose magisterial studies

of Italian Renaissance sculpture Hirmer had previously published in superbly illustrated volumes.

Two volumes were required for the period of the early Renaissance, the period between 1400 and 1510 especially rich in masterpieces of fresco painting, and its great narrative painters Masacccio, Fra Angelico, Filippo Lippi, Piero della Francesca, Ghirlandaio, Mantegna, Botticelli, Signorelli, Pinturicchio, and Perugino. These were written by Steffi Roettgen, a noted scholar who alternately taught in Munich and at the renowned Kunsthistorisches Institut in Florence. Hirmer also has her to thank for the groundbreaking two-volume study of the great 18th-century European master from Bohemia, Anton Raphael Mengs.

In the fourth volume in the series, the art historians Julian Kliemann and Michael Rohlmann presented the High Renaissance and Mannerism, including Raphael's and Michelangelo's masterpieces of painting in the Vatican, the sole fresco painting by the great Lorenzo Lotto, the Mannerists Pontormo, Bronzino, Giulio Romano, and Zuccari, the work of Veronese in the Villa Barbaro at Maser, and finally, Annibale Carracci's famous cycle in Rome's Palazzo Farnese.

Steffi Roettgen rounded off the series with an overview of major wall and ceiling painting cycles from the Baroque era and the Enlightenment. It begins with Roman masterworks by Guido Reni, Albani, Lanfranco, Guercino, and Pietro da Cortona, includes the daring ceilings by Pozzo so beloved by Rococo masters in Germany, and proceeds by way of Florence, Naples, and Turin to Venice and the Veneto, on the walls and ceilings of whose palaces Tiepolo's genius produced the last great triumphs.

Any traveler who has experienced even just one of the major works presented in these volumes under the less than optimal conditions of an art pilgrimage will cheerfully admit that they began to truly understand and appreciate what they had seen abroad only after seeing it again in one of these five magnificent Hirmer anthologies—and did not have to take leave of it after only a half-hour's visit.

ON HIRMER PHOTOGRAPHY

Michael Krüger

At some time in my youth, it became fashionable to visit Romanesque churches. People no longer headed to the great Gothic cathedrals to feel the thrill of the sublime, and they also ignored the Baroque churches with all their gold. They wanted to explore the beginnings of the monumental church structure preceding the Gothic era. Was it a desire to imagine what it felt like in former times to stand before their imposing tympanums? A curiosity to stand face to face with the very demons fighting for our souls? A wish to see the story of Christianity recounted in stone, to marvel at the incredible complexity of the work of those early sculptors who contributed so much to our notion of beauty?

But who was to be our guide, to open our eyes, to be the first to reveal all this beauty to us? It was to be—and remains to this day—the photographers within the Hirmer family. One need only compare how poor and inadequate the illustrations still were in Meyer Schapiro's book on Romanesque art with the gorgeous Hirmer plates that seemingly convey the very thoughts and feelings of those early Christian masters of visualization to appreciate what these photographers were able to achieve with a loving eye.

Thanks to a technique of making visible the obscure, as well as a flair for capturing the dramatic effect of Romanesque sculpture in the context of the social reality of the time, they managed to shed light on the shadowy life of these unique sacred objects. We have the Hirmers to thank for the fact that we can now read the incomparable testimony of the Romanesque as we would a medieval novel. Weathered stones begin to speak, revealing the hopes, desires, and imaginations of artists who not only associated religious and didactic intent with their work, but also meant to provide viewers with sensual visual pleasure.

Saint Bernard was aware of these charms: "So rich and so delightful is the variety of forms all about that we are tempted to read in marble instead of our books, and spend the whole day marveling at these things instead of meditating on God's commandments. For God's sake, if people are not embarrassed by these follies, why can't they at least recoil from their expense?"

Had Saint Bernard known of the Hirmer photographs, he would have spoken differently about the mystical symbolism of the Romanesque—and been full of praise!

THE ENGLISH PUBLISHING PROGRAM

English-language or bilingual titles were published only sporadically up until 2009, but in 2010 the house made a clear commitment to an English-language publishing program. This important turning point in Hirmer's history gave the publishing house access to the international book market. With direct acquisitions in the United States and Canada, we were able to expand our position in North America. Hirmer Publishers has meanwhile become a known "brand" in the English-speaking world and can count on successful collaboration with international houses in the United States, Canada, and even the Middle East.

Between 2010 and 2020, Hirmer Publishers issued over 500 English-language titles. It publishes roughly 60 new titles each year. At the close of 2020, some 450 English-language titles were available worldwide. The English program's continuing growth is reflected in Hirmer's bibliography during those eleven years: 20 titles were published in 2010, but in 2020 the number had risen to 59.

With our partnerships with The University of Chicago Press for the United States and Canada and with Thames & Hudson for the rest of the world, the house is ideally positioned for worldwide sales of its English-language books.

Mona AlJalhami, Murdo MacLeod, Mona Mansour, Idries Trevathan (eds.)
The Art of Orientation. An Exploration of the Mosque through Objects
Exhibition catalogue, The King Abdulaziz Center for World Culture (Ithra), Dhahran
Contributions by S. Angawi, A. H. Alkadi, M. al-Meheid, O. Ogunnaike, R. Ashour, M. Abd el-Salam, L. DeLong, M. Abdel Bari
264 pages, 200 color illustrations, 24 × 30 cm, hardcover

Thomas Köster (ed.)
Mary Bauermeister. In a Fairytale World. House and Garden
With a foreword by Petra Oelschlägel; 224 pages, 250 color illustrations, 33 × 28 cm, hardcover
Text: English | German

Wiebke Steinmetz, Viola Weigel (eds.)
Ruth Baumgarte. Become Who You Are! The Art of Living
Exhibition catalogue, Museum für Kunst und Kulturgeschichte Dortmund (MKK)
Essay by Eckhart J. Gillen
264 pages, 251 color illustrations, 24.5 × 29 cm, hardcover
Text: English | German

Henriette Huldisch (ed.)
Ericka Beckman. Double Reverse
Exhibition catalogue, MIT List Visual Arts Center, Cambridge, MA
Contributions by Henriette Huldisch, Piper Marshall, Shelby Shaw, Selby Nimrod; 92 pages, 248 color illustrations, 20.3 × 25.4 cm, softcover, dust jacket

Jan Dees, Museum für Lackkunst (ed.)
Breaking out of Tradition. Japanese Lacquer, 1890–1950
Exhibition catalogue, Museum of Lacquer Art, Münster; Rijksmuseum, Amsterdam
224 pages, 180 color illustrations, 24 × 28 cm, softcover with flaps

Gloria Köpnick (ed.)
Hin Bredendieck. From Aurich to Atlanta
Contributions by Gloria Köpnick, R. Stamm; 288 pages, 200 color illustrations, 24 × 28 cm, hardcover, dust jacket
Text: English | German
Graphic design: Sophie Friederich

Ingo Clauß (ed.)
Elina Brotherus. Why not?
Exhibition catalogue, Weserburg Museum für moderne Kunst, Bremen

Contributions by J. de Vries, I. Clauß, G. Boulboullé
160 pages, 104 color illustrations, 22.5 × 30 cm, hardcover, bookmark
Text: English | German

Adriana Proser (ed.)
Buddha and Shiva, Lotus and Dragon. Masterworks from the Mr. and Mrs. John D. Rockefeller 3rd Collection at Asia Society
Exhibition catalogue, NOMA, New Orleans Museum of Art, New Orleans, LA; Cummer Museum of Art & Gardens, Jacksonville, FL; Ackland Art Museum, Chapel Hill, NC; Kimbell Art Museum, Fort Worth, TX; Fundación Barrié, A Coruña, Spain
202 pages, 160 color illustrations, 22.9 × 25.4 cm, hardcover

Glenn Esterly, Abe Frajndlich
Bukowski. The Shooting. By Abe Frajndlich
German translation by Esther Ghionda-Breger and Carl Weissner
96 pages, 65 illustrations, 25.4 × 20.3 cm, hardcover
Text: English | German
Design: Hannes Halder

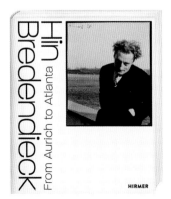

HIN BREDENDIECK. FROM AURICH TO ATLANTA

Hin Bredendieck (1904–1995) graduated from the Bauhaus and was a versatile designer and pioneering teacher of design. As the founding director of the Institute for Industrial Design at the Georgia Institute of Technology in Atlanta, he became one of the most influential mediators of Bauhaus ideas in America in the postwar years. His outstanding oeuvre and his worldwide network testify to the international significance of his work and ideas. This lavishly illustrated, high-quality monograph introduces in detail the life and work of Hin Bredendieck.

Christine Giles, David Evans Frantz
(eds.)
Gerald Clarke. Falling Rock
Exhibition catalogue, Palm Springs
Art Museum, Palm Springs, CA
Contributions by G. Clarke, D. Evans
Frantz, C. Giles, A. Holland,
G. Johnson; 152 pages, 100 color
illustrations, 19.7 × 26 cm
Graphic design: Content Object
Design Studio, Kimberly Varella

Gerry Beegan, Donna Gustafson
(eds.)
Angela Davis. Seize the Time
Exhibition catalogue, Zimmerli
Art Museum, Rutgers University,
New Brunswick
Contributions by G. Beegan,
A. Y. Davis, N. R. Fleetwood,
D. Gustafson, R. de Guzman,
T. Sokolowski, L. Tellefsen
192 pages, 175 color illustrations,
21.6 × 25.4 cm, hardcover
Design: Laura Lindgren

Yang Yuanzheng
**Dragon's Roar. The Chinese Literati
Musical Instruments in the Freer
and Sackler Collections and their
Archaeological Origin**
Introduction by J. Keith Wilson, Freer
Gallery of Art, and Arthur M. Sackler
Gallery; 240 pages, 127 color

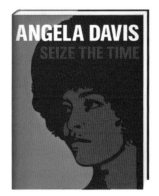

illustrations, 24 × 30 cm, hardcover
Graphic design: Rainald Schwarz

Ralph Gleis (ed.)
**Decadence and Dark Dreams.
Belgian Symbolism**
Exhibition catalogue, Alte National-
galerie, Staatliche Museen zu Berlin
Contributions by J. Block, M. Brod-
recht, Y. Deseyve, J. De Smet,
M. Draguet, R. Gleis, A. Gronewald-
Schmidt, H. Körner, I. Rossi, H. Todts,
C. Verleysen; 320 pages, 220 color
illustrations, 24.5 × 29 cm, hardcover

Contempo Rotterdam, Zweigstelle
Berlin (eds.)
**Isabelle Dyckerhoff. on canvas /
on paper**

Inspired by a private archive and
featuring contemporary work by art-
ists who acknowledge the continued
relevance of Angela Davis's experience
and politics, the essays, interviews
and images in this book provide a
compelling and layered narrative of
her journey through the junctures of
race, gender, economics, and politics.

Contributions by J. Daur, L. Seyfarth
100 pages, 100 color illustrations,
23 × 27 cm, softcover, Swiss brochure
with flaps; text: English | German

Esther Shakine
Exodus
48 pages, 93 illustrations,
17 × 25 cm, softcover with flaps
Graphic design: Marion Blomeyer

Ingrid Pfeiffer (ed.)
**Fantastic Women. Surreal Worlds
from Meret Oppenheim to
Frida Kahlo**
Exhibition catalogue, Schirn
Kunsthalle, Frankfurt; Louisiana
Museum of Modern Art, Humlebæk
Contributions by P. Allmer, T. Arcq,

Charles Bukowski, the "dirty old man" of American literature
whose poems and prose are closely interwoven with his life—
how does one go about portraying a person like that? In 1985,
the young photographer Abe Frajndlich took on this challenge.
We can say this much: it was not a job that could be accom-
plished in one shot. *The Shooting* presents a photographer's
attempt to zero in on a legend.

DECADENCE AND DARK DREAMS.
BELGIAN SYMBOLISM

Sensuousness, magic, a profound momentousness, and irrationality are the hallmarks of the new art movement of Belgian Symbolism, which emerged during the 1880s. From Georg Minne and Félicien Rops to Fernand Khnopff and James Ensor, the paintings revealed a fascination with Thanatos und Eros.

K. Degel, H. Eipeldauer, A. Görgen-Lammers, R. Herlemann, K. Hille, S. Levy, A. Mahon, C. Meyer-Thoss, L. Neve, I. Pfeiffer, G. Weisz Carrington; 420 pages, 350 color illustrations, 24 × 29 cm, hardcover
Graphic design: Sabine Frohmader

Katia Baudin, Eline Knorpp (eds.)
Folklore & Avant-Garde.
The Reception of Popular Traditions in the Age of Modernism
Exhibition catalogue, Kunstmuseen Krefeld
Contributions by K. Baudin, G. Breuer, V. Gardner Troy, M. Holzhey, M. Jongbloed, C. Kallieris, W. Kaschuba, B. Knorpp, E. Knorpp, Á. Moravánszky, E. Näslund, P. N'Guessan Béchié, et al.
288 pages, 350 color illustrations, 23 × 27 cm, softcover with flaps

Jürgen B. Tesch (ed.)
Abe Frajndlich. New York City.
Just like I pictured it
144 pages, 75 illustrations, 24.5 × 30 cm, hardcover

Graphische Sammlung ETH Zürich, Alexandra Barcal, Linda Schädler (eds.)
Franz Gertsch. Looking Back
Exhibition catalogue, Graphische

Sammlung, ETH Zürich, Zurich
112 pages, 50 color illustrations, 22.5 × 27.5 cm, hardcover
Text: English | German

Christian Alandete, Jo Widoff (eds.)
Alberto Giacometti. Face to Face
Exhibition catalogue, Moderna Museet Stockholm
Contributions by D. Ades, C. Alandete, G. Bataille, S. Beckett, J. Genet, A. Giacometti, C. Grenier, G. Ørskou J. Olsson, A. Vannouyong, J. Widoff
252 pages, 150 color illustrations, 21.7 × 28 cm, softcover with flaps
Design: Rita Jules and Julia Ma, Miko McGinty Inc.

Elsy Lahner, Klaus Albrecht Schröder (eds.)
Xenia Hausner. True Lies
Exhibition catalogue, The Albertina Museum, Vienna
Contributions by P. Blom, J. Crispin, S. Eiblmayr, M. Gaponenko, L. Gascoigne, A. Heller, E. Jelinek, D. Kehlmann, E. Lahner, T. Macho, E. Menasse, C. Ransmayr, L. Rideal, K. Sykora, B. Zemann
240 pages, 120 color illustrations, 29.5 × 29.5 cm, hardcover
Design: SCHIENERL D/AD, Vienna

Anna Schultz, Angela Lammert (eds.)
John Heartfield. Photography plus Dynamite
Exhibition catalogue, Akademie der Künste, Berlin; Museum de Fundatie, Zwolle; Royal Academy of Arts, London
Contributions by M. Gough, P. Krishnamurthy, A. Lammert, R. v. d. Schulenburg, A. Schultz, J. Toman, A. Zervigón, et al.
Statements by R. Deacon, T. Dean, M. Lammert, M. Odenbach, J. Wall
312 pages, 250 color illustrations, 21.5 × 27.5 cm, hardcover
Graphic design: Heimann + Schwantes, Berlin

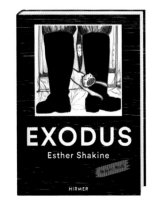

EXODUS

EXODUS tells the true story of a Jewish girl from Hungary. After her parents were abducted by the Nazis, she and other orphaned children were forced to shift for themselves amid the total destruction throughout the country. In 1947 she found a place on board the refugee ship *Exodus*, which was to carry over 4,000 Holocaust survivors to Palestine. What followed was a dramatic odyssey lasting for weeks.

Markus Heinsdorff (ed.)
**Markus Heinsdorff. static +
dynamic**
Contributions by Manfred Baur,
Rasmus Kleine, Gottfried Knapp,
Michael Müller-Verweyen, Christian
Schittich; 280 pages, 260 color
illustrations, 24 × 30.5 cm, hard-
cover; text: English | German

Hilti Art Foundation (ed.)
**Hilti Art Foundation.
The Collection. Vol. 2:
Art from 1950 to the Present Day**
320 pages, 180 color illustrations,
23.5 × 30 cm, hardcover

Leo Schmidt, Countess of
Hopetoun, Polly Feversham (eds.)
**Hopetoun. Scotland's Finest
Stately Home**
Foreword by The Marquess of
Linlithgow, contributions by
A. Bantelmann-Betz, P. Burman,
C. Dingwall, A. Farnusch, J. Hardy,
J. Holloway, Lord A. Hope, Earl of
Hopetoun, Countess of Hopetoun,
D. Jones, L. Schmidt, A. Skedzuhn-
Safir, C. M. Vogtherr; 240 pages,
209 color illustrations, 25.4 × 29 cm,
hardcover, cloth, dust jacket

Galerie Kornfeld, Mamuka Bliadze
(eds.)
**Natela Iankoshvili. An Artist's Life
between Coercion and Freedom**
Contributions by M. Bliadze,
G. Bouatchidzé, G. Laliaschwili,
E. Shawgulidse, M. Stoessel
160 pages, 66 color illustrations,
21 × 26 cm, hardcover

Helen Hirsch, Kunstmuseum Thun,
Christoph Wagner (eds.)
**Johannes Itten and Thun.
Nature in Focus**
Exhibition catalogue,
Kunstmuseum Thun
Contributions by H. Hirsch,

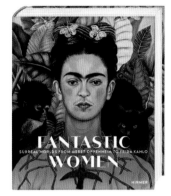

I. Rödl, C. Wagner
224 pages, 152 color illustrations,
21 × 28 cm, hardcover
Text: English | German

Circe Henestrosa (ed.)
**Frida Kahlo and San Francisco.
Constructing Her Identity**
Exhibition catalogue, Fine Arts
Museum of San Francisco, CA
Contributions by G. Ankori,
C. Henestrosa, H. C. Olcott
96 pages, 70 color illustrations,
20.3 × 25.4 cm, softcover with
flaps

Wilhelm Hausenstein
**Kairouan. Or How Paul Klee
Became a Painter**

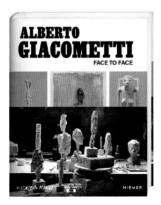

FANTASTIC WOMEN.
SURREAL WORLDS FROM MERET
OPPENHEIM TO FRIDA KAHLO

Between 1930 and the 1960s many
more women artists contributed to the
Surrealist movement than has hitherto
been assumed. The male Surrealists
surrounding André Breton mostly saw
them only as partners or models, but
this volume shows how much more
these women artists had to offer.

Foreword by Kenneth Croose Perry
176 pages, 32 color illustrations,
15.5 × 21 cm, hardcover

Bettina Baumgärtel (ed.)
Angelica Kauffman
Exhibition catalogue, Kunstpalast
Düsseldorf; Royal Academy of Arts,
London
Contributions by B. Baumgärtel,
I. M. Holubec, J. Myssok,
H. Valentine; 208 pages, 144 color
illustrations, 23.5 × 28.5 cm,
hardcover

Rosa von der Schulenburg, Jürgen
B. Tesch, Gannit Ankori (eds.)
Heinrich Knopf. Iron Society
Contribution by Joachim Kuolt;

ALBERTO GIACOMETTI.
FACE TO FACE

Alberto Giacometti forged a singular
path within European modernism,
restlessly seeking a new language for
sculpture as a "double of reality."
Presenting some 100 sculptures and
paintings, the publication tracks the
evolution of Giacometti's work from
Post-Cubism through Surrealism to
postwar Realism.

136 pages, 80 color illustrations, 24.5 × 31.5 cm, hardcover, dust jacket; text: English | German

Ina Fuchs, Stiftung Nantesbuch gGmbH, Börries von Notz (eds.)
Juul Kraijer. Twoness
Exhibition catalogue, Museum Sinclair-Haus, ALTANA-Kulturstiftung, Bad Homburg v. d. Höhe Including an interview with the artist; 112 pages, 50 color illustrations, 23 × 26 cm, softcover, Swiss binding; text: English | German Graphic design: Christian Padberg

Zweigstelle Berlin (ed.)
Elvira Lantenhammer. Color Siteplan
Exhibition catalogue, Neuer Kunstverein Aschaffenburg, KunstLANDing, Aschaffenburg Contributions by U. W. Claus, H. Heinemann, H. Holsing, W. Hülsen; 122 pages, 122 color illustrations, 24 × 30 cm, hardcover Text: English | German

Dr. Marion Bornscheuer (ed.)
Astrid Lowack. The Elements of Transcendence
Exhibition catalogue, Museum für Kunst und Kulturgeschichte Dortmund (MKK), Dortmund 108 pages, 53 color illustrations,

21 × 24 cm, hardcover
Text: English | German

Florian Steininger, Oscar Gardea Duarte, Maria Chiara Wang
Teresa Margolles. En la herida
Exhibition catalogue, Kunsthalle Krems 112 pages, 50 color illustrations, 16.5 × 21.5 cm, softcover with flaps, Swiss binding; text: English | German

Klaus Kinold (ed.)
Ludwig Mies van der Rohe. Barcelona Pavillon / Haus Tugendhat
Contributions by Christoph Hölz, Wolf Tegethoff, photographs by Klaus Kinold

XENIA HAUSNER. TRUE LIES

XENIA HAUSNER. TRUE LIES

Xenia Hausner ranks among the most important Austrian painters of our time. This splendid volume focuses on the aspect of stagecraft which characterizes all her works. Starting from the early paintings of the 1990s up to her moving *Exiles* series, the publication lures us into a female world filled with mysterious interpersonal relationships.

72 pages, 39 illustrations, 4 historical design drawings, 12 contemporary floor plans, elevations, and sections, 21 × 31.5 cm, hardcover, dust jacket; text: English | German

Bernd Pappe, Juliane Schmieglitz-Otten
Miniatures from the Time of Napoleon in the Tansey Collection
Ed. by The Tansey Miniatures Foundation at the Bomann Museum in Celle Contributions by H. Boeckh, B. Falconi, N. Lemoine-Bouchard, B. Pappe 452 pages, 225 color illustrations, 23 × 29.5 cm, hardcover, cloth, dust jacket; text: English | German

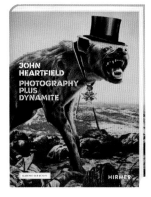

JOHN HEARTFIELD.
PHOTOGRAPHY PLUS DYNAMITE

The political collages of John Heartfield (1891–1968) have earned him a reputation as one of the most innovative graphic artists of the Weimar Republic. His photomontages and book covers based on collages which had their origins in Berlin's Dada scene were directed against Fascism and made him internationally famous. Their explosive power has lost none of its impact. This catalogue will include not only the working materials which reveal Heartfield's method, but also his trick films, work for the theater, and book design.

HOPETOUN.
SCOTLAND'S FINEST
STATELY HOME

Hopetoun House, on the Firth of Forth near Edinburgh, is the seat of the Marquess of Linlithgow. This lavishly illustrated book presents the architecture, sumptuously decorated rooms, and art collection, as well as the landscape and gardens.

Frank Laukötter
Paula Modersohn-Becker.
The Great Masters of Art
72 pages, 49 color illustrations,
14 × 20.5 cm, hardcover

Hans-Michael Koetzle
László Moholy-Nagy.
The Great Masters of Art
80 pages, 58 color illustrations,
14 × 20.5 cm, hardcover
Graphic design: Rainald Schwarz

Wilfried Rogasch (ed.)
Alfons Mucha.
The Great Masters of Art
80 pages, 54 color illustrations,
14 × 20.5 cm, hardcover

Meredith Malone (ed.), co-published
by Mildred Lane Kemper Art Museum
Multiplied. Edition MAT and the
Transformable Work of Art,
1959–1965
Exhibition catalogue, Kemper Art
Museum, Washington University,
St. Louis, Missouri
Contributions by S. Adams,
Á. Berecz, M. Holzhey, M. Isigro,
A. Kauffman, M. Malone, M. Moog
256 pages, 200 color illustrations,
20.3 × 25.4 cm, hardcover
Graphic design: Purtill Family
Business, Conny Purtill

Rafael Jablonka, Elsy Lahner, Klaus
Albrecht Schröder (eds.)
My Generation. The Jablonka
Collection
Exhibition catalogue, Albertina
Museum, Vienna
Contributions by H. Böhme,
M. Hentschel, J. Heynen, E. Juncosa,
P. Pakesch, N. Rosenthal, D. Schwarz,
J. P. Watts, A. Zagajewsky, with an
interview by Eric Fischl with Rafael
Jablonka
248 pages, 180 color illustrations,
24.5 × 28.5 cm, hardcover
Design: Kühle und Mozer, Cologne

Judith W. Mann (ed.)
Painting on Stone.
Science and the Sacred, 1530–1800

Exhibition catalogue, Saint Louis
Art Museum, Missouri
Contributions by J. W. Mann,
N. Groeneveld-Baadj, E. Cenalmor
Bruquetas, M. Casaburo,
J. Encarnacion, L. D. Gelfand,
A. Mészáros Miller, I. Purš, J. M.
Reifsnyder, H. Seifertová, J. Spicer
320 pages, 200 color illustrations,
25.4 × 30.5, hardcover

Stephan Koja (ed.)
Raphael and the Madonna
Exhibition catalogue, Gemälde-
galerie Alte Meister, Staatliche
Kunstsammlungen Dresden
Contributions by S. Girometti,
A. Henning, S. Koja, E.-B. Krems,
V. Perlhefter, P. Stephan
152 pages, 99 color illustrations,
20 × 25.2 cm, hardcover

Cheryl Sim (ed.)
Relations. Diaspora and Painting /
La diaspora et la peinture
Exhibition catalogue, Fondation Phi
pour l'art contemporain, Montréal
Contributions by R. Aima, E. Bélidor,
T. El-Sheik, D. Fontaine, J. Henry, Y.
Lee, J. Oscar, A. Osterweil, C. Sim,
K. Wilson-Goldie
224 pages, 62 color illustrations,
22.9 × 30.5 cm, hardcover
Text: English | French

ANGELICA KAUFFMAN

Angelica Kauffman (1741–1807) is regarded as the first woman artist of European standing. Well educated and very well connected, she pursued a brilliant career and was one of the outstanding artist personalities of the Classical Age in London and Rome. She was admired by Goethe and Herder and her clients included queens and emperors from across the continent.

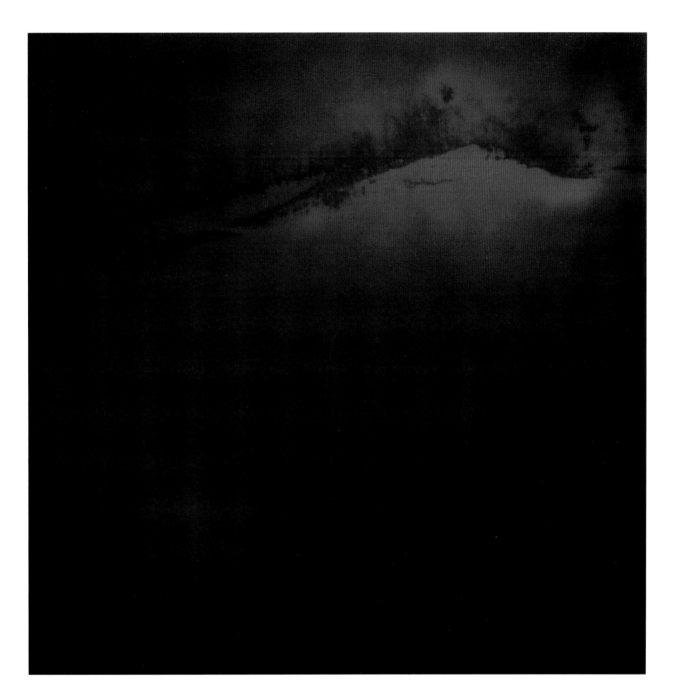

Helmut Schober, The Energy of Intuition, 2017, 120 x 120 cm, acrylic on canvas

2020

REVISIÓN. A NEW LOOK AT ART
IN THE AMERICAS

ReVisión: A New Look at Art in the Americas considers what makes the Americas the Americas. With essays by leading scholars of Latin American art history, this lavishly illustrated publication explores the ways in which the past continues to exert an influence on communities throughout the region.

Martina Nommsen, Annik Haldemann (eds.)
Rethinking Kirchner
Contributions by E. Bader,
F. Blythe, R. Bonnefoit, H. Delfs,
S. Dolz, T. Dziewicki, H. Erbsmehl,
M. Frick, J. Graser, W. Henze,
D. Hess, H. Ivanoff, S. Jordan,
N. Kelly, J. Lloyd, E. Moseman,
W. Murrer, S. Oppmann, M. Picchio,
L. Prins, T. Röske, S. Simmons,
K. Stremmel, C. Weikop
240 pages, 240 color illustrations,
24 × 28 cm, hardcover

Victoria Lyall, Jorge F. Rivas Pérez (eds.)
ReVisión. A New Look at Art in the Americas
Exhibition catalogue, Denver Art Museum, Denver, CO
Contributions by B. Adams,
J. González, E. Shtromberg
144 pages, 80 color illustrations,
22.9 × 27.9 cm, hardcover

Gerlinde Gruber, Elke Oberthaler (eds.)
Rubens's Great Landscape with a Tempest. Anatomy of a Masterpiece
Contributions by G. Bisacca,
P. Fraiture, C. Fryklund, J. de la Fuente, G. Gruber, E. Oberthaler,
G. Prast, I. Slama
128 pages, 211 illustrations,
24 × 28 cm, softcover with flaps

Rudolf Leopold
Egon Schiele. Catalogue raisonné. Paintings, Watercolours, Drawings
Revised 2nd edition, ed. by Elisabeth Leopold, with an updated catalogue raisonné of the paintings with the collaboration of Sonja Niederacher and Michael Wladika
Contributions by S. Niederacher,
M. Wladika
736 pages, 931 illustrations in color and b/w, 30 × 30 cm, hardcover, dust jacket

Dieter Ronte (ed.)
Helmut Schober. Vortex
160 pages, 100 color illustrations,
30.5 × 30.5 cm, hardcover
Text: English | German

Isabel Schulz
Kurt Schwitters. Merz Art
132 pages, 80 color illustrations,
14 × 20.5 cm, hardcover
Graphic design: Marion Blomeyer

Karin Althaus, Susanne Böller
Florine Stettheimer. The Great Masters of Art
80 pages, 60 color illustrations,
14 × 20.5 cm, hardcover

Pia Dornacher, Lisa Felicitas Mattheis, Ute Stuffer, Katharina Sturm (eds.)
Helmut Sturm. Subverting the Real
Exhibition catalogue, Kunsthalle Emden; Museum Lothar Fischer, Neumarkt in der Oberpfalz; Kunstmuseum Ravensburg
Contributions by O. Bergmann,
P. Dornacher, A. Heil, H. Heindl,
H. Herrmann, E. Huttenlauch,
B. Kleindorfer-Marx, A. Kühne,
L. F. Mattheis, S. Niggl, U. Stuffer,
K. Sturm
256 pages, 197 color illustrations,
22 × 28.5 cm, softcover with flaps
Text: English | German

RUBENS'S GREAT LANDSCAPE
WITH A TEMPEST. ANATOMY
OF A MASTERPIECE

Great Landscape with a Tempest is one of Rubens's largest and most dramatic landscapes. Starting from the far-reaching discoveries during the latest restoration, this volume provides a comprehensive insight into the process of creation as well as its art-historical interpretation.

Lynn Gumpert, Suheyla Takesh
(eds.)
**Taking Shape. Abstraction from
the Arab World, 1950s–1980s**
Exhibition catalogue, Grey Art
Gallery, New York University, New
York City, NY; The Block Museum
of Art, Northwestern University,
Evanston, IL; Herbert F. Johnson
Museum of Art, Cornell University,
Ithaca, NY; McMullen Museum of
Art, Boston College, Boston, MA;
University of Michigan Museum of
Art, Ann Arbor, MI
Contributions by I. Dadi, H. Feldman,
S. Hassan, A. Lenssen, S. Mikdadi,
S. Al Qassemi, N. Shabout,
S. Takesh, K. Wilson-Goldie
256 pages, 162 color illustrations,
21.6 × 27.9 cm, hardcover

Tameka Ellington, Kent State
University Museum, Joseph
L. Underwood (eds.)
**Textures. The History and
Art of Black Hair**
Exhibition catalogue, Kent State
University Museum, Kent, OH
Contributions by I. Banks, T. N.
Ellington, A. Mbilishaka, Z. Samudzi,
L. L. Tharps, J. L. Underwood
200 pages, 150 color illustrations,
22.9 × 30.5 cm, hardcover
Graphic design: Sophie Friederich

Annegret Laabs (ed.)
**Max Uhlig. The Windows
of the St. Johannis Church**
Contributions by M. Flügge,
U. Gellner, A. Laabs
142 pages, 100 color illustrations,
23 × 28 cm, 1 foldout, hardcover
Text: English | German

Matthias Frehner,
Klaus Albrecht Schröder (eds.)
**Van Gogh, Cézanne, Matisse,
Hodler. The Hahnloser Collection**
Exhibition catalogue,
Albertina Museum, Vienna
Contributions by M. Frehner,
B. Hahnloser, M. Hahnloser,
G. Kirpicsenko, R. Koella,
S. Ligas, H. Widauer

EGON SCHIELE. CATALOGUE
RAISONNÉ. PAINTINGS,
WATERCOLOURS, DRAWINGS

The monograph on Egon Schiele
edited by Rudolf Leopold in 1972
forms the basis for Egon Schiele's
world fame. This important
document of art-historical
literature is now available once
more in a revised edition.

288 pages, 180 color illustrations,
24.5 × 28.5 cm, hardcover

Heinz R. Böhme (ed.)
**We Haven't Seen Each
Other For So Long. Art of
the Lost Generation.
The Böhme Collection**
Exhibition catalogue, Museum
Kunst der Verlorenen Generation,
Salzburg
Foreword by Wilfried Haslauer,
with contributions by H. R. Böhme,
G. Ridler, R. Streibel
272 pages, 300 color illustrations,
22 × 28 cm, hardcover

Alexander Tutsek-Stiftung,
Eva-Maria Fahrner-Tutsek,
Petra Giloy-Hirtz (eds.)
**Ann Wolff. The Early Drawings
(1981–1988)**
128 pages, 70 illustrations,
22.6 × 26 cm, hardcover
Text: English | German

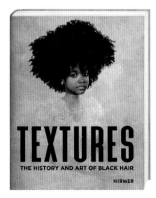

TEXTURES. THE HISTORY AND ART
OF BLACK HAIR

The book synthesizes research in history,
fashion, art, and visual culture to reassess
the hair story of peoples of African
descent. Long a fraught topic for African
Americans and others in the diaspora,
Black hair is here addressed by artists,
barbers, and activists in both its historical
perceptions and its ramifications for self
and society today.

Julian Wagner, Nils Rostek,
Uta Graff, Dietrich Fink (eds.)
Architects on Architects
160 pages, 120 color illustrations,
17 × 24 cm, softcover with flaps

Inés de Castro, Doris Kurella, Martin
Berger (eds.), in cooperation with
the Instituto Nacional de Antro-
pología e Historia (INAH), Mexico
The Aztecs
Exhibition catalogue, Linden-
Museum Stuttgart; Weltmuseum
Wien, Vienna; Museum Volken-
kunde, Leiden
Contributions by M. Aguilar-Moreno,
Y. Athie, R. Barrera, E. Bayer,
F. Berdan, M. Berger, G. van Bussel,
I. de Castro, X. Chavez, S. T. Evans,
F. Hinz, M. Janssen, D. Kurella,
L. López Lujan, R. Macuil Martínez,
E. Matos Moctezuma, B. Mundy,
G. Olivier, J. Olko, A. Rojas,
L Snjiders; 360 pages, 395 color
illustrations, 21 × 27 cm, hardcover
Graphic design: Lucia Ott

Carla Schulz-Hoffmann
Georg Baselitz
Exhibition catalogue, Pinakothek
der Moderne, Munich
Preface by Bernhard Maaz, Corinna
Thierolf; 144 pages, 100 color
illustrations, 17 x 22.5 cm, hardcover

Dieter Buchhart, Anna Karina
Hofbauer (eds.)
Basquiat by Himself
Contributions by D. Buchhart,
B. Bischofsberger, N. Cullinan,
M. Halsband, A.K. Hofbauer, L. Jaffe,
L. Rideal; 184 pages, 130 color
illustrations, 25 × 31 cm, hardcover
Graphic design: Hannes Halder

Florian Strob, Stiftung Bauhaus
Dessau (ed.)
Bauhaus Dessau. Architecture
168 pages, 120 color illustrations,
21 × 26.5 cm, hardcover

Wolfgang Holler, Ulrike Bestgen,
Ute Ackermann (eds.)
**Bauhaus Museum Weimar.
The Bauhaus Comes from Weimar**
Exhibition catalogue, Bauhaus
Museum Weimar
Contributions by U. Ackermann,
U. Bestgen, A. Blümm, M. Götze,
H. Hanada, J. Siebler, V. Stephani
160 pages, 106 color illustrations,
15 × 23 cm, softcover with flaps
Graphic design: Peter Grassinger

Franz Roh
Aenne Biermann
Hans-Michael Koetzle (ed.)
Essay by Hans-Michael Koetzle
104 pages, 61 b/w illustrations,

17.4 × 24 cm, softcover
Text: English | French | German

Kerstin Richter (ed.)
**Pieter Bruegel the Elder.
The Miracle in the Snow. Oskar
Reinhart Collection "Am Römer-
holz," Winterthur**
Exhibition catalogue, Sammlung
Oskar Reinhart „Am Römerholz",
Winterthur
Contributions by D. Allart, K. Baum-
hoff, C. Currie, V. Dietzel, P. Fraiture,
E. Oberthaler, S. Pénot, K. Richter
96 pages, 50 color illustrations,
21 × 22 cm, softcover with flaps

Ralph Gleis (ed.)
**Gustave Caillebotte. Painter and
Patron of Impressionism**
Exhibition catalogue, Alte National-
galerie, Staatliche Museen zu Berlin
Contributions by R. Gleis,
A. Groenewald-Schmidt, K. Sagner
120 pages, 71 color illustrations,
21.5 × 26.5 cm,
softcover with flaps

Christoph Wagner (ed.)
**Cinemas. From Babylon Berlin
to La Rampa Havana**
Accompanying exhibition:
Universitätsbibliothek Regensburg
Contributions by Gerald Dagit,
Peter Krieger, Barbara Muhr,
Michael M. Thoss, Christoph
Wagner; 96 pages, 80 color
illustrations, 26 × 29 cm, hardcover
Text: English | German

Wolfgang Jean Stock
**Creative Reconstruction. Hans
Döllgast – Karljosef Schattner –
Josef Wiedemann**
Klaus Kinold (ed.)
Accompanying exhibition:
Kunstverein Ingolstadt
Photographs by Klaus Kinold
96 pages, 74 illustrations,

THE AZTECS

Five hundred years ago, the landing of
Hernán Cortés in Mexico marked the
end of the Aztec Empire. This volume
presents the wealth of this culture with
spectacular, sometimes unpublished
finds: rare feathered shields, impressive
stone sculptures, precious mosaic masks,
and goldwork, as well as brilliantly
colored illustrated manuscripts, bring
the world of the Aztecs to life.

21 x 31.5 cm, hardcover, dust jacket
Text: English | German

Brigitte Leal, Christian Briend,
Ariane Coulondre (eds.)
The Cubist Cosmos.
From Picasso to Léger
Exhibition catalogue, Kunstmuseum
Basel
Contributions by O. Berggruen,
C. Briend, D. Cottington,
A. Coulondre, P. Karmel, B. Léal,
E. Reifert, et al.; 320 pages,
330 color illustrations,
24.5 x 29.5 cm, hardcover
Graphic design: Tauros /
Christophe Ibach

Wiesbaden Reinhard & Sonja Ernst
Stiftung (ed.)
Dazzled by Color. Abstract Painting.
The Reinhard Ernst Collection
Editorial team: Christoph Zuschlag,
Kirsten Maria Limberg,
with contributions by R. Ernst,
C. Langer, K. M. Limberg,
C. Zuschlag; 384 pages, 330 color
illustrations, 28.6 × 30.7 cm,
hardcover, cloth

Alexandra Palmer
Christian Dior. History and
Modernity, 1947–1957
Exhibition catalogue, Royal Ontario
Museum, Toronto
270 pages, 491 illustrations,
23 x 30.5 cm, hardcover, dust jacket
Graphic design: Tara Winterhalt

Wolfgang Pehnt
Egon Eiermann. Deutsche Olivetti.
Frankfurt am Main
Klaus Kinold (ed.)
Photographs by Klaus Kinold
72 pages, 60 illustrations,
21 x 31.5 cm, hardcover, dust jacket
Text: English | German

Bettina Zorn (ed.)
The Elegance of Hosokawa.
Tradition of a Samurai Family
Exhibition catalogue, Weltmuseum
Wien, Vienna
Contributions by J. Abe,
A. Funakushi, M. Hosokawa, C. Ito,
T. Kaneko, T. Komatsu, H. Miyake,
E. Sasaki, I. Suchy, B. Zorn
146 pages, 130 color illustrations,
24.5 × 29.5 cm, hardcover, cover of
uncoated art paper with trimmed
edges

Aya Soika, Lisa Marei Schmidt,
Meike Hoffmann (eds.), for the
Brücke Museum Berlin
Escape into Art? The Brücke
Painters in the Nazi Period

Exhibition catalogue, Brücke
Museum, Berlin
288 pages, 244 color illustrations,
24 × 30.5 cm, hardcover, dust jacket
Graphic design: Pascal Storz und
Fabian Bremer

Brandon Brame Fortune (ed.)
Eye to I. Self-Portraits from the
National Portrait Gallery
Exhibition catalogue, National
Portrait Gallery, Washington, D.C.
Contributions by Robyn Asleson,
Taína Caragol, Anne Collins Good-
year, Frank Goodyear III, Dorothy
Moss, Asma Naeem, Patricia Quealy,
Wendy Wick Reaves, Emily Caplan
Reed, Ann Shumard, Leslie Ureña,
Ann Prentice Wagner

"Art and technology: a new unit"—It was
with this slogan that the Bauhaus moved
to Dessau in 1925/26. The seven years in
Dessau were most productive for the
designers and architects at the Bauhaus.
This illustrated volume presents the
Bauhaus buildings in Dessau in words
and pictures and offers new perspectives
on these icons of modern architecture.

Aenne Biermann is regarded as one of the
important avant-garde photographers of the
20th century. Together with Bauhaus artists
such as Lucia Moholy and Florence Henri, she
was represented in the pioneering exhibitions
of the late 1920s and early 1930s. In 1930
Franz Roh dedicated to her a legendary
monograph, which is now being published
again as a reprint with commentary.

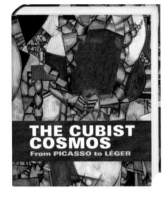

THE CUBIST COSMOS.
FROM PICASSO TO LÉGER

This volume unfolds the development of Cubism between 1907 and 1917. It conveys the movement's enormous stylistic range and its revolutionary potential for the art that would follow during the 20th century. It also presents the way that representatives of the avant-garde adopted and transformed the Cubist pictorial language.

336 pages, 178 color illustrations, 17.8 × 22.9 cm, hardcover
Graphic design: Hannes Halder

Ulrich Luckhardt
Lyonel Feininger.
The Great Masters of Art
72 pages, 54 illustrations,
14 × 20.5 cm, hardcover

Pedro Gadanho (ed.)
Fiction and Fabrication.
Photography of Architecture
after the Digital Turn
Exhibition catalogue, MAAT,
Museu de Arte, Arquitetura
e Tecnologia, Lisbon
Contributions by Pedro Gadanho,
Gloria Moure, Sérgio Fazenda

Rodrigues; 176 pages, 86 illustra-
tions, 23 × 27 cm, softcover with
flaps

Frank Vorpahl (ed.)
Georg Forster.
The South Seas at Wörlitz
Exhibition catalogue, Kulturstiftung
Dessau-Wörlitz, Wörlitz
Contributions by M. Ewert,
D. Heintze, J. Kittelmann, M. Korn,
J. Meißner, A. Pečar, U. Quilitzsch,
A. Thyng, L. Uhlig, F. Vorpahl
208 pages, 116 color illustrations,
22 × 28 cm, hardcover

Konrad Bitterli, Andrea Lutz,
Lynn Kost (eds.)
Frozen Gesture. Gestures in Painting

Exhibition catalogue, Kunst
Museum Winterthur
Contributions by K. Bitterli,
L. Kost, A. Lutz, et. al.; 144 pages,
100 color illustrations,
23 × 28 cm, softcover
Text: English | German

Krems Landesgalerie Nieder-
österreich (ed.)
Franz Hauer. Self-made Man
and Art Collector
Exhibition catalogue, State
Gallery of Lower Austria, Krems
304 pages, 300 color illustrations,
22.5 × 28.5 cm, hardcover

Anke Blümm, Martina Ullrich (eds.)
Haus am Horn.
Bauhaus Architecture in Weimar
Exhibition catalogue, Haus
am Horn / Klassik Stiftung Weimar
Contributions by A. Blümm,
M. Ullrich, U. Ackermann
112 pages, 86 illustrations,
15 × 23 cm, softcover with flaps

Elmar Zorn
Elisabeth Heindl
128 pages, 91 color illustrations,
24 × 28 cm, hardcover
Text: English | German

CHRISTIAN DIOR. HISTORY AND MODERNITY, 1947–1957

Arguably the most famous fashion designer of the 20th century, Christian Dior's postwar feminine fashions were desired, worn, and emulated by women around the world. This publication explores the brilliance behind the dramatic creations that revived the entire Paris haute couture industry after the devastation of the Second World War. In 1947 the opening of the new couture house and Dior's revolutionary "New Look" swept away the wartime masculine silhouette. The book breaks new ground as it explains key Dior signatures, based on the use of innovative and historical dressmaking techniques.

The private art collection of the Hilti Art Foundation includes more than 200 top-quality paintings, sculptures, and photographs from classical modernism to the present day. Volume 1 of the two-part catalogue of the collection presents 80 selected works from the late 19th to the mid-20th century, from Paul Gauguin to Alberto Giacometti, ranging thus from Post-Impressionism, Expressionism, Cubism, Futurism, Neo-Plasticism, and Surrealism to abstraction.

Hilti Art Foundation (ed.)
**Hilti Art Foundation.
The Collection. Vol. 1: Classical Modernism 1880–1950**
236 pages, 90 color illustrations, 23.5 × 30 cm, hardcover

Christoph Grunenberg, Eva Fischer-Hausdorf (eds.)
Icons. Worship and Adoration
Exhibition catalogue, Kunsthalle Bremen
Contributions by V. Borgmann, B. Dümpelmann, E. Fischer-Hausdorf, C. Grunenberg, A. Hoberg, M. Husemann, E. Kleimann, I. Müller-Westermann, L. Rickelt, A. Rosen, M. Schieren, M. Schulz, B. Straumann, R. Zieglgänsberger, et al.; 384 pages, 168 color illustrations, 15 × 20 cm, hardcover

Christoph Wagner, Chair of Art History, University of Regensburg
**Johannes Itten.
The Great Masters of Art**
80 pages, 56 illustrations, 14 × 20.5 cm, hardcover

Barbara Engelbach (ed.)
**Benjamin Katz.
Berlin Havelhöhe 1960/1961**
Exhibition catalogue, Museum Ludwig, Cologne

Contributions by Y. Dziewior, B. Engelbach, B. Katz; 160 pages, 78 b/w illustrations, 17 × 24 cm, hardcover; text: English | German
Graphic design: NOC Berlin, Sarah Nöllenheidt

Corinna Thierolf (ed.)
Königsklasse IV
Exhibition catalogue, Schloss Herrenchiemsee
136 pages, 50 color illustrations, 19.5 × 26 cm, softcover
Text: English | German
Graphic design: Blackspace GmbH

Alexandra Bürger, Claudia Teibler Förderkreis Kunstareal, Alexandra von Arnim, Verena Spierer (eds.)

Kunstareal München Guide
160 pages, 150 color illustrations, 12 × 17 cm, softcover with flaps

Beatrice von Bormann, Klaus Albrecht Schröder, Antonia Hoerschelmann (eds.)
Maria Lassnig. Ways of Being
Exhibition catalogue, Stedelijk Museum Amsterdam; Albertina Museum, Vienna
Foreword by Jan Willem Sieburgh and Klaus Albrecht Schröder, with contributions by B. von Bormann, W. Drechsler, A. Hoerschelmann, J. Ortner, W. Poschauko, S. Proksch-Weilguni; 208 pages, 177 color illustrations, 23 × 30 cm, hardcover
Graphic design: Lucia Ott

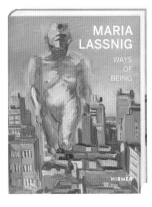

This volume gathers together paintings, drawings, films, and sculptures by Maria Lassnig (1919–2014) from a creative career that spanned some seventy years. It explains how she thought of herself in relation to the art scene of her time. This multimedia approach makes possible new ways of looking at the artist's multifaceted work. Examples of Maria Lassnig's writings round out the presentation.

Benjamin Katz, Dinard, 1977–80, all 30 x 20 cm or 20 x 30 cm, silver gelatine print on baryta paper

MAKING VAN GOGH

Making van Gogh focuses on the oeuvre of Vincent van Gogh in the context of its reception. This publication examines the particular role that German gallerists, collectors, critics, and museums played in the story of his success. At the same time, it sheds light on the importance of van Gogh as a role model for the avant-garde generation of artists.

Bernhard von Waldkirch, Marianne von Manstein, Zürcher Kunstgesellschaft / Kunsthaus Zürich, Albertina Museum Wien (ed.)
Wilhelm Leibl. The Art of Seeing
Exhibition catalogue, Kunsthaus Zürich, Zurich; Albertina Museum, Vienna
Contributions by J. Beyer, Z. Gonda, M. Meyer, T. Ketelsen; 288 pages, 160 color illustrations, 22 × 27 cm, hardcover

Robert Fleck, Antonia Lehmann-Tolkmitt
Heinz Mack. A 21st Century Artist
184 pages, 65 color illustrations, 17 × 24 cm, softcover with flaps

Felix Krämer, Alexander Eiling (eds.), with the cooperation of Elena Schroll
Making van Gogh
Exhibition catalogue, Städel Museum, Frankfurt
Contributions by H. Biedermann, R. Dorn, E. Eiling, J. Kaak, S. Koldehoff, F. Korn, F. Krämer, I. Schmeisser, E. Schroll
352 pages, 260 color illustrations, 23 × 28 cm, hardcover

Nicole Gnesa (ed.)
Michele Melillo
Accompanying exhibition:
Galerie Nicole Gnesa, Munich
Contributions by Veit Ziegelmeier
192 pages, 143 color illustrations,

26 × 29 cm, hardcover
Text: English | German
Graphic design: Hannes Halder

Lynn Gumpert (ed.)
Modernisms. Iranian, Turkish, and Indian Highlights from NYU's Abby Weed Grey Collection
Exhibition catalogue, Grey Art Gallery, New York City, NY; The Block Museum of Art, Northwestern University, Evanston, IL
288 pages, 120 color illustrations, 21.6 × 27.9 cm, hardcover

Moritz Woelk, Manuela Beer (eds.)
Museum Schnütgen.
A Survey of the Collection
Contributions by M. Beer, I. Metje, P. Ralcheva, A. Schieck, G. Sporbeck-Stracke, A. Stead, K. Straub, M. Woelk, et al.; 472 pages, 443 color illustrations, 24 × 28 cm, hardcover

Matthias Mühling, Stephanie Weber (eds.)
Senga Nengudi. Topologies
Exhibition catalogue, Städtische Galerie im Lenbachhaus und Kunstbau, Munich
Contributions by L. Goode-Bryant, M. Gaines, K. Jones, B. McCullough, M. Mühling, S. Nengudi, A. Straetmans, I. Wallace, S. Weber, C. Wood
336 pages, 245 color illustrations, 17 × 23.4 cm, hardcover
Text: English | German
Graphic design: Sabine Frohmader

Wolfgang Holler, Sabine Walter, Thomas Föhl (eds.)
Neues Museum Weimar.
Van de Velde, Nietzsche and Modernism around 1900
Exhibition catalogue, Bauhaus Museum Weimar; Neues Museum Weimar

SENGA NENGUDI. TOPOLOGIES

For almost fifty years, Senga Nengudi has shaped an oeuvre that inhabits a specific and unique place between sculpture, dance, and performance. Her iconic *R.S.V.P.* sculptures—performative objects made from pantyhose and materials such as sand and stone—have been acquired by important American museums. The publication accompanies the first solo exhibition of Nengudi in Germany, at the Lenbachhaus, Munich.

Few regions have undergone a more rapid and radical development than the American West in the mid-20th century. The modern infrastructure, technical innovations, spectacular architecture, and new leisure activities have been recorded on postcards with lively pictures in vivid colors. This volume shows 500 selected linen postcards from the America of the 1930s to 1950s with an incomparable wealth of detail.

Contributions by U. Bestgen, T. Föhl, K. Jost, A. Neumann, M. Ullrich, S. Walter, G. Wendermann; 184 pages, 160 illustrations, 15 × 23 cm, softcover with flaps

Wolfgang Wagener, Leslie Erganian
New West
304 pages, 500 illustrations, 29.2 × 22.9 cm, hardcover
Graphic design: Gunnar Musan

Klaus Albrecht Schröder, Elsy Lahner (eds.)
Nitsch. Spaces of Color
Exhibition catalogue, Albertina Museum, Vienna
Contributions by E. Lahner, J. Moebus-Puck, A. Ellegood,

S. Zalkind; 230 pages, 150 color illustrations, 1 foldout, 28.5 × 24.5 cm, hardcover
Graphic design: Sophie Friederich

Stephan Berg, Alexander Klar, Frédéric Bußmann (eds.)
Now! Painting in Germany Today
Exhibition catalogue, Kunstmuseum Bonn; Museum Wiesbaden; Kunstsammlungen Chemnitz, Museum Gunzenhauser, Chemnitz; Deichtorhallen Hamburg
Contributions by S. Berg, A. Klar, A. Richter, L. Schäfer, C. Schreier, et al.; 300 pages, 200 color illustrations, 24 × 30 cm, hardcover

Florian Steininger, Andreas Hoffer (eds.)
Adrian Paci. Lost Communities
Exhibition catalogue, Kunsthalle Krems
Contributions by Cristina Cannelli, Andreas Hoffer, Seamus Kealy, and Adrian Paci in an interview with Kathrin Rhomberg, Florian Steininger; 192 pages, 150 color illustrations, 23 × 28 cm, hardcover
Text: English | German

Gilbert Vicario (ed.)
Agnes Pelton.
Desert Transcendentalist
Exhibition catalogue, Phoenix Art Museum, Phoenix, AZ; New Mexico Museum of Art, Santa Fe, NM;

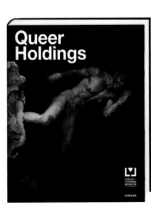

Founded in the context of social movements of the late 1960s, the Leslie-Lohman Museum of Art is dedicated to preserving art that speaks to the LGBTQ experience and fostering the artists who create it. Queer Holdings aims to reclaim scholarship from a queer perspective by surveying 200 works from the museum's permanent collection. A selection of essays by scholars, artists, and archivists explore the museum's possible futures by tracing its visual, cultural, and political evolutions in parallel with 50 years of shifting social conditions for LGBTQ communities.

Michele Melillo, not titled (LC), 2012, 80 x 60 cm, oil on canvas

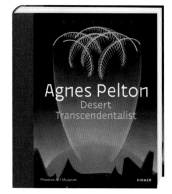

AGNES PELTON. DESERT TRANSCENDENTALIST

This publication seeks to clarify the artist's significance and role within the canon of American modernism, but also against the legacy of European abstraction. It is the first survey of this under-recognized American painter in over 22 years. Her distinctive paintings could be described as metaphysical landscapes rooted in the California desert near Cathedral City. Pelton chiefly drew on her own inspirations, superstitions, and beliefs to exemplify emotional states.

Whitney Museum of American Art, New York City, NY; Palm Springs Art Museum, Palm Springs, CA
Essays by G. Vicario, S. Aberth, E. Armstrong, E. Doss, M. Zakian, R. Sadvary Zebro; 220 pages, 132 color illustrations, 26 × 30 cm, hardcover
Graphic design: Sabine Frohmader

Annette Vogel (ed.)
Hans Purrmann. Vitality of Colour
Exhibition catalogue, Kunstforeningen Gl Strand, Copenhagen; Städtische Museen Heilbronn / Kunsthalle Vogelmann, Heilbronn
168 pages, 112 color illustrations, 21 × 26 cm, softcover
Text: English | Danish

**Outsider & Vernacular Art.
The Victor F. Keen Collection**
Exhibition catalogue, Colorado Institution Sangre de Cristo Arts Center, Pueblo, CO; Intuit: The Center for Intuitive and Outsider Art, Chicago, IL
Essays by Frank Maresca, Edward M. Goméz, Lyle Rexer; contributions by Alejandra Russi
272 pages, 243 illustrations, 21.6 × 24.5 cm, hardcover

Ibrahim Mohamed Jaidah
Qatari Style. Unexpected Interiors
224 pages, 175 color illustrations, 25 × 27 cm, hardcover, dust jacket

Leslie-Lohman Museum of Gay and Lesbian Art, Gonzalo Casals, Noam Parness (eds.)
Queer Holdings. A Survey of the Leslie-Lohman Museum Collection
Exhibition catalogue, Leslie-Lohman Museum of Gay and Lesbian Art, New York City, NY
Essays by D. Bright, V. A. Crockett, R. Fawaz, T. T. Latimer, H. Ryan, R. S. Sur, C. Vargas; 264 pages, 199 color illustrations, 20.3 × 25.4 cm, hardcover
Graphic design: Petra Lüer, Wigel

Maya Vinitsky (ed.)
Solar Guerrilla. Constructive Responses to Climate Change
Exhibition catalogue, Tel Aviv Museum of Art
344 pages, 180 color illustrations, 13.5 × 21 cm, softcover
Text: English | Hebrew

Frank Matthias Kammel, Johannes Pietsch (eds.)
Structuring Fashion. Foundation Garments through History
Contributions by D. Bruna, A. Descalzo Lorenzo, K. Hopfensitz, O. Kratz, B. Nutz, S. Passot, J. Pietsch, A. Rasche, P. Rasmussen, J. Tiramani
168 pages, 120 color illustrations,

THE SUPPER CLUB. BY ELIA ALBA

Elia Alba's photographic portrait series *The Supper Club* depicts U.S.-based artists of color. Alongside the portraits are excerpts from dinner conversations addressing issues that relate to race and visual culture, including sanctuary, policing, post-black identity, and intersectional identities connecting gender, race, and privilege.

24.5 × 29 cm, softcover with flaps
Graphic design: Lucia Ott

Sara Reisman, George Bolster,
Anjuli Nanda (eds.)
The Supper Club. By Elia Alba
Essays by R. Aranda-Alvarado, M.
Berger, S. Reisman, B. T. Summers
136 pages, 40 color illustrations,
20.3 × 25.4 cm, hardcover

Finbarr Barry Flood (ed.)
There Where You Are Not.
Selected Writings of Kamal Boullata
488 pages, 224 color illustrations,
17 × 24 cm, hardcover, dust jacket

Amanda Gilvin (ed.)
Fatimah Tuggar. Home's Horizons
Exhibition catalogue, Davis
Museum at Wellesley College,
Wellesley, MA
Foreword by Lisa Fischman,
with contributions by J. Bajorek,
D. Collier, N. R. Fleetwood
144 pages, 70 color illustrations,
28.5 × 23 cm, hardcover

Kunstmuseum Luzern (ed.)
Turner. The Sea and the Alps
Exhibition catalogue,
Kunstmuseum Luzern, Lucerne
Essays by D. Blayney Brown,
L. Breitschmid, F. Fetzer,
C. Nooteboom, E. Suter, B. Wismer
180 pages, 100 color illustrations,
22.2 × 28 cm, hardcover
Graphic design: Erich Brechbühl
[Mixer], Lucerne

Burcu Dogramaci (ed.)
Uninterrupted Fugue.
Art by Kamal Boullata
176 pages, 98 color illustrations,
17 × 24 cm, hardcover,
dust jacket

Extensive journeys in Britain and conti-
nental Europe provided an inexhaustible
source of inspiration for the visionary
color compositions of J. M. William
Turner. In Switzerland he experienced
the beauty and menace of the Alps, and
by the sea the colorful harmonies of the
diffuse light. This publication presents an
incomparably original artist on his route
to autonomy in art.

Achim Sommer (ed.)
Joana Vasconcelos. Maximal
Exhibition catalogue, Max Ernst
Museum Brühl des LVR, Brühl
Essays by P. Blümel, A. Sommer,
J. Vasconcelos, F. Voßkamp,
J. Wilhelm; 224 pages, 110 color
illustrations, 23 × 23 cm, hardcover
Text: English | German

Gerda Ridler, Simone Schimpf,
Klaus Peter Dencker, Agathe
Weishaupt, Maximilian Weishaupt
(eds.)
Peter Weber. Volume 1: Structure
and Folding. Volume 2: Catalogue
Raisonné 1968–2018
Galerie Renate Bender, Munich;
Museum für Konkrete Kunst,
Ingolstadt
2 volumes in a slip-case, 644 pages
in total, 1,700 color illustrations,
28 × 28 cm, hardcover
Text: English | German

Brigitte Salmen
Marianne von Werefkin.
The Great Masters of Art
80 pages, 53 illustrations,
14 × 20.5 cm, hardcover

Alexander Klee, Peter Weibel,
Christoph Wagner, Enrique Xavier
de Anda Alanís, Silvia Fernández,
Boris Friedewald, Valérie Hammer-
bacher, Margret Kentgens-Craig,
Salma Lahlou, David Maulen de
los Reyes, Christiane Post, Judith
Raum, Robin Rehm, Elisa Tama-
schke, Institut für Auslands-
beziehungen (ed.)
The Whole World a Bauhaus
Exhibition catalogue, ZKM |
Zentrum für Kunst und Medien,
Karlsruhe
200 pages, 160 color illustrations,
22 × 22 cm, softcover with flaps
Graphic design: HIT, Berlin

Cheryl Sim, Gunnar B. Kvaran (eds.)
Yoko Ono & John Lennon. Growing
Freedom. The instructions of Yoko
Ono. The art of John and Yoko
Exhibition catalogue, Fondation Phi
pour l'art contemporain, Montréal
Essays by C. Sim, G. B. Kvaran,
C. Andrieux, M. Kin Gagnon,
N. Seki; 176 pages, 80 color
illustrations, 12.7 × 19.7 cm,
softcover; text: English | French
Graphic design: Principal Studio

Bettina Krogemann (ed.)
About Black and Color. New Works by Brigitte Siebeneichler
Contributions by G. Rump,
A. Zeiller; 128 pages, 78 color
illustrations, 24 × 28 cm, hardcover
Text: English | German

Dr. David Zemanek (ed.)
African Art of the Mack Collection
Texts by Maria Valeria Mack,
Dr. David Zemanek; 280 pages,
150 illustrations, among them
80 exhibits, 26.5 × 30 cm, hardcover,
cloth; text: English | German

Peter van Ham with Amy Heller and
Likir Monastery
Alchi. Treasure of the Himalayas
Accompanying exhibition: MARKK,
Museum am Rothenbaum, Hamburg
With Amy Heller and Likir Monastery,
foreword by His Holiness the Dalai
Lama; 422 pages, 600 color
illustrations, 1 foldout, maps,
drawings, 29 × 31 cm, hardcover
Graphic design: Anke von der
Hagen, Munich

Dr. Otto Letze, Nicole Fritz (eds.)
**Almost Alive. Hyperrealistic
Sculpture in Art**
Exhibition catalogue, Kunsthalle
Tübingen

The world-famous Buddhist monastery
of Alchi lies in Ladakh (Northwest
India) and is the best-preserved temple
complex in the Himalayas. Inside it
houses thousands of incomparable
paintings and sculptures dating back to
11th-century western Tibet. For the first
time, the Dalai Lama has authorized
their comprehensive documentation.

144 pages, 70 color illustrations,
21.5 × 27 cm, softcover
Text: English | German

Lisa Fischman (ed.)
**Christiane Baumgartner.
Another Country**
Exhibition catalogue, Davis Museum
at Wellesley College, Wellesley, MA
Contributions by L. Fishman,
C. C. Whitner, R. S. Field
144 pages, 70 color illustrations,
27.9 × 22.9 cm, hardcover

Henriette Huldisch (ed.)
**Before Projection. Video Sculpture
1974–1995**
Exhibition catalogue, MIT List Visual
Arts Center, Cambridge, MA;

Sculpture Center, Long Island City,
New York City, NY
Contributions by Edith Decker-
Phillips, and Emily Watlington
144 pages, 58 color illustrations,
14.8 × 23.5 cm, softcover
Graphic design: Chad Kloepfer

Jürgen B. Tesch (ed.)
Gerhard Berger. Between Worlds
Essay by Agathe Schmiddunser
128 pages, 60 color illustrations,
24.5 × 30 cm, hardcover, dust
jacket; text: English | German

Alfred Weidinger, Jan Nicolaisen
(eds.), for the City of Leipzig
Anna-Eva Bergman. Light
Exhibition catalogue, Museum

Before Projection: Video Sculpture 1974–1995 shines a spotlight
on a body of work in the history of video art that has been
largely overlooked since its inception. The publication explores
connections between our current moment and the point at
which video art was transformed dramatically by the entry of
large-scale, cinematic installation into the gallery space. It pre-
sents a reevaluation of monitor-based sculpture since the 1970s
and serves as a tightly focused survey of works that have been
rarely seen in the last twenty years.

CARS – DRIVEN BY DESIGN.
SPORTS CARS FROM THE 1950S TO 1970S

The sports cars of the 1950s to the 1970s are fast, beautiful, eccentric, and innovative. In recent decades, these automobiles have not only become coveted collector's items, but have also enjoyed cult status. In an exciting journey through time, this volume presents 25 outstanding sports cars as design icons and illuminates their presentation in film and photography.

der bildenden Künste Leipzig
Contributions by Céline Flécheux, Romain Mathieu, Jan Nicolaisen
96 pages, 50 color illustrations, 22.5 × 28 cm, hardcover
Text: English | German

Alexander Klee, Stella Rollig (eds.)
Beyond Klimt. New Horizons in Central Europe
Exhibition catalogue, BOZAR – Centre for Fine Arts, Brussels; Belvedere, Vienna
Essays by S. Auer, É. Bajkay, K. De Boodt, G. Barki, G. Dobó, P. Dujardin, A. Groenewald-Schmidt, I. Hábán, A. Klee, B. Lésak, F. Mészáros, F. Smola, G. Spindler, A. Suppan, M. Szeredi, M. Theinhardt, J. Weiss
392 pages, 301 color illustrations, 23.5 × 28.5 cm, hardcover

Andreas Braun (ed.)
BMW i. Visionary Mobility
Exhibition catalogue, BMW Museum, Munich
240 pages, 175 color illustrations, 32 × 27 cm, hardcover
Text: English | German
Graphic design: Hannes Halder

Rupprecht Mayer
Bolihua. Chinese Reverse Glass Painting from the Mei-Lin Collection

Accompanying exhibition: Schloss Wernigerode, Wernigerode; Augsburger Schaezlerpalais, Augsburg
272 pages, 182 color illustrations, 24 × 28 cm, hardcover
Text: English | Chinese

Built towards the Light.
John Pawson's Redesign of the Moritzkirche in Augsburg
Contributions by H. Haug, U. Hörwick, A. Morris, S. Stötzer
120 pages, 111 color illustrations, 24 × 28 cm, hardcover, dust jacket
Text: English | German

Barbara Til, Dieter Castenow (eds.)
Cars – Driven by Design. Sports Cars from the 1950s to 1970s
Exhibition catalogue, Kunstpalast, Düsseldorf
Contributions by Christopher Butt, Niklas Maak, Barbara Til, Paolo Tumminelli; 180 pages, 187 color illustrations, 29 × 22 cm, hardcover
Graphic design: Sophie Friederich

Wolfgang Meisenheimer
Marcel Chassot.
Architecture and Photography — Amazement as Visual Culture
Essay by Wolfgang Meisenheimer
374 pages, 256 color illustrations, 23.5 × 33 cm, hardcover, dust jacket

Wolfgang Jean Stock
Hans Döllgast.
Creative Reconstruction
Klaus Kinold (ed.)
Accompanying exhibition: aut. architektur und tirol, Innsbruck
80 pages, 55 illustrations, 21 × 31.5 cm, hardcover, dust jacket; text: English | German

Robert Ferry, Elisabeth Monoian (eds.)
Energy Overlays.
Land Art Generator Initiative
Exhibition catalogue, Fed Square, Melbourne; RMIT University Design Hub, Carlton, Melbourne
240 pages, 250 color illustrations, 28 × 23 cm, hardcover
Graphic design: Paul Schifino

Dorlis Blume, Christiana Brennecke, Ursula Breymayer, Thomas Eisentraut (eds.)
Europe and the Sea
Exhibition catalogue, Deutsches Historisches Museum, Berlin
448 pages, 301 color illustrations, 114 b/w, 21 × 28 cm, hardcover
Graphic design: Peter Nils Dorén, Berlin

Verena Wolfgruber, Haifischbecken [Shark Tank], 2017, 41 × 90 cm, photographic print under acrylic glass

FLORENCE AND ITS PAINTERS.
FROM GIOTTO TO LEONARDO DA VINCI

Painting reinvented itself during the 15th century in Florence. Artists experimented in an innovative manner with pictorial subjects, forms, and techniques and thus arrived at an unprecedented diversity of means of artistic expression. This volume tells in an interesting and nuanced manner of a unique creative development which permanently changed art in Europe.

Gaensheimer Susanne, Kathrin Beßen (eds.)
Cao Fei
Exhibition catalogue, Kunstsammlung Nordrhein-Westfalen, K21, Ständehaus, Düsseldorf
Contributions by K. Beßen, K. Biesenbach, L. Cornell, C. Fei, S. Gaensheimer, A. Skolimowska, P. Tinari; 208 pages, 170 color illustrations, catalogue of works with 185 illustrations, 20 × 24.5 cm, softcover with flaps
Text: English | German
Graphic design: Simon Brenner, Sascha Lobe, L2M3 Kommunikationsdesign GmbH, Stuttgart

Andreas Schumacher (ed.)
Florence and Its Painters.
From Giotto to Leonardo da Vinci
Exhibition catalogue, Alte Pinakothek, Munich
Contributions by M. Burioni, C. Campbell, D. Carl, M. W. Cole, D. Korbacher, A. Kranz, W.-D. Löhr, N. Nanobashvili, S. Nethersole, U. Pfisterer, N. Pons, A. Röstel, A. Schumacher, T. Wagener
384 pages, 226 color illustrations, 23.5 × 28.5 cm, hardcover
Graphic design: Petra Ahke, Berlin

Yigal Gawze
Form and Light.
From Bauhaus to Tel Aviv
Exhibition catalogue, MAAT – Museu de Arte, Arquitetura e Tecnologia, Lisbon; Casa da Arquitectura, Porto
Essays by Yigal Gawze, Gilad Ophir, Michael Jacobson; 120 pages, 100 color illustrations, 24.1 × 27.9 cm, hardcover
Text: English | German
Graphic design: Wolfram Söll

Christoph Rauhut, Niels Lehmann (eds.)
Fragments of Metropolis -
East | Osten. The Expressionist
Heritage in Poland, the Czech
Republic and Slovakia
Preface by Gesine Schwan, introduction by Beate Störtkuhl
300 pages, 170 color illustrations, 40 plan drawings, maps, 15.5 × 24.5 cm, hardcover
Text: English | German

Katharina Hoins, Christoph Vogtherr (eds.), on behalf of the Hamburger Kunsthalle
Thomas Gainsborough.
The Modern Landscape
Exhibition catalogue, Hamburger Kunsthalle, Hamburg

Essays by M. Bills, B. Gockel, M. Hallett, K. Hoins, R. Jones, J. Karg, S. Pisot, C. Vogtherr
224 pages, 148 color illustrations, 24 × 28 cm, hardcover
Graphic design: Sophie Friederich

Barbara Nierhoff-Wielk, Evelyn Wöldicke (eds.)
Frank Gehry – Hans Scharoun.
Strong Resonances
Exhibition catalogue, Max Liebermann Haus – Stiftung Brandenburger Tor, Berlin
Foreword by Kai Uwe Peter, Bianca Richardt, Peter-Klaus Schuster, with contributions by E.-M. Barkhofen, M. Casciato, G. Fox, T. Gaethgens, F. O. Gehry; E. Pugh, B. Schulz, P.-K. Schuster, E. Wöldicke, M. Zenck; 176 pages, 217 illustrations, 21 × 25 cm, softcover
Text: English | German
Graphic design: Ariane Spanier Design (Stephie Becker, Ariane Spanier)

Deutsche Bundesbank, Carl-Ludwig Thiele (ed.)
Germany's Gold
Exhibition catalogue, Geldmuseum der Deutschen Bundesbank, Frankfurt
160 pages, 148 illustrations,

22 × 28 cm, hardcover, cloth,
dust jacket, bookmark

Julie Decker, Nicholas Bell (eds.)
John Grade. Reclaimed
304 pages, 244 color illustrations,
25.4 × 33 cm, hardcover

Maria Schneider
Alfred Haberpointner
192 pages, 133 color illustrations,
24 × 32 cm, hardcover
Text: English | German

Lawrence W. Nichols, Liesbeth
De Belie, Pieter Bisboer (eds.)
Frans Hals. A Familiy Reunion
Exhibition catalogue, Toledo
Museum of Art, Toledo, OH;
The Royal Museums of Fine Arts
of Belgium, Brussels; Fondation
Custodia / Collection Frits Lugt, Paris
112 pages, 70 color illustrations,
21 × 25 cm, hardcover

Staci Bu Shea, Carmel Curtis (eds.)
**Barbara Hammer.
Evidentiary Bodies**
Exhibition catalogue, Leslie-
Lohman Museum of Gay and
Lesbian Art, New York City, NY
112 pages, 75 color illustrations,
24 × 28 cm, hardcover

Eva-Maria Fahrner-Tutsek (ed.)
Havana. Short Shadows
Photographs by Eva-Maria
Fahrner-Tutsek, with essays by
Eva-Maria Fahrner-Tutsek, Michael
Freeman, and a text by Leonardo
Padura; 164 pages, 60 color
illustrations, 30 × 24 cm, hardcover
Text: English | Spanish | German
Graphic design: Christian Hölzl

Udo Kittelmann (ed.), for the
Nationalgalerie, Staatliche Museen
zu Berlin
Hello World. Revising a Collection

Exhibition catalogue, Hamburger
Bahnhof – Museum für Gegenwart,
Staatliche Museen zu Berlin
Contributions by D. Ananth,
Z. Badovinac, S. Beckstette,
A. Bertina, E. Blume, D. Bystron,
C. Deliss, J. Dirksen, A. Farenholz,
D. Garza Usabiaga, R. Gadebusch,
V. Galstyan, A. C. Gebbers,
N. Ginwala, A. Giunta, U. Kittel-
mann, G. Knapstein, V. König,
T. Mamine, A. Neufert, A. Nwag-
bogu, M. Pehlivanian, M. Rou-
miguière, G. Samboh, N. Schallen-
berg, K. Schrei, N. Sheikh, S. da
Silva, E. Supriyanto, H. Völckers;
432 pages, 600 color illustrations,
24 × 32 cm, softcover
Graphic design: Timo Hinze,
Paul Spehr, Müller & Wesse

CAO FEI

The projects of Beijing-based artist
Cao Fei (b. 1978) reflect the evolving
societal and urban situation in China.
Her works often make use of the latest
digital media. Located on the threshold
between reality and fiction, the videos,
photographs, drawings, and multimedia
installations in this book represent her
entire artistic oeuvre.

Sarah Lees (ed.)
**Innovative Impressions. Prints
by Cassatt, Degas, and Pissarro**
Exhibition catalogue, Philbrook
Museum of Art, Tulsa, OK
Essays by R. Brettell, C. Kannen-
berg; 130 pages, 100 color illustra-
tions, 24 × 28 cm, hardcover

Tom Jacobi
**Into the Light. Between Heaven
and Earth, Between Light and
Darkness**
Texts by Katharina Jacobi
144 pages, 70 color illustrations,
27 × 32 cm, hardcover
Text: English | German

FORM AND LIGHT.
FROM BAUHAUS TO TEL AVIV

While paying homage to the Bauhaus
spirit and the avant-garde photogra-
phers of the 1920s, Yigal Gawze's color
photography is also a tribute to past
ideals and present renewal. The images
add up to create a portrait of a place
by revealing the poetic essence of its
architecture and the role light plays in
shaping it.

PAUL KLEE.
CONSTRUCTION OF MYSTERY

This opulent volume on Paul Klee celebrates one of the most important and productive artists of the 20th century, whose work is as topical today as it ever was. Growing out of the inner conflict of modern man, Klee's imaginative works provide a link between the world of reason and the irrational "secrets" of human existence.

Christoph Wagner
Johannes Itten. Catalogue Raisonné Vol. I. Paintings, Watercolors, Drawings. 1907–1938
496 pages, 1.000 color illustrations, 27 × 32 cm, hardcover

Heinz Kress, Else Kress (eds.)
**Japan in miniature.
A Gift of Inrō, Ojime and Netsuke**
Exhibition catalogue, Museum of Lacquer Art, Münster
232 pages, 453 color illustrations, 24 × 30 cm, hardcover

Stiftung Haus der Kunst München, gemeinnützige Betriebsgesellschaft mbH, Julienne Lorz (ed.)
Joan Jonas
Exhibition catalogue, Tate Modern, London
Contributions by M. Bayer-Wermuth, O. Enwezor, J. Jonas, A. Lissoni, J. Lorz, F. Morris, C. Wood; 288 pages, 60 color illustrations, 15.5 × 20.5 cm, softcover with flaps
Graphic design: Sophie Friederich

Jacob Proctor (ed.)
Alex Katz. Painting the Now
Exhibition catalogue, Museum Brandhorst, Munich
Texts by K. Bell, A. Herrera,

J. Kantor, P. Peiffer, M. Saunders
120 pages, 107 color illustrations, 27 × 33 cm, hardcover
Graphic design: Lucia Ott

Philipp Demandt, Ilka Voermann (eds.)
King of the Animals. Wilhelm Kuhnert and the Image of Africa
Exhibition catalogue, Schirn Kunsthalle, Frankfurt
Contributions by F. Becker, K. Chapman, A. Gall, B. Gissibl, M. Oesterreich, I. Voermann
264 pages, 171 illustrations, 24 × 29 cm, hardcover

Oliver Kase (ed.), for Bayerische Staatsgemäldesammlungen
Paul Klee. Construction of Mystery
Exhibition catalogue, Pinakothek der Moderne, Munich
Contributions by R. Bonnefoit, N. Engel, C. Heise, C. Hopfengart, O. Kase, W. Kersten, C. Klingsöhr-Leroy, A. Schalhorn, C. Wagner, S. Watson, G. Wedekind
456 pages, 385 color illustrations, 23 × 30 cm, hardcover,
Not available in the United States, Canada
Graphic design: Stan Hema, Berlin

Corinna Thierolf
**Willem de Kooning.
The Great Masters of Art**
72 pages, 51 illustrations, 14 × 20.5 cm, hardcover

Patricia Frick, Beatrice Kromp (eds.)
Lacquer Friends of the World
Exhibition catalogue, Museum of Lacquer Art, Münster
Contributions by P. Frick, D. van Gompel, B. Kromp; 176 pages, 157 illustrations, 24 × 30 cm, hardcover

Hall Art Foundation (ed.)
**Landscapes After Ruskin.
Redefining the Sublime**
Exhibition catalogue, Grey Art Gallery, New York University, New York City, NY
Contributions by L. Gumpert, D. Jamison, J. Sternfeld, C. Wiley; 160 pages, 80 color illustrations, 25.5 × 28 cm, hardcover

Diethard Leopold
Rudolf Leopold. Connoisseur I Collector I Museum Founder
312 pages, 70 illustrations, 16.5 × 23.5 cm, hardcover

Cheryl Sim, Jon Knowles (eds.)
LIBRE DHC / ART
Contributions by S. Thornton, J. Verwoert, S. Starling, B. Clausen, V. Bonin, B. Droitcour, J. Fei, R. Tremblay, C. Sim, P. Greenberg, M. Lemaire, D. Fiset, E. Keenlyside, A. Beattie, P. Pyne Feinberg, J. Knowles; 300 pages, 238 color illustrations, 26.7 × 29.8 cm, hardcover
Graphic design: Orysia Zabeida

Majestic and magical landscapes, the soft beauty of fields of flowers, the raw cold of winter: the works of Harald Sohlberg combine a Romantic perception of nature with a contemporary pictorial language akin to Symbolism. This volume assembles some 60 paintings, in addition to a number of drawings, prints, and photographs by the artists, and grants insight into his conceptual world through his correspondence. It places one of his most famous works, *Winter Night in the Mountains,* in a new context and casts light on lesser-known aspects of his oeuvre.

Brigitte Salmen, Hermann Mayer (eds.)
James Loeb. Collector and Patron in Munich, Murnau and Beyond
280 pages, 130 color illustrations, 21 × 29.7 cm, hardcover
Text: English | German

Riccardo Naldi
Magnificence of Marble. Bartolomé Ordóñez and Diego de Silóe
390 pages, 266 illustrations, 25 × 29 cm, hardcover

Dieter Buchhart, Heinz Widauer (ed.)
Claude Monet. A Floating World
Exhibition catalogue, Albertina Museum, Vienna
Contributions by G. Bauer, M. Mathieu, H. Widauer; 272 pages, 140 color illustrations, 24.5 × 28 cm, hardcover

Karl Borromäus Murr (ed.)
Koho Mori-Newton. No Intention
Essay by K. B. Murr; 156 pages, 120 color, b/w illustrations, 28.5 × 24 cm, hardcover
Text: English | German

Elisabeth Leopold, Stefan Kutzenberger
Koloman Moser. The Great Masters of Art
80 pages, 78 color illustrations, 14 × 20.5 cm, hardcover

HL Museumsverwaltung (ed.)
Museum Liaunig.
An Austrian Collector's Museum
Collection catalogue, Museum Liaunig, Neuhaus
Interview by Mark Rosenthal with Ursula von Rydingsvard; 264 pages, 200 color illustrations, 24 × 29 cm, hardcover, dust jacket
Text: English | German

Karl Borromäus Murr (ed.)
Phoenix. Fashion Worlds of Stephan Hann
Exhibition catalogue, tim | Staatliches Textil- und Industriemuseum Augsburg
176 pages, 200 color illustrations, 21 × 27 cm, hardcover
Text: English | German

Maria Santangelo (ed.)
A Princely Pursuit.
The Malcolm D. Gutter Collection of Early Meissen Porcelain
Collection catalogue, Fine Arts Museum of San Francisco, CA
272 pages, 120 illustrations, 24 × 30 cm, hardcover
Graphic design: Bob Aufuldish, Aufuldish & Warinner

More than any other artist, Claude Monet represents Impressionist painting. This volume illustrates Monet's career from Realism via Impressionism to a form of painting in which the colors and light gradually become detached from the object. It focuses on the artist's color concept as well as his passionate study of subjects from his garden in Giverny.

2018

What a shock it must have been for the Utrecht painters ter Brugghen, van Honthurst, and van Baburen when they first encountered the breathtaking and unconventional paintings of Caravaggio in Rome. This volume shows impressively how the young artists individually explored this role model and thereby developed their own individual style.

Nicole Gnesa, Kate Powers (eds.)
Uta Reinhardt. Surface
Contributions by Gottfried Knapp, Ludger Schwarte; 152 pages, 110 color illustrations, 24.5 × 30.5 cm, hardcover
Text: English | German

Ursula von Rydingsvard.
The Contour of Feeling
Exhibition catalogue, The Fabric Workshop and Museum, Philadelphia, PA; National Museum of the Women in the Arts, Washington, D.C.
Foreword by Susan Lubowsky Talbott; "Why I Make Art" by Ursula von Rydingsvard; interview by Mark Rosenthal with Ursula von Rydingsvard; 128 pages, 82 color illustrations, 23 × 32 cm, hardcover
Graphic design: Christian Ring

Stella Rollig, Kerstin Jesse (eds.)
Egon Schiele.
The Making of a Collection
Exhibition catalogue, Belvedere, Vienna
Contributions by S. Auer, C. Bauer, K. Gratzer-Baumgärtner, S. Jahn, A. Boruszczak, K. Jesse, J. Kallir, A. Klee, S. Koja, W. Krug, M.Mayer, S. Rollig, F. Smola; 304 pages, 352 color illustrations, 23.5 × 28.5 cm, hardcover

Wolfgang Jean Stock
Rudolf Schwarz.
Church Architecture
Christoph Hölz, Arno Ritter (eds.)
Accompanying exhibition: aut. architektur und tirol, Innsbruck
Photographs by Klaus Kinold
72 pages, ca. 55 color illustrations, 21 × 31.5 cm, hardcover, dust jacket; text: English | German

Christine Giviskos
Set in Stone. Lithography in Paris, 1815–1900
Exhibition catalogue, Zimmerli Art Museum, Rutgers University, New Brunswick, NJ
184 pages, 130 color illustrations, 24 × 30 cm, hardcover

Stephan Koja, Claudia Kryza-Gersch (eds.)
Shadows of Time. Giambologna, Michelangelo and the Medici Chapel
Exhibition catalogue, Gemäldegalerie Alte Meister, Staatliche Kunstsammlungen Dresden
Contributions by C. Kryza-Gersch, R. Rosenberg, A. Lipinska, F. Scholten, M. Heisterberg
264 pages, 181 illustrations, 21 × 25.5 cm, softcover with flaps

Nationalmuseum Oslo (ed.)
Harald Sohlberg.
Infinite Landscapes
Exhibition catalogue, The National Museum, Oslo;

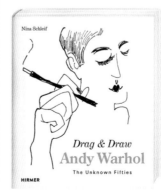

This book highlights two series of little-known drawings from the 1950s in which Andy Warhol first explored the controversial subject of drag. His oeuvre during the first decade of his career, before he became the godfather of Pop, has proven to be enormously influential on his life's work, yet so far has not received due attention.

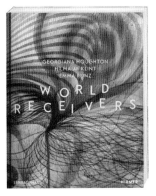

WORLD RECEIVERS. GEORGIANA HOUGHTON –
HILMA AF KLINT – EMMA KUNZ

Abstract paintings were being produced even before Kandinsky. Completely independently from each other, Georgiana Houghton (1814–1884) in England, Hilma af Klint (1862–1944) in Sweden, and Emma Kunz (1892–1963) in Switzerland developed an individual, abstract pictorial language. What they had in common was a desire to make visible the laws of nature, the intellect, and the supernatural. In addition, this volume shows stills by Harry Smith and James and John Whitney, who—inspired by various occult movements—made experimental films during the 1940s.

Dulwich Picture Gallery, London;
Museum Wiesbaden
240 pages, 200 color illustrations,
24 × 28 cm, hardcover
Graphic design: Sophie Friederich

Magdalena Holzhey, Ina Ewers-Schultz (eds.)
Tailored for Freedom.
The Artistic Dress in 1900 in
Fashion, Art, and Society
Exhibition catalogue, Kaiser Wilhelm Museum, Kunstmuseen Krefeld
Contributions by B. Dogramaci, I. Ewers-Schultz, I. Fleischmann-Heck, J. Hahn, M. Holzhey, I. Ganzer, A. Neumann-Golle, P. Ober, et al.
288 pages, 336 color illustrations,
24 × 28 cm, flexicover

Stephan Koja, Roland Enke (eds.)
"The most beautiful pastel ever
seen". The Chocolate Girl by
Jean-Étienne Liotard in the
Dresden Gemäldegalerie
Exhibition catalogue, Gemäldegalerie Alte Meister, Staatliche Kunstsammlungen Dresden
272 pages, 218 illustrations,
20 × 25 cm, hardcover

Gaëlle Morel, Paul Roth (eds.)
True to the Eyes.
The Howard and Carole Tanen-
baum Photography Collection
Exhibition catalogue, Main Gallery and University Gallery, Ryerson Image Centre, Toronto
Essays by Paul Roth, Gaëlle Morel, Charlene Heath, Denise Birkhofer, Anthony Bannon, Brian Wallis
232 pages, 177 illustrations,
24.1 × 27.9 cm, hardcover
Graphic design: Kelsey Blackwell, Meredith Holigroski, Studio Blackwell

Bernd Ebert, Liesbeth M. Helmus (eds.)
Utrecht, Caravaggio and Europe
Exhibition catalogue, Centraal Museum, Utrecht; Alte Pinakothek, Munich
Contributions by M. J. Bok, B. Ebert, L. M. Helmus, S. Hoppe, H. Langdon, V. Manuth, A. Roy
304 pages, 330 color illustrations,
24 × 28 cm, hardcover

Nina Schleif
Andy Warhol. Drag & Draw.
The Unknown Fifties
144 pages, 142 color illustrations,
24 × 29 cm, hardcover
Graphic design: Petra Lüer, Wigel

Assadullah Souren Melikian-Chirvani (ed.)
The World of the Fatimids
Exhibition catalogue, Aga Khan Museum, Toronto
376 pages, 180 illustrations,
24 × 26 cm, hardcover

Karin Althaus, Matthias Mühling, Sebastian Schneider (eds.)
World Receivers. Georgiana
Houghton – Hilma af Klint –
Emma Kunz
Exhibition catalogue, Städtische Galerie im Lenbachhaus, Munich
Contributions by K. Althaus, M. Mühling, S. Schneider
276 pages, 200 illustrations,
21.5 × 26.5 cm, hardcover
Graphic design: Sabine Frohmader

Roland Fischer, Schwimmunterricht mit Gregor Hildebrandt [Swimming Instruction with Gregor Hildebrandt], 2018,
70 × 98 cm, photographic print on acrylic glass

Maya Vinitsky (ed.)
3.5 Square Meters: Constructive Responses to Natural Disasters
Accompanying exhibition, Tel Aviv Museum of Art
248 pages, 186 illustrations, 13 × 21 cm, softcover
Text: English I Hebrew

Adrian Heathfield (ed.)
Ally. Janine Antoni, Anna Halprin, Stephen Petronio
Contributions by A. Heathfield, H. Cixous, C. Becker, J. Baas, Richard Move; 224 pages, 184 illustrations, 24.5 x 29 cm, hardcover

Filiz Çakır Phillip (ed.)
Arts of the East. Highlights of Islamic Art from the Bruschettini Collection
Exhibition catalogue, Aga Khan Museum, Toronto
Contributions by Filiz Çakır Phillip, Michael Franses, Claus-Peter Haase
248 pages, 114 illustrations, 24 cm × 32 cm, hardcover

Cathrin Klingsöhr-Leroy (ed.)
A cooperation between the Fondazione Gabriele e Anna Braglia, Lugano, and the Franz Marc Museum, Kochel am See
Blue Land and City Noise.

3.5 SQUARE METERS: CONSTRUCTIVE RESPONSES TO NATURAL DISASTERS

Natural disasters and their consequences dominate the news almost on a daily basis. Quick-impact preventive and aid measures are essential for the victims to survive.
This volume presents a selection of projects which demonstrate impressively how both cutting-edge technology and locally available materials and resources can be used for this purpose.

An Expressionist Stroll through Art and Literature
Exhibition catalogue, Franz Marc Museum, Kochel am See
Essay by Michael Kumpfmüller, texts by W. Benjamin, G. Benn, A. Chekhov, A. Döblin, T. Fontane, O. M. Graf, F. Kafka, W. Kandinsky, E. L. Kirchner, E. Laske-Schüler, H. Mann, K. Mann, T. Mann, R. Musil, V. Nabokov, M. Pechstein, R. M. Rilke, J. Roth, A. Schnitzler, H. Walden, S. Zweig; 160 pages, 61 color illustrations, 19.5 × 25 cm, hardcover, bookmark

Eva Michel (ed.)
Pieter Bruegel. Drawing the World
Exhibition catalogue, Albertina Museum, Vienna
Foreword by Klaus Albrecht Schröder, with contributions by Daniela Hammer-Tugendhat, Eva Michel, Laura Ritter
232 pages, 151 illustrations, 23.5 × 28.5 cm, hardcover
Graphic design: Peter Grassinger

Avinoam Shalem (ed.)
The Chasuble of Thomas Becket: A Biography
Foreword by Alessandro Bruschettini, with contributions by M. Ali-de-Unzaga, B. Borkopp-Restle, A. Dor, D. Jacoby, M. Járó, G. Liberati, U. Nilgen, R. Schorta, A. Shalem
304 pages, 2 loose inserts, 274 illustrations in color and b/w, 24 × 30 cm, hardcover, cloth, dust jacket

Petra Giloy-Hirtz
Erik Chmil. Solitude
156 pages, 80 illustrations, 30 × 26 cm, hardcover in hardcover, cloth; text: English I German

Mark Dean Johnson, Renny Pritikin (eds.)
Contraption. Rediscovering California Jewish Artists

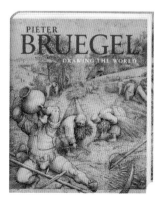

PIETER BRUEGEL. DRAWING THE WORLD

Pieter Bruegel the Elder is considered the greatest Netherlandish graphic artist of the 16th century. Even during his lifetime, his drawings were highly regarded and many were widely distributed. Drawing on the pictorial tradition of earlier generations of artists, Bruegel introduced completely new ideas with regard to both subject and form.

Exhibition catalogue,
The Contemporary Jewish Museum,
San Francisco, CA
Essays by R. Gross, M. D. Johnson,
R. Pritikin; 96 pages, 63 color
illustrations, 21.6 x 28 cm, hardcover
Graphic design: Sabine Frohmader

Klaus Albrecht Schröder, Elsy
Lahner (eds.)
Burhan Doğançay
Exhibition catalogue, Albertina
Museum, Vienna
Contributions by D. Beyazit, E. Köb,
E. Lahner, M. af Petersens
132 pages, 85 color illustrations,
22 × 26 cm, hardcover
Text: English | German

Wolfgang Felten (ed.), photographs
by Hubertus Hamm
Encounters with Art
232 pages, 190 color illustrations,
24 × 32 cm, hardcover, cloth,
dust jacket

Niklas Maak, Johanna Diehl
**Eurotopians. Fragments of
a different future**
Photographs by Johanna Diehl
192 pages, 140 illustrations,
17 x 24 cm, hardcover

Daniel Blau (ed.)
Extra! Weegee
Accompanying exhibition,
Swedish Museum for Photography,
Stockholm
Contributions by R. Adams, D. Blau,
H. Corey, S. Picasso; 336 pages,
361 illustrations, 30 × 24 cm,
hardcover, dust jacket

ARRI (ed.)
**The Filmmaker's View.
100 Years of ARRI**
Contributions by Jon Fauer,
Mark Hope-Jones, Sophie Kill
264 pages, 226 illustrations,

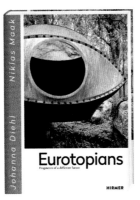

21.5 × 28 cm, hardcover, dust jacket
Graphic design: Peter Grassinger

Maria Antonella Pelizzari (ed.)
**Framing Community.
Magnum Photos, 1947 – Present**
Exhibition catalogue, Hunter
College Art Galleries' Bertha and
Karl Leubsdorf Gallery, New York
City, NY
128 pages, 110 illustrations,
20.3 × 25.4 cm, softcover
Graphic design: Sabine Frohmader

Christine Ekelhart (ed.)
**From Poussin to David. French
Drawings at the Albertina**
Exhibition catalogue, Albertina
Museum, Vienna

EUROTOPIANS.
FRAGMENTS OF A DIFFERENT FUTURE

How do we want to live? How shall we
build? Where can we find ideas for the
houses and cities of the future? Niklas Maak
and Johanna Diehl focus their attention on
these highly topical questions in their joint
project *Eurotopians*. In times of change, this
volume casts a retrospective view at the
work of European utopians in order to find
visions for the present.

Contributions by Christine Ekelhart,
Heinz Widauer; 176 pages, 100 color
illustrations, 23.5 × 28.5 cm,
hardcover

Isabelle Cahn, Eckhard Hollmann
**Paul Gauguin.
The Great Masters of Art**
80 pages, 49 illustrations,
14 × 20.5 cm, hardcover

Ingrid Pfeiffer, Jill Lloyd, Raymond
Coffer (eds.)
Richard Gerstl
Exhibition catalogue, Schirn
Kunsthalle, Frankfurt; Neue Galerie,
New York City, NY
Essays by R. Coffer, P. Demandt,
J. Kallir, D. Leopold, J. Lloyd,

THE CHASUBLE OF THOMAS BECKET:
A BIOGRAPHY

The so-called chasuble of Thomas Becket
(1118–1170) is one of the most magnifi-
cent medieval textiles in the Mediterranean
region. Richly decorated with ornaments,
fabulous animals, and figures in lavish gold
embroidery with Arabic inscriptions, this
precious liturgical garment provides
impressive proof of the reutilization of
the Islamic arts in the Christian world.

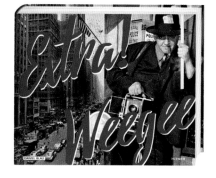

EXTRA! WEEGEE

No other photographer has caught the sensations, scandals, and catastrophes of the 1930s and 1940s in New York City with his camera as captivatingly as Weegee. Most of the vintage prints are being published for the very first time in this volume.

Moritz Woelk
Stella Hamberg
160 pages, 173 illustrations, 21 × 29 cm, hardcover

Dagmar Täube
In) Formation. On the Philosophy and Art of Alice Teichert
Exhibition catalogue, St. Annen Museum, Lübeck
Essay by John K. Grande
144 pages, 101 illustrations, 21 × 26 cm, hardcover
Text: English | German

I. Pfeiffer, M. Sitte; 240 pages, 134 illustrations, 23.5 × 28 cm, hardcover, dust jacket
Graphic design: Büro für Gestaltung | Christian Bredl Frankfurt am Main

Klaus Fußmann
Vincent van Gogh.
The Great Masters of Art
64 pages, 44 illustrations, 14 × 20.5 cm, hardcover

Roman Zieglgänsberger, Evelyn Bergner (eds.)
Werner Graeff. Recollections of a Bauhaus Artist
Contributions by E. Bergner, W. Graeff, U. Graeff-Hirsch, J. Neugebauer, R. Zieglgänsberger
288 pages, 105 illustrations, 19.5 × 25 cm, hardcover, cloth, dust jacket; text: English | German

Helene B. Grossmann.
Share the Light
Essays by Raimund Thomas, Christoph Vitali; 180 pages, 187 illustrations, 30 × 30 cm, hardcover, dust jacket
Text: English | German, with a summary in French

Kunst- und Ausstellungshalle der Bundesrepublik Deutschland GmbH, Kunstmuseum Bern (ed.)
Gurlitt: Status Report
Exhibition catalogue, Martin-Gropius-Bau, Berlin; Kunstmuseum Bern
348 pages, 480 color illustrations, 24 × 28 cm, hardcover
Graphic design: Sophie Friederich

Petra Giloy-Hirtz (ed.)
Elke Härtel. Rapunzel.
Genesis of a Sculpture
96 pages, 46 color illustrations, 21 × 26 cm, hardcover
Text: English | German
Graphic design: Christian Schmid

Elmar Zorn, Cordula Gielen (eds.)
Marcus Jansen. Aftermath
Accompanying exhibition: Galerie Kellermann, Düsseldorf; Kallmann-Museum, Ismaning; Kunst und Kultur zu Hohenaschau e.V., Aschau im Chiemgau; Galerie Kronprinz, Zitadelle Berlin;
Essays by Manfred Schneckenburger, Gottfried Knapp, Dieter Ronte
160 pages, 87 illustrations, 28 × 28 cm, hardcover
Text: English | German

Hajo Düchting
Vasily Kandinsky.
The Great Masters of Art
80 pages, 51 illustrations, 14 × 20.5 cm, hardcover

THE FILMMAKER'S VIEW.
100 YEARS OF ARRI

"The best just got better" is how the new ARRI camera is advertised, and indeed the slogan is a perfect summary of the career of the company. To mark the centenary, 100 famous filmmakers describe their experiences with ARRI—a fascinating glimpse behind the scenes and an entertaining journey from the era of celluloid to the age of digital films.

Founded in 1947 on the shared belief in humanist values, the Magnum photo agency has mostly focused on a transient world in times of unrest, collapsing social structures, and polarizing politics. This volume is being published to mark the 70th anniversary of the agency and sheds new light on Magnum according to one important theme: community.

Exhibition catalogue, Deutsches Historisches Museum, Berlin
80 pages, 70 Illustrations, 12 × 22 cm, softcover

Helmut Friedel (ed.)
MACK – Licht / Light / Lumière
Essay by Heinz-Norbert Jocks
458 pages, 342 color illustrations, 26 × 30 cm,
hardcover, dust jacket
Text: English I French I German

Robert Fleck (ed.), in cooperation with Beck & Eggeling International Fine Art
Heinz Mack.
ZERO Painting. CATALOGUE RAISONNÉ 1956–1968
Contributions by E. Derom, R. Fleck, A. Knop, B. Weiand
2 volumes, 428 pages, 520 illustrations, 26.5 × 30 cm,
hardcover, cloth, slipcase
Text: English I German

Thorsten Sadowsky
Ernst Ludwig Kirchner.
The Great Masters of Art
80 pages, 61 illustrations, 14 × 20.5 cm, hardcover

Anita Haldemann, Antonia Hoerschelmann (eds.)
Maria Lassnig. Dialogues
Exhibition catalogue, Albertina Museum, Vienna; Kunstmuseum Basel
Contributions by A. Haldemann, A. Hoerschelmann, B. Reisinger, with an interview by Ralph Ubl with Miriam Cahn; 240 pages, 159 illustrations, 24.5 × 28 cm, hardcover
Text: English I German

Stiftung Luthergedenkstätten in Sachsen-Anhalt (ed.)
Luther! 95 Treasures – 95 People
Exhibition catalogue, Stiftung Luthergedenkstätten in Sachsen-Anhalt, Wittenberg
Contributions by M. Mosebach, T. Dorn, U. Tellkamp, B. Beuys, H. Münkler, C. Methuen, C. Geyer, A. Vind, C. Dieckmann, E. Straub, V. Leppin, J. Schilling, et al.; 624 pages, 335 illustrations, 18.5 × 24 cm, hardcover, cloth, dust jacket
Graphic design: cyan Berlin (Daniela Haufe und Detlef Fiedler)

Deutsches Historisches Museum (ed.)
**The Luther Effect. Protestantism –
500 Years in the World**
Exhibition catalogue, Deutsches Historisches Museum, Berlin
Essays by P. Burschel, O. Czaika, A. Eckert, J. H. Grayson, M. Hochgeschwender, A. Jarlert, S. Jobs, M. Kern, Y.-J. Lee, F. Ludwig, F. Mahali, L. Minardi, J. W. Parsalaw, V. Reinhardt, U. Rublack, H. Rydving, D. Y. Ryu; 432 pages, 457 illustrations, 21 × 28 cm, hardcover
Graphic design: Sabine Frohmader

Deutsches Historisches Museum (ed.)
**The Luther Effect. Protestantism
– 500 Years in the World.
Short Exhibition Guide**

Annelie Lügtens, Thomas Köhler (eds.)
**Jeanne Mammen. The Observer.
Retrospective 1910–1975**
Exhibition catalogue, Berlinische Galerie, Berlin
Contributions by K. Aurich, J. Bertschik, G. Kühnast, T. Köhler, A. Lütgens, S. Mainberger,

The Viennese artist Richard Gerstl is still regarded as an insider tip. And yet he was one of the most important artists in Vienna around 1900, alongside Klimt, Schiele, and Kokoschka. Although he was only 25 years old when he died, he created an exciting and unusual oeuvre. This volume accompanying the first comprehensive retrospective in Germany introduces all aspects of this exceptional artist.

GURLITT: STATUS REPORT

Otto Dix, Franz Marc, Emil Nolde, Paul Cézanne, Wassily Kandinsky, and Claude Monet—when more than 1,000 artworks by outstanding artists of the modern era appeared on the scene in 2012, the find was celebrated as a sensation, though the suspicion that it might be art looted by the Nazis also reared its head. This extensive, lavishly illustrated publication documents for the first time a selection of works from the estate of the art dealer Hildebrand Gurlitt and examines the turbulent story of the "Gurlitt art trove."

E. Scharrer, D. Schöne, J. Schubert, C. Smith, C. Thiele, G. Wolter
256 pages, 327 color illustrations, 23 × 27 cm, hardcover
Graphic design: e o t. essays on typography, Berlin, Karolina Leczkowski

Stella Rollig, Georg Lechner (eds.)
Maria Theresa and the Arts
Exhibition catalogue, Belvedere, Vienna
Contributions by A. Gamerith, S. Grabner, M. Hohn, R. Johannsen, G. Lechner, M. Pötzl-Malikova, S. Rollig, B. Schmidt, K. Schmitz-von Ledebur, S. Schuster-Hofstatter
232 pages, 160 color illustrations, 23 × 29 cm, hardcover

Markus Müller
Henri Matisse.
The Great Masters of Art
80 pages, 52 illustrations, 14 × 20.5 cm, hardcover

Gero Seelig, Staatliches Museum Schwerin (ed.)
Medusa's Menagerie.
Otto Marseus van Schrieck
and the Scholars
Exhibition catalogue, Staatliches Museum Schwerin; Rijksmuseum Twenthe, Enschede
Contributions by G. Seelig, E. Jorink, B. van de Roemer, K. Leonhard; 224 pages, 180 color illustrations, 24 × 27 cm, hardcover
Graphic design: Sophie Friederich

Thomas Mellins, Donald Albrecht (eds.)
Mexico Modern. Art, Commerce, and Cultural Exchange
Exhibition catalogue, Harry Ransom Center, University of Texas, Austin, TX
176 pages, 200 illustrations, 23 × 27 cm, hardcover

Deutsche Bundesbank (ed.)
The Money Museum of the Deutsche Bundesbank
Collection catalogue, Geldmuseum der Deutschen Bundesbank, Frankfurt
200 pages, 391 color illustrations, 22 × 28 cm, hardcover

HEINZ MACK. ZERO PAINTING. CATALOGUE RAISONNÉ 1956–1968

Heinz Mack is famous above all for his sculptures and reliefs. The starting point of his search for new artistic forms of expression, however, was painting. This publication documents for the first time Mack's painting during the ZERO years, whose radical color reduction and concentration on light and rhythm were path-setting for international art during the years after 1945.

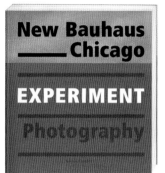

NEW BAUHAUS CHICAGO.
EXPERIMENT PHOTOGRAPHY

This lavishly illustrated volume looks at 80 years of photography from Chicago. At the New Bauhaus and what later became the Institute of Design, teachers such as László Moholy-Nagy, György Arthur Siegel, Harry Callahan, and Aaron Siskind taught an uninhibited approach to the medium which influenced generations of photographers.

Oliver Kornhoff (ed.)
Henry Moore. Vision. Creation. Obsession
Exhibition catalogue, Arp Museum Bahnhof Rolandseck, Remagen
192 pages, 172 illustrations, 30 × 24 cm, hardcover

Bauhaus-Archiv, Museum für Gestaltung (ed.)
New Bauhaus Chicago. Experiment Photography
Exhibition catalogue, Bauhaus-Archiv / Museum für Gestaltung, Berlin
Contributions by A. Bähr, S. Daiter, J. Grimes, S. Hoiman, K. Lowis, E. Siegel; 208 pages, 183 color illustrations, 23 × 25 cm, softcover with open spine
Graphic design: Birgit Schlegel, gewerkdesign

Art Centre Basel, Katharina Beisiegel (ed.)
New Museums. Intentions, Expectations, Challenges
Exhibition catalogue, Musée d'Art et d'Histoire de Genève, Geneva
Essays by S. MacLeod, C. Dercon, K. van den Berg, W. Ullrich, K. Tzortzi, A. Gröner; 216 pages, 260 illustrations, 24 × 30 cm, softcover

Karl Borromäus Murr (ed.)
Beate Passow. Monkey Business
Exhibition catalogue, tim | Staatliches Textil- und Industriemuseum Augsburg; Museum Villa Stuck, Munich
64 pages, 32 color illustrations, 21 × 27 cm, hardcover
Text: English | German
Graphic design: Felix Weinold

Zürcher Kunstgesellschaft / Kunsthaus Zürich (ed.)
Praised and Ridiculed. French Painting 1820–1880
Contributions by O. Bätschmann, S. Gianfreda, M. Koos, M. Krüger, M. Leonhardt, J. H. Rubin; 248 pages,

184 color illustrations, 23 × 28 cm, softcover

Achim Gnann (ed.)
Raphael
Exhibition catalogue, Albertina Museum, Vienna
Contributions by C. Whistler, B. Thomas; 448 pages, 280 color illustrations, 24 × 30 cm, hardcover

Elizabeth Angelicoussis
Reconstructing the Lansdowne Collection of Classical Marbles
728 pages (Volumes I + II), 548 illustrations, 23 × 28 cm, hardcover, cloth, dust jacket

Christoph Schreier, Kunstmuseum Bonn (ed.)
Gerhard Richter. About Painting
Exhibition catalogue, Kunstmuseum Bonn; Stedelijk Museum voor Actuele Kunst, Ghent
Contributions by Stephan Berg, Martin Germann, Christoph Schreier; 128 pages, 68 color illustrations, 24 × 32 cm, softcover

Wolff Mirus (ed.)
Otto Ritschl
Contributions by K. Leonhard, W. Mirus, O. Ritschl; 406 pages, 93 color plates, more than

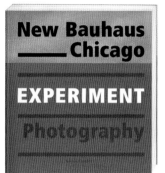

NEW MUSEUMS.
INTENTIONS, EXPECTATIONS, CHALLENGES

The past decade was characterized by a real museum boom which persists today. Throughout the world, museums have been built that are as unique as the art they contain. This volume assembles 15 of these museums, designed and realized by the who's who of the architect scene.

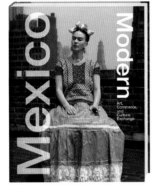

MEXICO MODERN. ART, COMMERCE, AND CULTURAL
EXCHANGE

Rivera, Kahlo, Tamayo, Covarrubias, Weston, Modotti,
Bravo, Spratling—names closely linked with the inter-
nationally celebrated art, photography, and design scene
of the 1920s and 1930s in the United States and Mexico.
This lavishly illustrated publication traces the dynamic
cultural exchange, which left its mark on both sides of
the border.

1,800 illustrations, mostly in color,
23 × 27 cm, hardcover
Text: English | German

Jochen Sander, Stefan Weppel-
mann, Gerlinde Gruber (ed.)
Rubens.
The Power of Transformation
Exhibition catalogue, Kunst-
historisches Museum, Vienna;
Städel Museum, Frankfurt
Contributions by G. Bisacca,
N. Büttner, M. Daiman,
A. Georgievska-Shine, G. Gruber,
F. Healy, N. van Hout, D. Jaffé,
E. Oberthaler, G. Prast, J. Sander,
I. Slama, A. Vergara, S. Weppelmann,
J. Wood; 312 pages, 304 color
illustrations, 24 × 28 cm, hardcover

Stephan Berg, Matthias Mühling,
Christoph Schreier, Eva Huttenlauch
(eds.)
The KiCo Collection.
Mentally Yellow. High Noon
Exhibition catalogue, Kunstmuseum
Bonn; Städtische Galerie im
Lenbachhaus, Munich
Contributions by S. Berg, M. Müh-
ling, H. Friedel in conversation with
the collectors; 352 pages, 130
illustrations, 1,600 illustrations
5 × 5 cm, 24.5 × 31 cm, hardcover,
cloth binding
Text: English | German

Klaus Albrecht Schröder, Johann
Thomas Ambrózy (eds.)
Egon Schiele

Exhibition catalogue, Albertina
Museum, Vienna
Contributions by J. T. Ambrózy,
K. A. Schröder, E. Werth; 380 pages,
328 illustrations,
25 × 29 cm. hardcover

Diethard Leopold
Egon Schiele.
The Great Masters of Art
80 pages, 59 illustrations,
14 × 20.5 cm, hardcover

Alexander Klar, Jörg Daur (eds.)
Richard Serra. Props, Films,
Early Works
Exhibition catalogue, Museum
Wiesbaden
Contributions by J. Daur, P. Forster,
M. Nieslony, S. von Berswordt-
Wallrabe; 144 pages, 73 duplex
illustrations, 24 × 30 cm, hardcover
Text: English | German
Graphic design: Frank Bernhard
Übler

Kunst- und Ausstellungshalle der
Bundesrepublik Deutschland GmbH
(ed.)
Katharina Sieverding.
Art and Capital
Exhibition catalogue,
Bundeskunsthalle Bonn
Contributions by T. Ebers, U. Frohne,

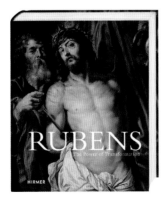

RUBENS. THE POWER
OF TRANSFORMATION

Peter Paul Rubens is not only one of the
most important painters of the Baroque,
he is also a virtuoso of the art of transfor-
mation. More than virtually any other
painter, he sought inspiration in the works
of other artists and was thus constantly
reinventing his art in a highly radical man-
ner. This publication enables you to
immerse yourself in the creative process.

H. J. Hafner, S. Kleine, G. Schröder
256 pages, 300 illustrations,
24.5 × 28 cm, hardcover

Ingrid Pfeiffer (ed.)
**Splendor and Misery in the Weimar
Republic. From Otto Dix to Jeanne
Mammen**
Exhibition catalogue, Schirn
Kunsthalle, Frankfurt
Contributions by K. Hille,
A. Lütgens, S. Moeller, O. Peters,
I. Pfeiffer, D. Price, M. Weinland
300 pages, 200 color illustrations,
24 × 29 cm, hardcover

Donna Gustafson, Andrés Mario
Zervigón (eds.)
**Subjective Objective. A Century
of Social Photography**
Exhibition catalogue, Zimmerli Art
Museum, Rutgers University, New
Brunswick, NJ
Contributions by D. Gustafson, S. M.
Miller, J. Tulovsky, A. M. Zervigón
368 pages, 229 illustrations,
21.6 × 25.4 cm, hardcover
Graphic design: Laura Lindgren

Suzanne Greub, Art Centre Basel
(ed.)
**Towards Impressionism. Landscape
Painting from Corot to Monet**
Exhibition catalogue, Cornell Fine

Arts Museum, Rollins College,
Winter Park, FL; Frye Art Museum,
Seattle, WA
144 pages, 100 color illustrations,
19.5 × 25 cm, hardcover

Janaina Tschäpe. Flatland
240 pages, 142 illustrations,
26 × 30 cm, hardcover
Text: English | German

Joanne Northrup (ed.)
Unsettled
Exhibition catalogue, Nevada
Museum of Art, Reno, NV;
Anchorage Museum, Anchorage;
Palm Springs Art Museum, Palm
Springs, CA
Contributions by J. Decker,

J. Northrup, J. Wiersema,
W. L. Fox, A. Warden; 224 pages,
200 color illustrations, 25.4 × 33 cm,
hardcover
Graphic design: Brad Bartlett
Design

Zürcher Kunstgesellschaft /
Kunsthaus Zürich (ed.)
**Vibrant Metropolis / Idyllic Nature.
Kirchner. The Berlin Years**
Exhibition catalogue,
Kunsthaus Zürich, Zurich
Contributions by G. Gercken,
S. Gianfreda, C. W. Haxthausen,
M. Pfister, K. Schick, U. M.
Schneede; 272 pages, 233 illustra-
tions, 23 × 29 cm, hardcover
Graphic design: Lena Huber

Egon Schiele (1890–1918) is considered
to be one of the pioneers of Austrian
modernism, together with Gustav Klimt
and Oskar Kokoschka. Coinciding with
the start of the commemoration of the
centenary of his death, this volume
approaches Schiele's fascinating works
from a new perspective and introduces a
paradigm change in the interpretation of
his oeuvre.

UNSETTLED

"The Greater West" is a region extending thousands of miles
from Alaska to the west coast of North America, through
Central America, and down to Colombia. Its history, culture,
and the artists living there are equally full of contrasts and
yet often very similar. Through the 200 or so artworks in
this publication, *Unsettled* illuminates their creative ap-
proach in this field of tension from the Pre-Columbian
period to the modern age.

Beate Reifenscheid (ed.)
Grimanesa Amorós. Ocupante
Exhibition catalogue, Ludwig
Museum im Deutschherrenhaus,
Koblenz
Essays by Beate Reifenscheid,
Andreas Backoefer, with an
interview by Tim Goossens
128 pages, 60 illustrations,
24 × 28 cm, hardcover
Text: English | German

Eleanor Antin
An Artist's Life.
By Eleanora Antinova
216 pages, 53 illustrations,
17 × 24 cm, hardcover,
dust jacket

Sabine Breitwieser (ed.)
Anti : Modern
Exhibition catalogue, Museum der
Moderne, Salzburg
336 pages, 106 illustrations,
16.3 × 23.5 cm, softcover with flaps
Text: German with an appendix in
English

Max Hollein, Eva Mongi-Vollmer
(eds.)
Georg Baselitz. The Heroes
Exhibition catalogue, Städel
Museum, Frankfurt; Moderna
Museen, Stockholm; Palazzo

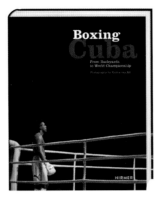

Boxing is the top popular sport in
Cuba and part of its cultural identity.
The martial arts, acquire here an
unexpected elegance, speed and
technical perfection. This publication
reflects the Cuban love of sport,
from youth work in the back yards
of Havana to the preparations for
the Olympic Games.

delle Esposizioni, Rome; Museo
Guggenheim, Bilbao
Essays by U. Fleckner, M. Hollein.
A. Kluge, E. Mongi-Vollmer, R. Shiff
166 pages, 100 illustrations,
24 × 30 cm, hardcover
Graphic design: Büro Schramm
für Gestaltung GmbH

Stephan Koja (ed.)
Andrea Bischof. Color Truth
Essays by Stephen Koja, Irina
Katnik, foreword by Carl Aigner, and
an interview by Wolfgang Huber-
Lang with the artist; 104 pages, 85
illustrations, 24 × 28 cm, hardcover
Text: English | German

Andreas Braun (ed.)
BMW. 100 Masterpieces
Exhibition catalogue, BMW
Museum, Munich
236 pages, 404 illustrations,
32 × 27 cm, hardcover, cloth,
dust jacket; text: English | German

Andreas Hemmerle, Caroline
Schulenburg (eds.)
**The BMW Group Home Plant
in Munich**
e-book, 272 pages, 318 illustrations

Michael Schleicher (ed.)
**Boxing Cuba. From Backyards to
World Championship**
Exhibition catalogue, Museum Fünf
Kontinente, Munich; Stadthaus Ulm

In 1965/66 Georg Baselitz created the monumental series *The Heroes*
and *New Types*, which he presented in wild color and with defiant
style. By turning his attention to the tradition of representational
painting, his work formed a striking contrast to the trends toward
abstraction and Expressionism prevailing during the 1960s, thereby
embarking on his own unique path. In his sceptical basic attitude to
postwar Germany, Baselitz emphasized in his works the ambivalent
aspects of the present in which he lived.

CHAGALL TO MALEVICH.
THE RUSSIAN AVANT-GARDES

The Russian avant-garde represents one of the most fascinating chapters in the history of 20th-century art. Artists such as Malevich, Kandinsky, and Chagall are highly esteemed. But this movement was much more diverse than is generally realized For the first time, this artistic wealth is being presented in a major sequence of pictures.

Photographs by Katharina Alt, introduction by Charles Schumann, essays by Petra Giloy-Hirtz, Michael Schleicher, Claudia Strand
184 pages, 102 illustrations,
24 × 28 cm, hardcover
Text: English | German
Graphic design: Hannes Halder

Institut für moderne Kunst Nürnberg (ed.)
Cathedrals for Garbage.
Winfried Baumann
Essay by Harriet Zilch, with an introduction by Bazon Brock
384 pages, 660 illustrations,
27 × 24 cm, hardcover
Text: English | German

Klaus Albrecht Schröder
Chagall to Malevich.
The Russian Avant-Gardes
Exhibition catalogue, Albertina Museum, Vienna
Essays by H. Altrichter, J. E. Bowlt, B. Groys, J. Epshtein, G. Fischer, M. Mautner Markhof, K. A. Schröder
312 pages, 194 mostly color illustrations, 24.5 × 30 cm, hardcover

Hessisches Landesmuseum Darmstadt (ed.)
Tony Cragg. Unnatural Selection
Exhibition catalogue, Hessisches

Landesmuseum Darmstadt
Essays by T. Cragg, K.-D. Pohl, J. Wood; 120 pages, 120 illustrations, 21 × 28 cm, hardcover

Sabine Reithmaier, Lisa Trockner
Mario Dilitz. Sculptures
Essays by M. Dilitz; 128 pages,
78 color and b/w illustrations,
22 × 30 cm, hardcover
Text: English | German

Oliver Götze, Lieselotte Kugler
Divine Golden Ingenious.
The Golden Ratio as a Theory of Everything?
Exhibition catalogue, Museum für Kommunikation Berlin; Museum für Kommunikation Frankfurt

Essays by W. Beinert,
A. Beutelspacher, M. Braun,
W. Busch, C. Erbar, K. Fendius,
J. Fingerhut, H. Fladt, O. Götze,
P. Hirschmiller, H. Höge, B. Högner,
M.-L. Kinne, M. Kuhn, P. Leins,
M. Lauer, D. Lordick, T. Niemeyer,
K. Schillinger, F. Schütz, E. Spieker-mann, P. Zizka; 224 pages, 115 color illustrations, 17.8 × 23 cm, softcover

Museum Giersch der Goethe-Universität, Jüdisches Museum der Stadt Frankfurt (ed.)
Eavesdropper on an Age.
Ludwig Meidner in Exile
Exhibition catalogue, Museum Giersch der Goethe-Universität, Frankfurt
Essays by S. Behr, L. Berankova, B. Möckel, M. Padberg, E. Riedel, B. Sander; 240 pages, 208 color illustrations, 23 × 27.5 cm, hardcover; text: English | German

Musée d'Art Moderne de la Ville de Paris (ed.)
Eva & Adele. You Are My Biggest Inspiration. Early Works
Exhibition catalogue, Musée d'Art Moderne de la Ville de Paris
160 pages, 186 illustrations,
21 × 27 cm, hardcover
Text: English | French

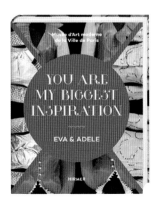

EVA & ADELE. YOU ARE MY BIGGEST INSPIRATION. EARLY WORKS

The exhibition at the Musée d'Art Moderne de la Ville de Paris is the first comprehensive solo show of the early work of the radical artist duo EVA & ADELE. In addition to their very first joint work, the video installation HELLAS, this publication shows for the first time early key works, focusing attention on the Gesamtkunstwerk EVA & ADELE.

ROLAND FISCHER. REFUGEES

Roland Fischer was inspired by the current political and social events relating to the topic of refugees to create a collective portrait consisting of more than 1,000 separate photographs. Central questions about identity and solidarity, which are the subject of discussion in the sociopolitical debate, are raised and treated in an artistic manner.

ROLAND FISCHER – TEL AVIV. ISRAELI COLLECTIVE PORTRAIT

How should you portray a collective? Roland Fischer shows us in his latest large-format photo project, in which 1,000 students from Tel Aviv University agreed to take part. The result is a multifaceted collective portrait of Israels new generation and at the same time a series of fascinating individual portraits.

Björn Vedder (ed.)
Roland Fischer – Tel Aviv. Israeli Collective Portrait
Exhibition catalogue, Schafhof – Europäisches Künstlerhaus Oberbayern, Freising
Essays by Moshe Zuckermann, Bernhard Waldenfels, Björn Vedder
200 pages, 80 color illustrations, 24.8 × 31.2 cm, softcover
Text: English | German
Graphic design: Philippe Loup

Christoph Rauhut, Niels Lehmann (eds.)
Fragments of Metropolis. Expressionist Heritage of the Rhine-Ruhr region
Foreword by Paul Kahlfeldt
256 pages, 150 color illustrations, 30 drawn-up maps, 15.5 × 24.5 cm, hardcover; text: English | German

Michael Buddeberg, Bruno Richtsfeld (eds.)
From the Land of the Snow Lion. Tibetan Treasures from the 15th to the 20th Century
Exhibition catalogue, Museum Fünf Kontinente, Munich
Essays by Justyna Buddeberg, Michael Buddeberg, Koos de Jong, Christiane Kalantari, Petra Maurer, Ulrike Montigel, H. and H. Neumann, Lisa Niedermayr, Bruno Richtsfeld, Rupert Smith, Friedrich Spuhler, Elena Tsareva, Hans Weihreter, Thoma Wild; 340 pages, 627 illustrations, 21.0 × 31.5 cm, hardcover

Christoph Stölzl (ed.)
Albrecht Gehse - Turmoil. 50 Pictures of the World – A Cycle
Exhibition catalogue, EUREF AG, Gasometer Schöneberg, Berlin
Contributions by Albrecht Gehse, Christoph Stölzl, Manfred Thiede
156 pages, 108 color illustrations,

Joshua I. Cohen, Sandrine Colard, Giulia Paoletti, The Miriam and Ira D. Wallach Art Gallery (eds.)
The Expanded Subject. New Perspectives in Photographic Portraiture from Africa
Exhibition catalogue, The Miriam and Ira D. Wallach Art Gallery, New York City, NY
Essays by J. I. Cohen, S. Colard, G. Paoletti, introduction by Z. S. Strother; 128 pages, 65 color illustrations, 20.3 × 25.4 cm, hardcover

C. von Marlin, A. Schmedding
Expressed Reform: Architecture and Art of the University of Konstanz
Universität Konstanz (ed.)
Essays by G. Bechthold, U. Rüdiger,

T. Steier, photographs by Inka Reiter; 280 pages, 294 color illustrations, 24 × 30 cm, hardcover

Bazon Brock
Monika Fioreschy. Strip-Cut-Collage
240 pages, 134 illustrations, 20 × 32 cm, hardcover, dust jacket
Text: English | German

Kunstverein Rosenheim (ed.)
Roland Fischer. Refugees
Exhibition catalogue, Kunstverein Rosenheim e.V., Rosenheim; Centro Galego de Arte Contemporánea, Santiago de Compostela
Essays by Bernhard Waldenfels, Stephan Lessenich
208 pages, 221 color illustrations, 17 × 24 cm, softcover
Text: English | German

Colors are only reflected light, assembled in our brains, which is also known as "grey matter." Tom Jacobi spent two years photographing archaic landscapes throughout the world. He discovered mystic places that had been created by nature. When photographed in the twilight world, they unfold their immortal power.

60 of them in large format,
35 × 37 cm, hardcover, dust jacket
Text: English | German

Diethard Leopold
Richard Gerstl.
The Great Masters of Art
80 pages, 52 illustrations,
14 × 20.5 cm, hardcover

Tom Jacobi
Grey Matter(s)
Foreword by Bryan Adams
144 pages, 73 illustrations,
34 × 28 cm, hardcover
Text: English | German

Peter van Ham
Guge – Ages of Gold.
The West Tibetan Masterpieces
Exhibition catalogue, Historisches
und Völkerkundemuseum, St. Gallen
390 pages, 527 color illustrations,
2 foldouts, 28 × 28 cm, hardcover,
dust jacket

Elmar Zorn (ed.)
Gabriela von Habsburg. 2016–1996
Greeting by Winfried Wiegand,
essays by Manfred Schneckenburger, Dieter Ronte; 240 pages,
100 illustrations, 24.5 × 31.5 cm,
hardcover, dust jacket
Text: English | German

Friedrich Meschede (ed.)
Hans Hofmann.
Creation in Form and Color
Exhibition catalogue, Kunsthalle
Bielefeld; Musée National d'Histoire
et d'Art, Luxembourg
Essays by L. Barnes, J. Hülsewig-Johnen; 188 pages, 130 color
illustrations, 24 × 28 cm, hardcover,
dust jacket

Sabine Schulze, Nora von Achenbach, Simon Klingler (eds.)
Hokusai × Manga.
Japanese Pop Culture since 1680
Exhibition catalogue, Museum für
Kunst und Gewerbe Hamburg
Essays by S. Schulze, N. v. Achenbach, S. Klingler, J. Berndt, J. Singer
240 pages, 231 illustrations,
21 × 28 cm, softcover with flaps
Graphic design: Heine/Lenz/Zizka,
Frankfurt a. M.

Stephan Berg (ed.)
Thomas Huber. On The Horizon
Exhibition catalogue, Kunstmuseum
Bonn; Musées des Beaux-Arts,
Rennes
With texts by Thomas Huber
and an interview between
Stephan Berg, Thomas Huber
and Wolfgang Ullrich; 168 pages,
124 color illustrations, 29 × 23 cm,

hardcover, cloth; text: English |
German

Petra Giloy-Hirtz (ed.)
Stefan Hunstein. In the Ice
Essays by M. Krüger, U. Pohlmann,
P. Giloy-Hirtz, A. M. Bonnet
128 pages, 58 color illustrations,
29 × 30 cm, hardcover

Sabine Grabner, Agnes Husslein-Arco (eds.)
Is that Biedermeier? Amerling,
Waldmüller and more
Exhibition catalogue, Belvedere,
Vienna
Contributions by E. Békefi, W. Busch,
E. Doppler, U. Felbinger, S. Grabner,
F. Mazzocca, K. Monrad, S. Paccoud,
A. Schmidt, R. Vondráček, C. Witt-Dörring; 312 pages, 204 color illustrations, 23 × 28.5 cm, hardcover

Katia Baudin (ed.)
Fernand Léger. Painting in Space
Exhibition catalogue, Museum
Ludwig, Cologne
Essays by J. Barsac, K. Baudin,
Y. Dziewior, D. Gay, J. v. d. Heer,
R. Jubert, G. Lista, P. Mandt,
P. Mennekes, K. Michel, D. Severo,
S. Wilson; 312 pages, 528 illustrations, 22.5 × 27 cm, softcover
with flaps
Graphic design: studio tino graß

Staatliches Museum für Kunst und
Design Nürnberg Neues Museum
(ed.)
Sherrie Levine. After All
Exhibition catalogue, Staatliches
Museum für Kunst und Design
Nürnberg, Nuremberg
Contributions by K. Heymer,
J. Heynen, M. Kliege; 192 pages, 129
illustrations, 24 × 30 cm, softcover
with flaps; text: English | German
Graphic design: Kühle und Mozer,
Cologne

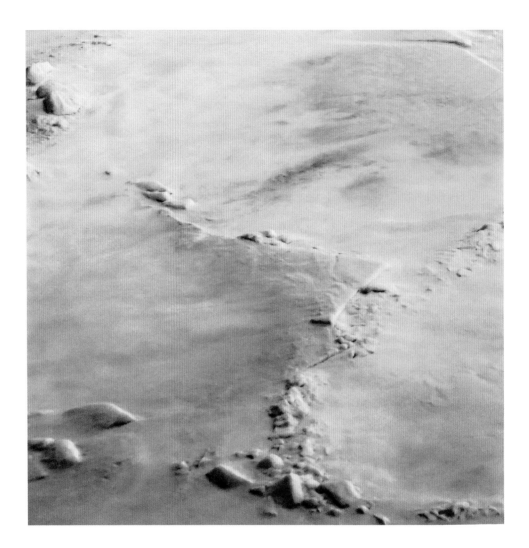

Stefan Hunstein, Im Eis, Nr. 3 (In the Ice, no. 3), Special Edition, 3/50, 2014, 42 x 42 cm, digital print on Tecco paper

Stefan Hunstein, Im Eis, Nr. 2 (In the Ice, no. 2), Special Edition, 1/50, 2014, 42 x 42 cm, digital print on Tecco paper

GUGE – AGES OF GOLD.
THE WEST TIBETAN MASTERPIECES

During the 10th century, Buddhism blossomed in the far west of Tibet into unexpected magnificence and greatness. In breathtaking views of temple complexes that are no longer accessible to Western cameras, this volume shows for the first time anywhere in the world the masterly relics of that incomparable era that have survived to the present day, from both the Indian and the Tibetan side of the old Kingdom of Guge.

Christine Ljubanovic (ed.)
Christine Ljubanovic. Conversation Portraits
Essays by Robert Fleck, Julia Garimorth, with a poem by Raoul Schrott; 164 pages, 61 duplex illustrations, 24 × 31 cm, softcover
Text: English I French I German

Gottfried Knapp (ed.)
Max Mannheimer.
The Marriage of Colours
144 pages, 73 illustrations, 24.5 × 30 cm, hardcover, dust jacket; text: English I German

Matthias Frehner, Valentina Locatelli (eds.)
Masterpieces Kunstmuseum Bern
Contributions by some 70 authors, including Heike Eipeldauer, Uwe Fleckner, Matthias Frehner, Matthias Haldemann, Andreas Hüneke, Valentina Locatelli, Kristin Schmidt, Beat Stutzer, Rudolf Koella, Christoph Wagner; 460 pages, 203 illustrations, 24 × 30 cm, hardcover

Philipp Gutbrod (ed.)
Ludwig Meidner. Encounters
Exhibition catalogue, Museum Künstlerkolonie, Institut Mathilden-höhe Darmstadt
Essays by P. Gutbrod, T. Müller, S. Sikora, M. Y. Zentgraf, L. Meidner,

J. van Hoddis, J. Ringelnatz
272 pages, 197 color illustrations, 23 × 27.5 cm, hardcover
Text: English I German

Bernd Pappe, Juliane Schmieglitz-Otten (eds.)
Miniatures from the Baroque Period in the Tansey Collection
Exhibition catalogue, Bomann Museum, Celle
Essays by Hans Boeckh, Nathalie Lemoine-Bouchard, Christophe Marcheteau de Quinçay, Gerrit Walczak; 396 pages, 210 illustrations, 24 × 30 cm, hardcover; text: English I German

Hermann Arnhold, Münster Westfälisches Landesmuseum (ed.)
Henry Moore. A European Impulse
Exhibition catalogue, LWL – Museum für Kunst und Kultur, Münster
Essays by C. Stephens, C. Lichten-stern, M. Müller, T. Pirsig-Marshall
258 pages, 240 illustrations, 24 × 30 cm, hardcover

Gaia Regazzoni Jäggli (ed.)
Zoran Music.
The Braglia Collection
Exhibition catalogue, Fondazione Gabriele e Anna Braglia, Lugano

HOKUSAI × MANGA.
JAPANESE POP CULTURE SINCE 1680

Early Japanese popular culture, in the form of the colored woodcuts of artists such as Hokusai and Kuniyoshi, achieved world fame after Japan's opening. The pop culture of today, from manga to anime, has also conquered the globe. Now, woodcuts by the most famous renowned ukiyo-e artists confront the visual mass media in the comics and cartoons of modern Japan.

Essays by K. de Barañano, J. Clair,
S. Contini, F. Gualdoni, M. Pasquali,
G. Regazzoni Jäggli, G. Soccol
192 pages, 147 color illustrations,
24 × 30 cm, hardcover
Text: English | Italian | German

Ekaterina Nozhova
Networks of Construction
Uta Hassler, Institut für Denkmal-
pflege und Bauforschung der
ETH Zürich (ed.)
360 pages, 94 color,
161 b/w illustrations, 21 × 28.5 cm,
hardcover, dust jacket, includes
a construction plan
Graphic design: Jonas Vögeli

Christian Ring, Hans-Joachim Throl
Emil Nolde.
The Great Masters of Art
Essays by Christian Ring, Hans-
Joachim Throl; 72 pages,
55 illustrations, 14 × 20.5 cm,
hardcover

Alte Oper Frankfurt (ed.)
One Day in Life. A Concert Project
by Daniel Libeskind and the Alte
Oper Frankfurt
Contributions by Daniel Libeskind,
Dr. Stephan Pauly, et al.; 352 pages,
200 color illustrations,

16.5 × 21.5 cm, hardcover,
incl. DVD; text: English | German

Jürgen B. Tesch (ed.)
Paper Dances. Maria Beykirch
With an introduction by Gottfried
Knapp; 120 pages, 60 full-page
color illustrations, 24.5 × 30 cm,
hardcover, dust jacket
Text: English | German

Markus Müller
Pablo Picasso.
The Great Masters of Art
80 pages, 76 illustrations,
14 × 20.5 cm, hardcover

Walter Grasser, Franz Hemmerle
(eds.)

Max Mannheimer (1920–2016)
survived the Holocaust as a Jew in a
concentration camp. His moving life
history has been published in several
books in different languages. However,
few people are aware of his paintings,
which were created under his Hebrew
name: Ben Jakov. This volume assembles
a selection of 70 of his works.

Precious Cufflinks. From Pablo
Picasso to James Bond
128 pages, 150 color illustrations,
22 × 28 cm, hardcover
Text: English | German

Hajo Düchting
Harald Puetz. Lichträume
140 pages, 111 color illustrations,
28.5 × 28.5 cm, hardcover
Text: English | German

Werner-Reinisch-Institut (ed.)
Werner Reinisch. Villages de
lumière et îles de rêves
Exhibition catalogue, Heimat-
ministerium Nürnberg, Nuremberg
Essays by Andreas Kühne, Josef
Walch, Walter Israel, a greeting by

Henry Moore has influenced the history of 20th-century sculpture more
decisively than anyone else. He was one of the first contemporary
sculptors to realize his ideas in the public space throughout the world.
Typical of his work is the interrelationship between nature and abstrac-
tion. He discovered the "voids," so-called openings and holes which
heighten the sculptural, three-dimensional effect of his works. His
oeuvre was a lasting source of inspiration for an entire generation of
artists—from Hans Arp, Alberto Giacometti, and Pablo Picasso to the
younger generation of German sculptors.

CARLO SCARPA.
LA TOMBA BRION SAN VITO D'ALTIVOLE

The Venetian artist Carlo Scarpa (1906–1978) was one of the outstanding architects of the 20th century—and at the same time a convinced lone wolf who saw his discipline as a form of art based on craftsmanship. In addition to buildings for museums in Venice, Florence, and Verona, his principal works include the tomb of the businessman Giuseppe Brion in San Vito d'Altivole (Treviso).

Markus Söder, and a foreword by Pierre Wolff, Matthias Everding, Franz Pany; 260 pages, 107 color illustrations, 24 × 30 cm, hardcover
Text: English | French | German

Monika Kopplin
Russian Lacquer
Collection catalogue, Museum of Lacquer Art, Münster
312 pages, 248 color illustrations, 24 × 30 cm, hardcover

Peter Latz
Rust Red. The Landscape Park Duisburg Nord
Essays by E. Bodmann, K.-H. Danielzik, J. Dettmar, P. Keil, T. Latz, K. Ganser, G. Lipkowsky,

W. Riehl, M. Treib, K. Walter, R. Winkels, introduction by Karl Ganser, Marc Treib; 288 pages, 300 color illustrations, 22 × 28 cm, hardcover
Graphic design: Sabine Frohmader

Hans-Michael Koetzle (ed.)
Carlo Scarpa.
La Tomba Brion San Vito D'Altivole
Accompanying exhibition: Walter Storms Galerie, Munich
Photographs by Klaus Kinold
72 pages, 55 illustrations, 21.0 × 31.5 cm, hardcover, cloth, dust jacket; text: English | German with an Italian appendix
Graphic design: Klaus Kinold, Dagmar Zacher

Jürgen B. Tesch (ed.)
Eran Shakine.
A Muslim, a Christian and a Jew Knocking on Heaven's Door
Exhibition catalogue, Jüdisches Museum Berlin; Jüdisches Museum München, Munich; Museum Ons' Lieve Heer op Solder, Amsterdam
Introduction by Edward van Voolen
96 pages, 44 illustrations, 17 × 24 cm, softcover
Text: English | German

Agnes Husslein-Arco, Alexander Klee (eds.)
Sin and Secession.
Franz von Stuck in Vienna
Exhibition catalogue, Belvedere, Vienna
Essays by A. Husslein-Arco, A. Klee, E. Mendgen, J. Kennedy, M. T. Brandlhuber, S. Lehner
320 pages, 344 illustrations, 23 × 28.5 cm, hardcover
Text: English | German

Ulrike Lorenz, Anna Friedrichson (eds.)
Sovak. Clear Vision[s].
Catalogue Raisonné 1995–2016
Exhibition catalogue, Kunsthalle Mannheim

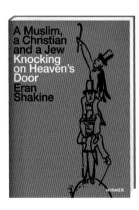

ERAN SHAKINE.
A MUSLIM, A CHRISTIAN AND A JEW
KNOCKING ON HEAVEN'S DOOR

Muslims, Christians, and Jews have a great deal in common. In his new oilstick drawings, Eran Shakine shows them appearing together as an indistinguishable trio in actions that are both profound and humorous. He thus reveals both their diversity and similiarities and shows his own highly individual view of these three world religions.

Essays by A. Friedrichson,
T. Köllhofer, U. Lorenz, N. Smolik
176 pages, 242 color illustrations,
25 × 28 cm, hardcover
Text: English | German

Staatliche Museen zu Berlin,
Kunsthalle München (ed.)
The Spanish Golden Age.
Painting and Sculpture in the Time
of Velázquez
Exhibition catalogue, Gemälde-
galerie, Staatliche Museen zu Berlin;
Kunsthalle der Hypo-Kulturstifung,
Munich
336 pages, 206 color illustrations,
24 × 29 cm, hardcover

Manfred Schneckenburger,
Christian Noorbergen (eds.)
Gérard Stricher
Accompanying exhibition:
Kallmann-Museum, Ismaning
160 pages, 76 color illustrations,
24 × 30 cm, hardcover
Text: English | French | German

Artur Rosenauer
Titian. The Grimani Risen Christ.
An Early Masterpiece
64 pages, 52 illustrations,
27 × 33.6 cm, hardcover

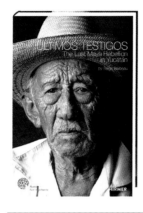

Michael Hering (ed.)
Gert & Uwe Tobias. Grisaille
Exhibition catalogue, Staatliche
Graphische Sammlung, Munich
Essays by B. Heid, M. Hering
172 pages, 110 color illustrations,
24 × 32 cm, hardcover
Text: English | German
Graphic design: Sarah Nöllenheidt,
Büro Noc Berlin

Christine Kron (ed.)
Últimos Testigos. **The Last Maya**
Rebellion in Yucatán
Exhibition catalogue, Museum
Fünf Kontinente, Munich
Photographs by Serge Barbeau

ÚLTIMOS TESTIGOS. THE LAST MAYA
REBELLION IN YUCATÁN

Between 1847 and 1935, the Maya on the
Yucatán Peninsula rebelled against their
oppression and were eventually defeated by
Mexican troops. The Canadian photogra-
pher Serge Barbeau has visited the descend-
ants of those Maya rebels. This volume
reproduces in oversize format his expressive
portraits documenting their desire for
independence.

96 pages, 60 color illustrations,
26 × 38 cm, hardcover
Text: English | Spanish | German
Graphic design: Hannes Halder

Volker Adolphs
The Uncanny Home. Interiors from
Edvard Munch to Max Beckmann
Exhibition catalogue, Kunstmuseum
Bonn
Contributions by V. Adolphs,
J. Binotto, F. Krämer; 240 pages,
120 color illustrations, 24 × 30 cm,
hardcover; text: English | German

Klaus Albrecht Schröder (ed.)
Ways of Pointillism. Seurat, Signac,
Van Gogh
Exhibition catalogue, Albertina
Museum, Vienna
Essays by M.-L. Bernadac,
C. Grammont, K. A. Schröder,
H. Widauer; 288 pages, 170 color
illustrations, 23.5 × 28.5 cm,
hardcover
Graphic design: Klaus E. Göltz,
Halle

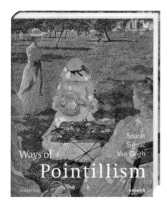

WAYS OF POINTILLISM.
SEURAT, SIGNAC, VAN GOGH

With their pioneering method using
dots, the artists of Pointillism no longer
directed their gaze toward only the
imitation of reality. In their paintings
between 1886 and 1930, their dots,
color, and light assumed an independent
existence to create masterpieces of
unprecedented brightness and color
diversity.

Eran Shakine, A Muslim, a Christian and a Jew at the Tunnel of Love, 2016, 143 x 120 cm, spray paint on light foam board

Eran Shakine, A Muslim, a Christian and a Jew Figuring God's Plan, 2016, 143 x 120 cm, spray paint on light foam board

Eran Shakine, A Muslim, a Christian and a Jew Knocking on Heaven's Door, 2016, 143 x 120 cm, spray paint on light foam board

Alexander Klar (ed.)
The Art Collections. Museum Wiesbaden
Essays by J. Daur, P. Forster, A. Klar, R. Zieglgänsberger; 260 pages, 200 color illustrations, 22 × 26.5 cm, softcover
Text: English | German

Martin Engler (ed.)
John Baldessari. The Städel Paintings
Exhibition catalogue, Städel Museum, Frankfurt
Essays by J. Baumann, M. Engler, D. Salle, including an interview with John Baldessari and Philipp Kaiser
176 pages, 78 color illustrations, 28 × 28 cm, hardcover
Text: English | German

Dieter Buchhart, Anna Karina Hofbauer (eds.)
Basquiat. Museum Security
Essays by Dieter Buchhart, Sam Keller; 116 pages, 50 color illustrations, 31 × 31.5 cm, hardcover in slipcase
Text: English | French | German
Graphic design: Peter Grassinger

Berlinische Galerie (ed.)
Berlinische Galerie.
Museum of Modern Art

Texts by R. Burmeister, U. Domröse, S. Heckmann, T. Köhler, A. Lütgens, U. Müller, M. Winzen, et al.
280 pages, 347 illustrations in color and b/w, 23 × 27 cm, hardcover

Andreas Hemmerle, Caroline Schulenburg (eds.)
The BMW Group Home Plant in Munich
272 pages, 318 illustrations, 24.5 × 27 cm, hardcover

Klaus Albrecht Schröder, Elsy Lahner (ed.)
Drawing Now
Exhibition catalogue, Albertina Museum, Vienna
Essays by P. Guevara, A. Haldemann, E. Lahner, A. Schallhorn, K. A. Schröder, B. Schwenk; 232 pages, 180 illustrations, 22 × 28 cm, hardcover; text: English | German
Graphic design: Klaus E. Göltz, Halle

Sabine Grabner, Agnes Husslein-Arco, Werner Telesko (eds.)
Europe in Vienna.
The Congress of Vienna 1814/1815
Exhibition catalogue, Belvedere, Vienna
Essays by U. Felbinger, E. Hilscher, W. Godsey, S. Grabner, W. Häusler,

R. Johannsen, G. Kugler, K. Lovecky, L. Markina, B. Mazohl, R. Panchieri, K. Schneider, R. Stauber, W. Telesko, E. Treichel, E. M. Werner, A. Wilton, et al.; 408 pages, 364 mostly color illustrations, 23 × 28.5 cm, hardcover

Kay Heymer
Pavel Feinstein. The Small Format
124 pages, 72 color illustrations, 24 × 28 cm, hardcover
Text: English | German

Christoph Rauhut, Niels Lehmann (eds.)
Fragments of Metropolis.
Expressionist Heritage in Berlin
Photographs by Niels Lehmann, epilogue by Hans Kollhof
256 pages, 140 color illustrations, 56 maps, sketches, 15.5 × 24.5 cm, hardcover; text: English | German

Andrea Firmenich, Johannes Janssen (eds.)
Ori Gersht. Forces of Nature
Exhibition catalogue, Museum Sinclair-Haus, ALTANA-Kultur-stiftung, Bad Homburg v. d. Höhe
120 pages, 92 illustrations, 22 × 29 cm, softcover
Text: English | German

Bruno Brunnet (ed.)
F.C. Gundlach Collection
Exhibition catalogue, Contemporary Fine Arts, Berlin
Essay by K. Honnef; 184 pages, 168 illustrations, 23.5 × 32 cm, hardcover; text: English | German
Graphic design: Imke Wagener

Minh Häusler.
The Fusion of Flora and Art
232 pages, 233 color illustrations, 28 × 28 cm, hardcover, dust jacket
Text: English | German

BASQUIAT. MUSEUM SECURITY

This publication focuses on a series of 12 key works by Jean-Michel Basquiat, created in the spring of 1983. The series draws on the subjects most important in his oeuvre: from music, anatomy, sports, and comics via work, the economy, becoming and decaying, to the history of African Americans and the history of art.

Alessandra Russo, Gerhard Wolf,
Diana Fane (eds.)
**Images Take Flight. Feather Art in
Mexico and Europe 1400–1700**
480 pages, 271 color illustrations,
24 × 30 cm, hardcover, dust jacket

Max Hollein, Matthias Ulrich (eds.)
Alicja Kwade
Exhibition catalogue, Schirn
Kunsthalle, Frankfurt
Essay by Donatien Grau; 64 pages,
32 color illustrations, 21 × 27 cm,
softcover; text: English | German

Niklas Maak
**Living Complex. From Zombie City
to the New Communal**
240 pages, 117 illustrations,
11.5 × 20 cm, hardcover

Robert Fleck (ed.)
Heinz Mack. Reliefs
Essays by U. Fleckner, E. Blume,
C.-P. Haase, U. Schmitt, F. Jacobi
400 pages, 371 color, duplex
illustrations, 26.5 × 30 cm,
hardcover; text: English | German

Andreas Braun (ed.)
The MINI Story
Exhibition catalogue, BMW
Museum, Munich
236 pages, 286 color illustrations,
32 × 27 cm, hardcover
Text: English | German

Zürcher Kunstgesellschaft /
Kunsthaus Zürich, Zürcher Kunst-
gesellschaft (ed.)
Joan Miró. Wall, Frieze, Mural
Exhibition catalogue, Kunsthaus
Zürich, Zurich; Schirn Kunsthalle,
Frankfurt
Essays by J. Punyet Miró,
S. Fraquelli, W. Jeffett, C. Lanc
168 pages, 130 color illustrations,
28 × 22 cm, hardcover

Suzanne Greub (ed.)
Monet. Lost in Translation
Exhibition catalogue, ARoS,
Museum of Art, Aarhus
240 pages, 129 color illustrations,
23.5 × 29.5 cm, hardcover

John Kennedy
**Mr Radley Drives to Vienna.
A Rolls-Royce Silver Ghost
Crossing the Alps – 1913 & 2013**
152 pages, 108 illustrations in color
and b/w, 27 × 28 cm, hardcover
Text: English | German

Christoph Schreier (ed.)
New York Painting
Exhibition catalogue, Kunstmuseum
Bonn

Essays by C. Schreier, R. Shiff, et al.
196 pages, 100 color illustrations,
24 × 32.5 cm, softcover, dust jacket
Text: English | German
Graphic design: Silke Fahnert,
Uwe Koch, Köln

Christian Ring, Hans-Joachim Throl
**Emil Nolde.
The Great Colour Wizard**
Exhibition catalogue, Louisiana
Museum of Modern Art,
Humblebaek
Essays by Christian Ring, Hans-
Joachim Throl; 72 pages,
55 illustrations, 14 × 20.5 cm,
hardcover

LIVING COMPLEX. FROM ZOMBIE CITY
TO THE NEW COMMUNAL

Approximately one billion units of accommoda-
tion will need to be built worldwide over the
course of the next twenty years. Houses as we
know them today will no longer be economically
or ecologically affordable in the future. What,
then, should these dwellings look like? The
author introduces international examples that
also stand for a new architectural outlook.

JOAN MIRÓ. WALL, FRIEZE, MURAL

Joan Miró's lifelong fascination with the
materiality and beauty of walls, which he
regarded as the point of departure for
his paintings, began with the walls of his
parental country estate in Montroig.
Wall, Frieze, Mural explores this central
aspect of the Spanish painter's work and
presents Miró's important wall paintings
in the context of his oeuvre.

Pavel Feinstein, not titled, 2014, 100 x 120 cm, oil on canvas

2015

JEAN PAGLIUSO.
POULTRY SUITE

The American artist Jean Pagliuso (b. 1941) explores an unusual subject in her most recent experimental photographs: chickens. More than twenty breeds modeled for her in her studio, resulting in insightful black-and-white photographs that present the birds in their unmistakable glory.

Michael Beck, Ute Eggeling (eds.)
**Nolde, Klee & Der Blaue Reiter.
The Braglia Collection**
Exhibition catalogue, Fondazione Gabriele e Anna Braglia, Lugano
Essays by V. Adolphs, T. Belgin, J. Dahlmanns, E. Dewes, M. Folini, H. Friedel, G. Geiger, C. Klingsöhr-Leroy, U. Luckhardt, M.-A. von Lüttichau, O. Okuda, C. Ring, A. Soika; 232 pages, 142 color illustrations, 24 × 30 cm, hardcover
Text: English I Italian I German

Jean Pagliuso. Poultry Suite
112 pages, 45 tri-tone photographs, 24 × 30.5 cm, hardcover, dust jacket; text: English I German
Graphic design: Sam Shahid, Matthew Kraus

Didier Ottinger, Diana Widmaier-Picasso, Emilie Bouvard (eds.)
Picasso.Mania. Picasso and the Contemporary Masters
Exhibition catalogue, Grand Palais, Paris
Essays by E. Bouvard, C. Chenais, C. Chicha-Castex, M. Fitzgerald, S. Guégan, C. Millet, D. Ottinger, E. Philippot, J. Pissarro, D. Semin, A. Ténèze, D. Widmaier-Picasso
340 pages, 394 color illustrations, 6 foldouts, 24.5 × 29 cm, hardcover

Bernhard Maaz (ed.)
**The Pinakothek Museums in Bavaria.
Treasures and Locations of the Bavarian State Painting Collections**
Contributions by A. Bambi, P. Dander, B. Ebert, N. Engel, I. Graeve-Ingelmann, E. Hipp, J. Kaak, O. Kase, M. Neumeister, H. Rott, M. Schawe, B. Schwenk, A. Schumacher, C. Thierolf, with a photo essay by Martin Fengel
180 pages, 144 color illustrations, 15 × 21 cm, softcover with flaps

Gerhard Wolf, Marzia Faietti (eds.)
The Power of Line
Essays by A. Akiyama, E. Bogdanova-Kummer, H. Bredekamp, J. van Brevern, T. Dufrêne, M. Faietti,

R. Felfe, S. Krämer, A. Nakhli, S. Osano, V.-S. Schulz, A. Schwan, M. Søberg, N. Suthor, F. Tancini
260 pages, 160 color illustrations, 17 × 24 cm, hardcover

Walter Grasser, Franz Hemmerle (eds.)
**Precious Cufflinks.
From Pablo Picasso to James Bond**
128 pages, 150 color illustrations, 22 × 28 cm, hardcover
Text: English I German

Corinna Thierolf (ed.)
**Gerhard Richter – Brigid Polk.
Königsklasse III**
Exhibition catalogue, Schloss Herrenchiemsee
Essays by Sabine Knust, Bernhard Maaz, Tilman Spengler, Corinna Thierolf; 96 pages, 69 color illustrations, 19.5 × 26 cm, softcover
Text: English I German
Graphic design: KMS Blackspace

Harald Scheicher
**Harald Scheicher.
Paintings 2010–2014**
Introduction by Stephan Koja, preface by Wieland Schmied, essays by Harald Scheicher, Verena Perlhefter; 240 pages, 182 color illustrations,

PICASSO.MANIA. PICASSO AND THE CONTEMPORARY MASTERS

Picasso's work appears never to have ceased to haunt the imagination of his peers. The great stylistic periods and certain emblematic works by Picasso, such as *Guernica*, have been answered by contemporary artworks. This publication showcases the rich confrontation with Picasso's work undertaken by contemporary artists since the 1960s.

Bernd Zimmer (b. 1948) is one of the most important representatives of Germany's artists known as Junge Wilde (Young Wild Ones). He has developed an unmistakable style characterized by a combination of free, abstract painting and representationalism that is always linked to nature. This catalogue is the first to provide a comprehensive overview of his most recent series of paintings, *Schwimmendes Licht* (Swimming Light).

24 × 28 cm, hardcover
Text: English | German

Martin Mosebach, Brigitte Schermuly (eds.)
Peter Schermuly. Catalogue Raisonné
336 pages, 847 color illustrations, 24 × 30 cm, hardcover, dust jacket

Christian Bauer (ed.)
Egon Schiele. Almost a Lifetime
Essays by C. Bauer, A. Comini, N. Fritz, W. Krug, S. Tretter, G. Wagensommerer; 306 pages, 200 illustrations, 22.5 × 28.5 cm, hardcover

Oliver Kornhoff (ed.)
Bernard Schultze.
A Bright Wisp, a Glistening Wind
Exhibition catalogue, Arp Museum Bahnhof Rolandseck, Remagen
Essays by A. Duden, K. O. Götz, M. Haupt, O. Kornhoff, H. Kraft, G. Laschen, J. Mattern; 120 pages, 55 color illustrations, 24 × 31 cm, hardcover; text: English | German

Stephan Berg, Dieter Daniels (eds.)
TELE-GEN. Art and Television
Exhibition catalogue, Kunstmuseum Bonn; Kunstmuseum Liechtenstein, Vaduz

Essays by S. Berg, I. Blom, D. Daniels, U. Eco, U. Frohne, M. Ries, S. Waldschmitt
352 pages, 584 color illustrations, 23 × 32.5 cm, hardcover
Text: English | German
Graphic design: Lamm & Kirch, Leipzig

Graphische Sammlung ETH Zürich (ed.)
Andy Warhol.
The LIFE Years 1949–1959
Exhibition catalogue, Graphische Sammlung, ETH Zürich, Zurich
Essays by A. Barcal, O. Kunde, P. Tanner; 196 pages, 123 color and b/w illustrations, 24 × 32 cm, hardcover, dust jacket
Text: English | German
Graphic design: Petra Lüer, Wigel

Ulrich Pohlmann (ed.)
Sepp Werkmeister.
New York 60s. Photographs
Exhibition catalogue, Stadtmuseum München, Munich
128 pages, 100 color illustrations, 16 × 24 cm, hardcover
Text: English | German

Museum Angerlehner, Johannes Holzmann (ed.)
Bernd Zimmer. Everything Flows. Painting
Exhibition catalogue, Kunstmuseum Heidenheim, Museum Angerlehner, Thalheim bei Wels
Essays by R. Hirner, J. Holzmann, J. Schilling; 144 pages, 85 color illustrations, 21 × 27 cm, hardcover
Text: English | German

The architecture of Expressionism heralded the onset of the Roaring Twenties. Berlin's remaining Expressionist buildings demonstrate a great creativity of form and a skillful use of light, color, and material.

Bernd Zimmer, Wüste/Cosmos [Desert/Cosmos], 2002, 70 x 50 cm, acrylic on paper

Beat Wismer, Dedo von Kerssen-
brock-Krosigk, Sven Dupré (eds.)
Art and Alchemy.
The Mystery of Transformation
Exhibition catalogue, Kunstpalast,
Düsseldorf
Essays by S. Dupré, C. Göttler,
T. Meganck, W. Newman,
L. Principe, J. Rampling, U. Seegers,
M. E. Warlick; 280 pages, 194 color
illustrations, 20 × 28 cm, hardcover
Graphic design: Kühle und Mozer,
Köln

Museum der Moderne Salzburg,
Sabine Breitwieser (ed.)
Art / Histories
Exhibition catalogue, Museum
der Moderne, Salzburg
Essays by Sabine Breitwieser,
Karl-Markus Gauß, Eva Kernbauer
204 pages, 298 illustrations,
24 × 28 cm, softcover with flaps
Text: English | German

David Ippen
The Art of Self.
An Interpretation of Traditional
Taekwon-Do
128 pages, 1 b/w illustration,
13.5 × 21 cm, softcover

Hermann Arnhold, Münster
Westfälisches Landesmuseum (ed.)
Bare Life. Bacon, Freud, Hockney
and others.
London artists working from life
1950–80
Exhibition catalogue, LWL –
Museum für Kunst und Kultur,
Münster
Essays by A. Brighton, E. Gillen,
E. Gruber, L. Hallman, I.-T. Hollaus,
C. Lampert, M. Lukowicz, L. Morris,
T. Pirsig-Marshall, C. Wiggins
260 pages, 200 mostly color
illustrations, 24 × 30 cm,
softcover with flaps
Graphic design: Katja Durchholz

ART AND ALCHEMY.
THE MYSTERY OF TRANSFORMATION

This volume presents a comprehensive
overview of the relationship between
alchemy and art, bringing together key
artworks that take alchemy as their inspira-
tion—from the enigmatic paintings of Jan
Bruegel the Elder to contemporary works by
Anish Kapoor. It includes recent studies by
internationally renowned scientists.

Herbert Beck Estate (ed.)
Herbert Beck. Miniatures
Essays by Ina Ewers-Schultz,
Andrea Knop, Regina Landherr;
152 pages, 179 color illustrations,
24 × 28 cm, hardcover
Text: English | German

Max Hollein, Matthias Ulrich (eds.)
Daniele Buetti.
It's All in the Mind
Exhibition catalogue, Schirn
Kunsthalle, Frankfurt
Introduction by Max Hollein
64 pages, 16 double-page spread
color illustrations, 21 × 27 cm,
softcover; text: English | German

Philipp Demandt, Anke Daemgen
(eds.)
Rembrandt Bugatti.
The Sculptor 1884–1916
Exhibition catalogue, Alte National-
galerie, Staatliche Museen zu Berlin
Essays by P. Elliott, O. Ferlier,
G. Ginex, C. Wessely; 220 pages,
247 color illustrations,
24.5 × 29.5 cm, hardcover
Graphic design: Katja Durchholz

Andreas Schumacher (ed.)
Canaletto.
Bernardo Bellotto Paints Europe
Exhibition catalogue, Alte
Pinakothek, Munich
Essays by E. Götz, A. Gottdang,
B. A. Kowalzcyk, P. O. Krückmann,

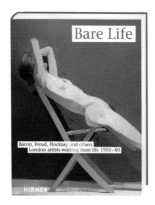

BARE LIFE. BACON, FREUD, HOCKNEY
AND OTHERS. LONDON ARTISTS
WORKING FROM LIFE 1950–80

Between 1950 and 1980, a pioneering
group of painters, began pursuing new
directions in figurative art, investing
representations of the human body with
unprecedented expressiveness and depth
and seeking to capture more accurately
the truth of human existence.

C. Quaeitzsch, A. Schumacher,
B. Schwabe, J. Thoma, T. Wagener,
W. Wiedemann, W. Zech
360 pages, 311 color illustrations,
29 × 30 cm, hardcover
Graphic design: Sophie Friederich

Stefan Weber, Ulrike al-Khamis
(eds.)
Early Capitals of Islamic Culture.
The Artistic Legacy of Umayyad
Damascus and Abbasid Baghdad
(650–950)
Exhibition catalogue, Sharjah
Museum of Islamic Civilization,
Sharjah, United Arab Emirates
Essays by M. Ataya, I. Dolezalek,
J. Ebert, M. Eissenhauer, U. Franke,
J. Gonnella, G. Helmecke, S. Kamel,
U. al-Khamis, Y. El Khoury,
K. Meinecke, S. Vassilopoulou,
S. Weber; 72 pages, 84 mostly color
illustrations, 23. 5 × 26.5 cm,
hardcover; text: English | Arabic

Ingrid Pfeiffer, Max Hollein (eds.)
Esprit Montmartre.
Bohemian Life in Paris around 1900
Exhibition catalogue, Schirn Kunst-
halle, Frankfurt
Essays by N. Bakker, M. A. Castor,
P. D. Cate, D. Devynck, A. Hop-
mans, P. Kropmanns, C. Langlais,
V. Panyella, R. Parker, I. Pfeiffer,

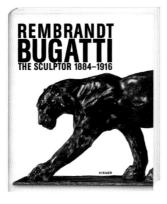

M. Raeburn; 320 pages, 290 color
illustrations, 24 × 29 cm, hardcover
Graphic design: Kühle und Mozer,
Köln

Nicole Gnesa (ed.)
EVA & ADELE. ADSILA
Accompanying exhibition:
Galerie Nicole Gnesa, Munich
144 pages, 67 illustrations,
20 × 14 cm, hardcover

Friedhelm Mennekes (ed.)
Monika Fioreschy.
Interwoven Energy
Including an interview with Monika
Fioreschy; 136 pages, 60 color
illustrations, 24. 5 × 30 cm,
hardcover; text: English | German

REMBRANDT BUGATTI.
THE SCULPTOR 1884–1916

Rembrandt Bugatti was one of the most
remarkable and innovative sculptors of
the early 20th century. He produced
more than three hundred works,
including the small-scale bronze animal
sculptures for which he is best known.
This publication offers a comprehensive
retrospective of Bugatti's brief but
highly productive career.

Petra Giloy-Hirtz (ed.)
Roland Fischer. Façades
Exhibition catalogue, Städtische
Galerie im Fruchtkasten des Klosters
Ochsenhausen, Ochsenhausen;
Galerie Walter Storms, Munich
Essays by Sheryl Conkelton,
Petra Giloy-Hirtz, Lyle Rexer
224 pages, 101 color illustrations,
25 × 31.5 cm, hardcover, dust
jacket; text: English | German
Graphic design: Philippe Loup

Museum der Moderne Salzburg,
Sabine Breitwieser (ed.)
Simone Forti.
Thinking with the Body
Exhibition catalogue, Museum
der Moderne, Salzburg
Essays by S. Breitwieser, J. Bryan-
Wilson, F. Dewey, D. Graham,
L. Kotz, R. Morris, M. Morse,
T. Wada, S. Paxton, Y. Rainer,
S. Forti; 304 pages, 538 illustrations,
24 × 28 cm, hardcover

Hilke Thode-Arora (ed.)
From Samoa with Love? Samoan
Travellers in Germany 1895–1911.
Retracing the Footsteps
Exhibition catalogue, Museum
Fünf Kontinente, Munich
Essays by P. Hempenstall,
G. A. Hunkin, H. Rumschöttel,

CANALETTO. BERNARDO
BELLOTTO PAINTS EUROPE

This book highlights the Italian
painter's capacity to create paintings
that are both remarkably realistic and
compositionally idealistic. Depicting
Venice, Dresden, Vienna, Turin,
Warsaw and Florence, the paintings
demonstrate an elaborate attention to
architectural and natural detail and a
sophisticated use of light.

ESPRIT MONTMARTRE. BOHEMIAN
LIFE IN PARIS AROUND 1900

Removed from the glamour of Paris
during the French Belle Époque, the
village-like district of Montmartre
offered a bohemian refuge for many
poets and artists. *Esprit Montmartre*
explores this rich period of artistic
production, its sociopolitical contexts,
and how they continue to influence the
image of artists and their subjects today.

Emma Lavigne (ed.)
Pierre Huyghe
Exhibition catalogue, Museum
Ludwig, Cologne
Essays by A. Barikin, T. Garcia,
E. Lavigne, V. Normand; 248 pages,
770 color illustrations, plus 160 b/w
miniature illustrations, 20.6 × 28 cm,
softcover with flaps
Graphic design: de Valence, Paris

M. Tuffery; 224 pages, 176 mostly
color illustrations, 21 × 27 cm,
hardcover

Agnes Husslein-Arco, Harald Krejci,
Matthias Boeckl (eds.)
**Hagenbund. A European Network
of Modernism 1900–1938**
Exhibition catalogue, Belvedere,
Vienna
Essays by É. Bajkay, E. Boeckl,
C. Cabuk, V. Gamper, K. Jesse,
M. Kaiser, A. Köhne, K. Kókai,
D. Kudelska, V. Lahoda, O. Rath-
kolb; 448 pages, 462 color illustra-
tions, 23 × 28.5 cm, hardcover

Alexandra Hendrikoff.
Metamorphosis
Accompanying exhibition: Up Art
Gallery, Neustadt an der Weinstraße
Essay by Cornelia Gockel, interview
by Geseko von Lüpke with Alexandra
Hendrikoff; 120 pages, 95 color
illustrations, 24 × 28 cm, hardcover
Text: English | German

Max Hollein, Kristin Schrader (eds.)
Roni Horn
Exhibition catalogue, Schirn
Kunsthalle, Frankfurt
Introduction by Max Hollein, essay
by Kristin Schrader; 104 pages,
50 color and b/w illustrations,
21 × 27 cm, softcover
Text: English | German

W. Michael Satke (ed.)
Ireland Glenkeen Garden
Photographs by Ulrike Crespo,
Oliver Jiszda, W. Michael Satke,
Kurt-Michael Westermann, Gerald
Zugmann; 9 volumes in a luxury
presentation box, limited to
999 numbered copies, 546 pages in
total, 581 mostly color illustrations,
Volume 1, 3–9: 37 × 28 cm,
Volume 2: 28 × 37 cm, softcover,
Presentation box: 38 × 30 × 9 cm
Text: English | German
Graphic design: Herbert Winkler

Corinna Thierolf (ed.)
**Königsklasse I. Artworks from
the Pinakothek der Moderne
in Herrenchiemsee Palace**
Exhibition catalogue, Schloss
Herrenchiemsee
68 pages, 27 color illustrations,
19.5 × 26 cm, softcover
Text: English | German

Corinna Thierolf (ed.)
**Königsklasse II. Artworks from
the Pinakothek der Moderne in
Herrenchiemsee Palace**
Exhibition catalogue, Schloss
Herrenchiemsee
Essays by Umberto Eco, Sten
Nadolny, Klaus Schrenk, Tilman
Spengler, Corinna Thierolf
160 pages, 44 illustrations,
19.5 × 24.5 cm, softcover
Text: English | German

RONI HORN

The complex nature of identity is the
subject of the work of the American artist
Roni Horn. She explores the topic of
changing identities using a wide variety of
media, including photography, sculpture,
installation, drawing, and text. This
volume comprises a series of photographic
portraits presented in a public space as
part of a project designed for the Schirn
Gallery, Frankfurt.

Joanne Northrup, Adam Duncan
Harris (eds.), for the Nevada
Museum of Art
Late Harvest
Exhibition catalogue, Nevada
Museum of Art, Reno, NV
192 pages, 107 color illustrations,
21 × 28.6 cm, hardcover
Graphic design: Brad Bartlett Design

Agnes Husslein-Arco, Stephan Koja
(eds.)
**Looking at Monet. The Great
Impressionist and His Influence
on Austrian Art**
Exhibition catalogue, Belvedere,
Vienna
Essays by Dominique de Font-
Réaulx, Stephan Koja, Peter Peer,
Bernadette Reinhold, et al.
256 pages, 140 color illustrations,
23 × 28 cm, hardcover

Manuela Beer, Iris Metje, Karen
Straub, Saskia Werth, Moritz Woelk
(eds.)
The Magi. Legend, Art and Cult
Exhibition catalogue, Museum
Schnütgen, Cologne
Contributions by Manuela Beer, Iris
Metje, Karen Straub, Saskia Werth
and Moritz Woelk; 336 pages, 230
mostly color illustrations; includes a
leporello fold: "View of the City of

Late Harvest is characterized by unusu-
al—and unforgettable—juxtaposi-
tions: contemporary art created with
taxidermy sits alongside historically
significant wildlife paintings. The result
highlights intriguing parallels and
startling aesthetic contrasts, while
simultaneously confirming and
subverting viewers' preconceptions of
the place of animals in culture.

Cologne in 1531," 24 × 28 cm,
hardcover
Graphic design: Magnus Neumeyer,
Cologne

Ulrike Gehring, Peter Weibel (eds.)
**Mapping Spaces. Networks of
Knowledge in the Landscape
Painting of the 17th Century**
Exhibition catalogue, Museum für
Neue Kunst, ZKM | Zentrum für
Kunst und Medien, Karlsruhe
Essays by U. Gehring, D. Aten,
J. Vander Auwera, P. Biesboer,
O. Breidbach; 500 pages, 350 color
illustrations, 25 × 28 cm, hardcover

Susan Kamel, Kunstsammlung
Nordrhein-Westfalen (ed.)
**Annette Messager. Exhibition/
Exposition**
Exhibition catalogue, Kunstsamm-
lung Nordrhein-Westfalen, K21
Ständehaus, Düsseldorf
Essays by M. Ackermann, F.
Thurmes, and an interview with
Annette Messager; 88 pages, 49
illustrations, 25 × 19 cm, hardcover,
cloth; text: English | German
Graphic design: L2M3 Kommunika-
tionsdesign, Stuttgart; David Arzt,
Sascha Lobe

Museum Angerlehner, Caroline
Messensee (ed.)
Messensee. Beyond Contradictions

PIERRE HUYGHE

Presenting fifty projects from French-born, New York-based contem-
porary artist Pierre Huyghe's twenty-year career, this richly illustrated
book provides an overview of his work across film, installation art, and
live event. Since the 1990s, Huyghe's work has challenged the status of
the exhibition format. With projects like *One Year Celebration* and the
foundation in 1995 of the collaborative Association of Freed Time,
Huyghe developed a particular interest in the relationship between
time and memory—an interest that has carried through to his works
Untilled and the three-part *The Host and the Cloud*.

2014

Exhibition catalogue, Museum Angerlehner, Thalheim bei Wels
Essays by S. Aigner, J. Holzmann, W. Lamprecht, C. Messensee
144 pages, 72 color illustrations, 21 × 27 cm, hardcover
Text: English | German

Andrea C. Theil (ed.)
Rita de Muynck.
Under the Skin
Essays by Christa Sütterlin, Andrea C. Theil, Thomas Zacharias
190 pages, 153 color illustrations, 24 × 28 cm, softcover
Text: English | German

Frances Archipenko Gray
My Life with Alexander Archipenko
208 pages, 84 illustrations, 17 × 24 cm, hardcover, dust jacket

Tilman Spengler, Annika Tepelmann
Herbert Nauderer.
Mouseman's Land
Exhibition catalogue, Rathaus-galerie, Munich
120 pages, 86 color illustrations, 21 × 27 cm, hardcover
Text: English | German

Veit Görner (ed.)
Jochen Plogsties.
Kisses in the Afternoon
Exhibition catalogue, Kestner-gesellschaft, Hanover
Essays by L. Dinse, V. Görner, A. Reckwitz; 128 pages, 77 color illustrations, 22 × 30 cm, hardcover, dust jacket; text: English | German

Andreas Braun (ed.), for the BMW Museum, Munich
Rolls-Royce Motor Cars

Exhibition catalogue, BMW Museum, Munich
180 pages, 200 color illustrations, 32 × 27 cm, hardcover, cloth, bookmark; text: English | German
Graphic design: Peter Grassinger

Andreas Braun (ed.), for the BMW Museum, Munich
Rolls-Royce Motor Cars.
Deluxe Edition
Exhibition catalogue, BMW Museum, Munich
180 pages, 200 color illustrations, 32 × 27 cm, leather-bound with bookmark, silver edging, limited to 150 copies
Text: English | German

Staatsgalerie Stuttgart, Ina Conzen (ed.)
Oskar Schlemmer.
Visions of a New World
Exhibition catalogue, Staatsgalerie Stuttgart
Essays by I. Conzen, S. Diefenthaler, M. Droste, W. Eiermann, S. Kaufmann, K. von Maur, B. Sonna, F. Zimmermann; 300 pages, 352 color illustrations, 24 × 28 cm, hardcover
Graphic design: Peter Grassinger

Hans-Ulrich Kessler (ed.)
Schlüter in Berlin. A City Guide
Essays by C. Guinomet, H.-U. Kessler, B. W. Lindemann, P. Zitzlsperger; 80 pages, 34 color illustrations, maps, 13 × 20 cm, softcover with flaps
Text: English | German

Thomas Schütte
Exhibition catalogue, Städtische Museen Heilbronn / Kunsthalle Vogelmann, Heilbronn
Essays by Marc Gundel, Rita E. Täuber; 160 pages, 105 mostly color illustrations,

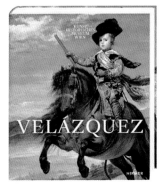

The Spanish artist Diego Velázquez was one of the most important painters of the Golden Age. Taking as its starting point a group of masterly children's portraits from the high-profile collection of the Kunsthistorisches Museum in Vienna, this opulent volume shows a representative cross-section of Velázquez's oeuvre.

19 × 25 cm, softcover with flaps
Text: English | German

Karin Althaus, Matthias Mühling, Susanne Böller (eds.)
Florine Stettheimer
Exhibition catalogue, Städtische Galerie im Lenbachhaus, Munich
Essays by K. Althaus, E. Bilski, B. Bloemink, E. Butterfield-Rosen, S. Böller, K. Dillkofer, R. C. Ferrari, E. Giers, A.-K. Harfensteller, J. Koether, J. B. Lee, N. Mauss, M. Mühling, E. Sussman; 192 pages, 134 color illustrations, 24.5 × 28 cm, hardcover
Graphic design: Sabine Frohmader

Peter van Ham
Tabo – Gods of Light.
The Indo-Tibetan Masterpiece
Accompanying exhibition: The Block Museum of Art, Evanston, IL; Rubin Museum of Art, New York City, NY; Historisches und Völkerkundemuseum, St. Gallen; Museum Angewandte Kunst, Frankfurt
Essay by Gerald Kozicz, introduction by Tsenshap Serkong Rinpoche; 308 pages, 405 color illustrations, 2 foldouts, 28 × 28 cm, hardcover, dust jacket

Gottfried Knapp (ed.)
Horst Thürheimer.
Fire and Chalk
Essays by Gottfried Knapp, Andreas Kühne; 128 pages, 63 color illustrations, 24.5 × 32 cm, hardcover
Text: English | German

Annegret Laabs (ed.)
Max Uhlig.
Grown Up in Front of Nature
Exhibition catalogue, Kunstmuseum Kloster Unser Lieben Frauen, Magdeburg
Essays by U. Gellner, A. Laabs, I. Rambausek; 168 pages, 133 illustrations, 23.5 × 27 cm, hardcover, dust jacket
Text: English | German

Institut für moderne Kunst Nürnberg (ed.)
Urban Nomads. Winfried Baumann
Essays by Ludwig Fels, Harriet Zilch, including an interview by Nicola Graef with Winfried Baumann
360 pages, 418 color illustrations, 27 × 24 cm, softcover
Text: English | German

Sabine Haag, Sylvia Ferino (eds.)
Velázquez
Exhibition catalogue, Kunsthistorisches Museum, Vienna
Essays by S. Albl, D. W. Carr, S. Ferino-Pagden, G. Finaldi, S. Haag, E. Oberthaler, J. P. Pérez, M. Strolz, G. Swoboda
336 pages, 170 illustrations, 24 × 28 cm, hardcover
Text: English | German

Jürgen B. Tesch (ed.)
Maurice Weiss. Facing Time
With an introduction by Alexander Smoltczyk; 128 pages, 55 color illustrations, 24.5 × 30 cm, hardcover; text: English | German

Paul Zwietnig-Rotterdam
Wild Vegetation. From Art to Nature
236 pages, 22 illustrations, 13.5 × 21 cm, softcover

For gardeners, Roaring Water Bay in West Cork, Ireland, is a paradise. Over the past twenty years, a true masterpiece of garden art has been created here: Glenkeen Garden. Five photographers show the growth and development of the garden from their own personal point of view.

Torsten Reiter, Maerzgalerie (ed.)
Hans Aichinger. Truth or Duty
Exhibition catalogue, maerzgalerie,
Leipzig
Essays by Joachim Penzel,
Christoph Tannert; 160 pages,
83 color illustrations, 24 × 30 cm,
hardcover; text: English | German

Art Cologne 2013
572 pages, 300 illustrations in color
and b/w, 17 × 21 cm, softcover
Text: English | German

Jürgen B. Tesch (ed.)
Isabella Berr. Walking Dreams
Essay by Holden Luntz; 128 pages,
62 color photographs, 24.5 × 28 cm,
hardcover, dust jacket
Text: English | German

Kunstsammlung Nordrhein-
Westfalen (ed.)
Alexander Calder.
Avant-Garde in Motion
Exhibition catalogue, Kunst-
sammlung Nordrhein-Westfalen,
Düsseldorf
Essays by Marion Ackermann,
Susanne Meyer-Büser, Daniela
Hahn, Gryphon Rower-Upjohn,
Alexander S. C. Rower; 144 pages,
80 color, 38 b/w illustrations,
26.5 × 34.5 cm, hardcover, includes

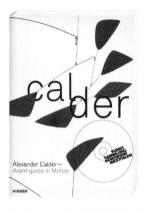

ALEXANDER CALDER.
AVANT-GARDE IN MOTION

Alexander Calder is one of the most
important American artists of the 20th
century. This lavishly illustrated book
focuses on Calder's works of the 1930s
and 1940s, a period in which the
sculptor experimented with wildly
different artistic directions.

a DVD by Ralph Goertz
Graphic design: Simon Brenner,
Sascha Lobe; L2M3 Kommunika-
tionsdesign GmbH, Stuttgart

Susanne Meyer-Büser (ed.)
Alexander Calder.
Avant-Garde in Motion.
Exhibition catalogue, Kunst-
sammlung Nordrhein-Westfalen,
Düsseldorf
e-book, 144 pages, 80 color,
38 b/w illustrations, 7 videos,
format: ePub, copy-protected

Elmar Zorn
Inge Doldinger.
Catchers of the Light
100 pages, 65 color illustrations,

24.5 × 30.5 cm, softcover with flaps
Text: English | German

Thomas Herzog, Zhihong Jin,
Baofeng Li, Li Wang (eds.)
Engineering Design.
Made in Wuhan – China
Exhibition catalogue, Oskar von
Miller Forum, Munich
80 pages, 79 mostly color photo-
graphs, 28 × 30 cm, softcover
Text: English | Chinese | German

Isabelle Dervaux, Friedrich
Meschede (eds.)
Dan Flavin. Drawing
Exhibition catalogue, Kunsthalle
Bielefeld; Morgan Library &
Museum, New York City, NY
Contributions by T. Bell, I. Dervaux,
D. Flavin, W. M. Griswold, J. Raab
220 pages, 143 mostly color
illustrations, 24 × 28 cm, hardcover

Beate Reifenscheid (ed.)
Flourishing Spirits – Blüte des
Geistes. Xu Jiang & Shi Hui
Exhibition catalogue, Ludwig
Museum im Deutschherrenhaus,
Koblenz
282 pages, 121 color illustrations,
23 × 29 cm, hardcover
Text: English | German

FLOWERS & MUSHROOMS

Flowers and mushrooms risk being
considered trivial subjects for contem-
porary art. In recent years, however,
they have experienced a revival as
complex subjects in their presentation
by contemporary artists, including
Peter Fischli and David Weiss, David
LaChapelle and Robert Mapplethorpe.

Toni Stooss (ed.)
Flowers & Mushrooms
Exhibition catalogue, Museum der Moderne, Salzburg
Essays by M. Harder, M. Moschik, T. Teufel, P. Weiermair, V. Ziegelmaier, et al.; 256 pages, 130 color, 41 b/w illustrations, 23.5 × 28 cm, hardcover
Graphic design: Petra Ahke und Erril Fritz, Berlin

Toni Stooss (ed.)
Focus on Photography. The Fotografis Bank Austria Collection
Exhibition catalogue, Museum der Moderne, Rupertinum, Salzburg
240 pages, 131 illustrations and photographs, 26 × 30.5 cm, hardcover; text: English I German

Gregor Wedekind, Max Hollein (eds.)
Géricault. Images of Life and Death
Exhibition catalogue, Schirn Kunsthalle, Frankfurt; Museum voor Schone Kunsten, Ghent
Contributions by B. Chenique, B. Fornari, C. Quétel, G. Wedekind
224 pages, 155 color, 10 b/w illustrations, 24 × 28 cm, hardcover

Gunther Gerlach.
Sculpture and Space

Essays by Arie Hartog, Yvette Deseyve; 144 pages, 64 color, 30 b/w illustrations, 22 × 29 cm, hardcover; text: English I German

Ingvild Goetz, Karsten Löckemann (eds.)
Happy Birthday!
20 Years of the Goetz Collection
Exhibition catalogue, Sammlung Goetz, Munich
Interview with Ingvild Goetz, texts by Katharina Bitz, Cornelia Gockel, Ingvild Goetz, Jerry Gorovoy, Leo Lencsés, Karsten Löckemann, Larissa Michelberger, Birgit Sonna, Katharina Vossenkuhl
240 pages, 99 color illustrations, 17 × 24.5 cm, softcover

The Goetz Collection comprises numerous works by important artists. On the occasion of its 20-year anniversary, the collection is opening its archives and showing selected works by Louise Bourgeois, Anselm Kiefer, Mária Bartuszová, and George Segal, among others. They include works from the 1940s to the present day.

Text: English I German
Graphic design: Schmid + Widmaier Design

Berlinische Galerie (ed.)
K. H. Hödicke.
Painting, Sculpture, Film
Exhibition catalogue, Berlinische Galerie, Berlin
Essays by G. Fassbender, C. Klöckner, T. Köhler, L. Seyfarth, H. Stahlhut, R. Stange; 126 pages, 79 mostly color illustrations, 23 × 27 cm, hardcover
Text: English I German

Ralf Beil, Philipp Gutbrod (eds.)
Bernhard Hoetger.
The Plane Tree Grove

In preparation for his masterpiece *The Raft of the Medusa*, Géricault produced studies of invalids and even fragments of corpses from the hospitals of Paris. His oeuvre represents a new form of observation and ventures into uncommon territory. It can be compared in its radical modernity to the works of Goya, Delacroix, and Menzel.

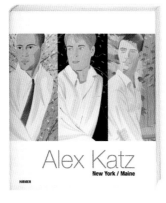

ALEX KATZ.
NEW YORK / MAINE

For decades, Alex Katz has split his time between New York and Maine, and the two very different locales have left their marks on his work. This collection is the first to highlight the distinctions between the works he created in each place.

Exhibition catalogue, Freigelände und Museum Künstlerkolonie, Institut Mathildenhöhe, Darmstadt
144 pages, 59 color, 13 b/w illustrations, 29 × 25 cm, hardcover
Text: English | German

Prussian Cultural Heritage Foundation (ed.)
The Humboldt Forum in the Berliner Schloss. Planning, Processes, Perspectives
Essays by H. Bredekamp, M. Eissenhauer, R. Haas, M. Heller, V. Heller, L.-C. Koch, V. König, J.-H. Olbertz, H. Parzinger, B. Probst, U. Rahmannsteinert, M. Rettig, K. Ruitenbeek, F. Stella, A. Wegner, M. Wemhoff, B. Wolter,

M. Wullen; 128 pages, 81 mostly color illustrations, 22.5 × 29.5 cm, softcover
Graphic design: Petra Ahke

Agnes Husslein-Arco, Axel Köhne, Harald Krejci (eds.)
Hundertwasser.
Japan and the Avant-Garde
Exhibition catalogue, Belvedere, Vienna
Contributions by A. Husslein-Arco, H. Krejci, A. Köhne, R. Fleck, A. Hubin, T. Mamine, S. Osaki
256 pages, 106 color, 101 b/w illustrations, 23.5. × 28.5 cm, softcover with Japanese binding
Graphic design: Willi Schmid

Beate Reifenscheid (ed.)
IntroSpection. Xiao Hui Wang, Wang Xiaosong
Exhibition catalogue, Ludwig Museum im Deutschherrenhaus, Koblenz
2 volumes in a slipcase, 472 pages, 244 color illustrations, 25 × 32 cm, hardcover; text: English | Chinese | German

Toni Stooss (ed.)
Alex Katz. New York / Maine
Exhibition catalogue, Museum der Moderne, Salzburg
Essays by Chuck Close, Sharon Corwin, Vincent Katz, Christina Penetsdorfer, Toni Stooss, Tina Teufel, Veit Ziegelmaier; 240 pages, 243 mostly color illustrations, 23.5 × 28 cm, hardcover
Text: English | German

Benjamin Katz
Benjamin Katz:
Georg Baselitz at Work
Text by Cornelia Gockel; 144 pages, 93 full-page color photographs, 24 × 28 cm, hardcover
Text: English | German

Hans-Michael Koetzle (ed.)
Ulrich Mack: Kennedy in Berlin.
50th Anniversary

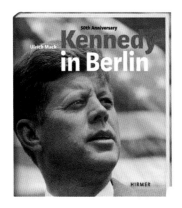

ULRICH MACK:
KENNEDY IN BERLIN. 50TH ANNIVERSARY

Published to mark the 50th anniversary of John F. Kennedy's historic visit to Berlin in June 1963, *Kennedy in Berlin* captures the event in a series of hitherto unpublished photographs by Ulrich Mack. Technically superb, Mack's photographs feature not only the great set pieces of the visit, but also candid, unscripted, and personal moments in stunning close-up.

Accompanying exhibition:
In Focus Galerie, Cologne;
Willy-Brandt-Haus, Berlin
Essays by Jasper von Altenbockum,
Egon Bahr, Hans-Michael Koetzl
144 pages, 91 b/w photographs,
24.5 × 27 cm, hardcover
Graphic design: Detlev Pusch, Berlin

Peter Kluska.
Landscape Architecture
Text by Peter Kluska; 280 pages,
218 color illustrations, 61 maps,
28 × 25 cm, hardcover
Text: English | German

Verena Landau (ed.)
Verena Landau. Passages,
Passengers, Places
Exhibition catalogue, fiftyfifty
Galerie, Düsseldorf
Essays by W. Ullrich, S. Holschbach,
F. Schulz, T. Huhn, T. Klemm,
H. Pupat; 144 pages, 154 mostly
color illustrations, 30.5 × 21.5 cm,
hardcover; text: English | German

Röbbig München (ed.)
Meissen Snuffboxes of the
Eighteenth Century
Exhibition catalogue, Röbbig
München, Munich
Essays by S.-K. Acevedo, B. Beau-
camp-Markowsky, H. Ottomeyer,

U. Pietsch, M. Röbbig-Reyes,
L. Seelig, H. Zech; 432 pages,
379 color, 130 b/w illustrations,
24 × 28 cm, hardcover, dust jacket

Bernd Pappe, Juliane Schmieglitz-
Otten
Miniatures. From the Time of
Marie Antoinette in the Tansey
Collection
500 pages, 233 mostly color
illustrations, 24 × 30 cm, hardcover
Text: English | German

Christoph Rauhut (ed.)
Modernism London Style.
The Art Deco Heritage
Introduction by Adam Caruso
216 pages, 379 b/w photographs,

Nukuoro Atoll is a ring of tiny islands
with a total area of 1.7 square kilometers
encircling a lagoon 6 kilometers in
diameter. Nukuoro has a dwindling
population of 300 inhabitants. The fame
and almost legendary popularity of the
tinu aitu sculptures from this atoll in
Micronesia is built on their exceptional
rarity and unusual forms.

123 as full-page plates, 24 × 27 cm,
hardcover; text: English | German
Graphic design: Niels Lehmann,
Christoph Rauhut

Agnes Husslein-Arco, Stephan Koja
(eds.)
Emil Nolde. In Radiance and Color
Exhibition catalogue, Belvedere,
Vienna
Contributions by
A. Husslein-Arco, A. Fluck, S. Koja,
K. Lovecky, M. Reuther, C. Ring
312 pages, 347 color illustrations,
23 × 29 cm, hardcover

Once firmly accepted social concepts such as "body,"
"masculinity," and "nudity" have become less concrete over
the past few decades. This volume presents an enthralling
expedition into art history, tracing representations of
naked men from the Age of Enlightenment to the
present day.

Tobias G. Natter, Elisabeth Leopold
(eds.)
**Nude Men. From 1800 to the
present day**
Exhibition catalogue, Leopold
Museum, Vienna
348 pages, 291 color, 52 b/w
illustrations, 24.5 × 29 cm, hardcover
Graphic design: atelier stecher,
Götzis

Oliver Wick, Christian Kaufmann
(eds.)
**Nukuoro. Sculptures from
Micronesia**
Essays by P. Peltier, H. Thode-Arora,
R. Neich, M. Melk-Koch, C. Hellmich,
A. Kaeppler, B. de Grunne
280 pages, 308 mostly color
illustrations, 24.5 × 30.5 cm,
hardcover
Graphic design: Heinz Hiltbrunner

Rudolf Berliner
**Ornamental Design Prints.
From the Fifteenth to the
Twentieth Century**
Foreword by Corinna Rösner
128 pages, 145 b/w illustrations,
24 × 28 cm, hardcover

Peter Kohlhaas, Ludger Schwarte
Uta Reinhardt.
Painting
Nicole Gnesa (ed.)
Exhibition catalogue, Galerie
Nicole Gnesa, Munich; Kutschen-,
Wagen-, und Schlittenmuseum,
Rottach-Egern; Rudolf-Stolz-
Museum, Sexten
160 pages, 102 color illustrations,
24.5 × 30.5 cm, hardcover
Text: English | German

Julian Gardner
**The Roman Crucible.
The Artistic Patronage of the
Papacy 1198–1304**
520 pages, 393 color illustrations,
22.5 × 30 cm, hardcover

Christian Bauer (ed.)
**Egon Schiele.
The Beginning**
Exhibition catalogue,
Egon Schiele Museum, Tulln;
Kunstmuseum Ravensburg
Essays by Carl Aigner, Christian
Bauer, Nicole Fritz
226 pages, 149 color,
44 b/w illustrations,
22.5 × 28.5 cm, hardcover
Text: English | German

**Schloss Herrenhausen.
Architecture – Gardens –
Intellectual History**
Essays by B. Adam, O. Herwig,
I. Lauterbach, G. Ruppelt;
176 pages, 150 mostly color
illustrations, 29.3 × 23 cm,
hardcover; text: English | German

Anna Lenz (ed.)
**Strong Women for Art.
In Conversation with Anna Lenz**
296 pages, 155 color illustrations,
17 × 24 cm, softcover with flaps

Astrid Becker (ed.)
Wols. Retrospective
Exhibition catalogue, Bremer
Kunsthalle, Bremen; Menil
Collection, Houston, TX
Contributions by P. de Bieberstein
Ilgner, T. Kamps, E. Rathke,
K. Siegel; 298 pages, 225 color and
224 thumbnail illustrations,
24 × 30.5 cm, hardcover

Werner Schuster
**X-Ray.
Art Photography**
Essay by René Harather
110 pages, 99 color illustrations,
30 × 23 cm, hardcover
Text: English | German

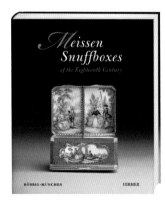

MEISSEN SNUFFBOXES
OF THE EIGHTEENTH CENTURY

Powdered tobacco, originally used in Europe as a
medicine, became a fashionable stimulant in high
society during the 18th century. Precious little contain-
ers known as tabatières (snuffboxes) were important
accessories for elegant ladies and gentlemen. This publi-
cation presents 124 of the finest snuffboxes.

Tilo Baumgärtel, Nachtgarten [Night Garden], 2011, 87 x 66 cm (sheet: 103 x 77 cm), hand-colored lithograph, edition of 12

Art Cologne 2012
624 pages, 226 color, 64 b/w illustrations, 17 × 21 cm, softcover
Text: English | German

Karin Sagner, Max Hollein (eds.)
Gustave Caillebotte. An impressionist and photography
Exhibition catalogue, Schirn Kunsthalle, Frankfurt
Essays by G. Chardeau, M. Chlumsky, C. Ghez, U. Pohlmann, K. Sagner, K. Schrader
245 pages, 80 color, 139 b/w illustrations, 23 × 26.5 cm, hardcover
Graphic design: Peter Grassinger

Francesco Clemente. Nostalgia, Utopia
Exhibition catalogue, Mary Boone Gallery, New York City, NY
Essay by Peter Lamborn Wilson
72 pages, 20 color illustrations, 26.5 × 25 cm, hardcover

Uta Hassler, Christoph Rauhut (eds.), in cooperation with Santiago Huerta and the Institut für Denkmalpflege und Bauforschung der ETH Zürich
Construction Techniques in the Age of Historicism
336 pages, 41 color plates, 17 b/w plates, 110 color,

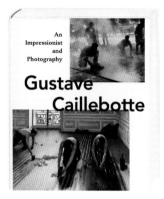

51 b/w illustrations, 199 design drawings, maps, charts, ground plans, 25.5 × 30.5 cm, hardcover with dust jacket
Text: English | French | German

Dirk Syndram, Claudia Brink (eds.)
The Dream of a King. Dresden's Green Vault
Exhibition catalogue, Museum of Islamic Art, Doha
248 pages, 159 color illustrations, 23 × 28.5 cm, hardcover
Text: English | Arabic
Graphic design: Anke von der Hagen, Reproline Genceller

GUSTAVE CAILLEBOTTE. AN IMPRESSIONIST AND PHOTOGRAPHY

Gustave Caillebotte not only depicted the 19th-century Paris of Haussmann, but also painted landscapes, still lifes, portraits, and interiors. Today, he has taken his place as one of the most outstanding French Impressionists. His avant-garde approach to perspective and composition anticipated pictorial forms of 20th-century photography.

William M. Griswold, Michael Semff (eds.)
Dürer to de Kooning. 100 Master Drawings from Munich
Exhibition catalogue, Morgan Library & Museum, New York City, NY
264 pages, 107 color, plates, 53 color, 12 b/w illustrations, 24 × 28 cm, hardcover

Katharina Eisch-Angus, Ines Kohl, Karin Schrott (eds.)
Erwin Eisch. Clouds have been my foothold all along. Glass and paintings
240 pages, 218 color, 35 b/w illustrations, 24 × 30 cm, hardcover, dust jacket; text: English | German

Generaldirektion der Stiftung Preußische Schlösser und Gärten Berlin-Brandenburg (ed.)
The Fashion Monkey. A staged promenade through the Neues Palais
Exhibition catalogue, Neues Palais, Stiftung Preußische Schlösser und Garten Berlin-Brandenburg, Potsdam
Essays by Samuel Wittwer
128 pages, 137 color illustrations, 23.5 × 29 cm, hardcover
Text: English | German

CONSTRUCTION TECHNIQUES IN THE AGE OF HISTORICISM

In the 19th century, methods of construction were as eclectic as architectural style. This book focuses on the realization of architectural projects at the time, their structure, building method, and construction theory.

Daniel Blau, Klaus Maaz (eds.)
Fish Hooks of the Pacific Islands.
A pictorial guide to the fish hooks
from the peoples of the Pacific
Islands
Texts by Daniel Blau, Klaus Maaz,
Sydney Picasso; 374 pages,
10 foldouts in color, 341 color,
34 b/w illustrations, 22.5 × 28 cm,
hardcover

Jutta Götzmann (ed.)
Frederick and Potsdam.
A City is Born
Exhibition catalogue, Potsdam
Museum – Forum für Kunst und
Geschichte, Potsdam
212 pages, 125 color, 14 b/w illustra-
tions, 21 × 27 cm, hardcover

Agnes Husslein-Arco, Thomas
Zaunschirm (ed.)
Gold. Artists and Gold
Exhibition catalogue, Belvedere,
Vienna
Contributions by J. Borchhardt, M.
Castor, J. Driller, U. Gehring, B. Hell,
A. Klee, L. Pelzmann, V. Pirker-
Aurenhammer, E. Putzgruber, M. V.
Schwar, T. Zaunschirm; 368 pages,
316 color illustrations, 25 × 32.5 cm,
hardcover, gilt edging

Petra Kipphoff von Huene, Marvin
Altner (eds.)
Stephan von Huene. Split Tongue
Essay by Petra Kipphoff von Huene
196 pages, 73 color, b/w illustra-
tions, 23 × 25 cm, hardcover
Text: English | German

Dietmar Elger, Gerhard Richter
Archive (ed.)
Benjamin Katz:
Gerhard Richter at work
Essays by Wilfried Wiegand,
Stephan von Wiese, Paul Moor-
house, introduction by Dietmar
Elger; 144 pages, 94 b/w plates,

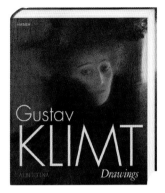

On the occasion of Gustav Klimt's
150th birthday, the Albertina Museum
in Vienna and the J. Paul Getty
Museum in Los Angeles have dedicated
a special exhibition to this artist's
outstanding graphic work. This amply
illustrated publication is the pinnacle
of their project.

24 × 28 cm, hardcover
Text: English | French | German

Marian Bisanz-Prakken (ed.)
Gustav Klimt. Drawings
Exhibition catalogue, Albertina
Museum, Vienna; J. Paul Getty
Museum, Los Angeles, CA
Introduction by K. A. Schröder, D.
Bomford; 304 pages, 266 mostly
color illustrations, 25 × 29.5 cm,
hardcover

Patricia Frick, Soon-Chim Jung (eds.)
Korean Lacquer Art. Aesthetic
Perfection
Exhibition catalogue, Museum
of Lacquer Art, Münster
Essays by Patricia Frick, Jihyun

Hwang, Soon-Chim Jung, Koji
Kobayashi, Margarete Prüch,
Kyuhee Wahlen; 208 pages,
163 color illustrations, 24 × 30 cm,
hardcover

Harry Dirrigl (ed.)
Stephan Maria Lang. Architecture.
A Journey to the Soul
Interview with Oliver Herwig
152 pages, 176 color photographs,
30 × 26 cm, hardcover, dust jacket
Text: English | German

Suzanne Greub (ed.)
William MacKendree.
Vinyl Vocabulary
Introduction by Michel Buillard
152 pages, 161 mostly color

Home to five museums—the Old and
New Museums, the Old National Gallery,
the Bode Museum, and the Pergamon
Museum—Berlin's Museum Island was
declared a UNESCO World Heritage site
in 1999 and represents nearly 200 years of
museum history. This book takes readers
on a fascinating tour of the history and
architecture of the museums, as well as
their collections.

NORDIC ART.
THE MODERN BREAKTHROUGH 1860–1920

The late 19th and early 20th centuries marked a defining moment in Nordic art. Through more than two hundred paintings, *Nordic Art* tells the story of this important period. In dialogues between Scandinavian culture and other European contemporary art of the time, Nordic artists developed their own distinctive interpretations of Realism, Impressionism, and Symbolism.

illustrations, 24.5 × 30.5 cm, hardcover; text: English | French

Hans Georg Hiller von Gaertringen
Masterpieces of the Gipsformerei. Art manufactury of the Staatliche Museen zu Berlin since 1819
Published for the Gipsformerei of the Staatliche Museen zu Berlin by Miguel Helfrich and Elisabeth Rochau-Shalem; 144 pages, 124 color illustrations, 20 × 27 cm, hardcover

Gabriel Mayer (ed.)
Franz Mayer of Munich. Architecture, Glass, Art
Essays by Bernhard G. Graf, Gottfried Knapp; 358 pages,

643 color illustrations, 24 × 30 cm, hardcover
Text: English | German

Michael Eissenhauer, Astrid Bähr, Elisabeth Rochau-Shalem (eds.), for the Staatliche Museen zu Berlin
Museum Island Berlin
416 pages, 254 mostly color illustrations, 25 × 32.5 cm, hardcover

Susanne Fischer
News – The Televised Revolution. Monika Huber – Susanne Fischer
Exhibition catalogue, Maximilians-Forum, Munich
Essays by Susanne Fischer, Hazim al-Sharaa, Atiaf al-Wazir, Raghda al-Halawany, Maryam Hassan, Sabry

Khaled, Zainab al-Khawaja, Raed Rafei, Tiare Rath, Ulrich Wilmes, Razan Zeitouneh; 160 pages, 53 color plates, 21.5 × 30 cm, hardcover
Graphic design: Monika Huber

Groninger Museum, Kunsthalle München, David Jackson (eds.)
Nordic Art. The Modern Breakthrough 1860–1920
Exhibition catalogue, Kunsthalle der Hypo-Kulturstiftung, Munich; Groninger Museum, Groningen
260 pages, 154 mostly color illustrations, 1 map, 29.5 × 28.5 cm, hardcover

Sabine Grabner, Agnes Husslein-Arco (eds.)
Orient & Occident. Travelling 19th Century Austrian Painters
Exhibition catalogue, Belvedere, Vienna
264 pages, 195 color, 19 b/w illustrations, 23 × 28.5 cm, hardcover

Christian Schoen (ed.)
Passage 2011. An Actionistic Trans-alpine Drama. A project on the occasion of the 54th Biennale di Venezia

CLIFFORD ROSS.
THROUGH THE LOOKING GLASS

Multimedia artist Clifford Ross looks beyond the natural world to uncover a world bound only by the imagination. Ross uses old and new methods to produce exceptionally beautiful and radically redesigned conceptions of reality, thus presenting his own digital vision.

Exhibition catalogue, Kunsthalle
Emden
Essays by Marcus A. Friedrich, Arne
Rautenberg, Christian Schoen
193 pages, 200 color illustrations,
28.5 × 19 cm, hardcover
Text: English | German

Max Seidel
Nicola and Giovanni Pisano.
Father and Son
2 volumes, 996 pages in total,
875 b/w illustrations, 23 × 29.5 cm,
hardcover
Graphic design: Tapiro, Venice

Joachim Jacoby, Martin Sonnabend
(eds.)
Raphael. Drawings
Exhibition catalogue, Städel
Museum, Frankfurt
260 pages, 171 color illustrations,
23 × 28 cm, hardcover

Clifford Ross.
Through the Looking Glass
With a text by Paul Goldberger
176 pages, 122 mostly color illustra-
tions, 29.5 × 31 cm, hardcover
Graphic design: Petra Lüer, Wigel

Agnes Husslein-Arco, Alexander
Klee (eds.)
Emil Jakob Schindler.
Poetic Realism
Exhibition catalogue, Belvedere,
Vienna
Contributions by S. Auer,
M. Fellinger, A. Husslein-Arco,
E. Kamenicek, A. Klee, A. Winkl-
bauer; 128 pages, 47 color plates,
74 color, 7 b/w illustrations,
19 × 24 cm, hardcover

Steven Scott.
Luminous Icons
Essay by R. C. Morgan; 192 pages,
321 color illustrations, 24 × 27 cm,
hardcover

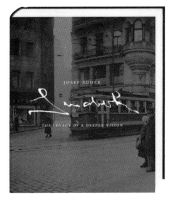

Daniel Blau (ed.)
From Silverpoint to Silver Screen.
Andy Warhol. 1950s Drawings
Exhibition catalogue, Louisiana
Museum of Modern Art, Humble-
baek; Teylers Museum, Haarlem;
Staatliche Graphische Sammlung,
Munich
Essays by J. Hofmaier, S.Picasso
248 pages, 120 color illustrations,
24 × 28 cm, hardcover
Text: English | German

Maia-Mari Sutnik (ed.)
Josef Sudek.
The Legacy of a Deeper Vision
Exhibition catalogue, Art Gallery
of Ontario, Toronto
Essays by Maia-Mari Sutnik,

Antonín Dufek, Richard Rhodes,
Geoffrey James; 288 pages,
210 photographs, 32 × 26 cm,
hardcover
Graphic design: The Office of
Gilbert Li

Alistair Layzell (ed.)
Eugène Vernier.
Fashion, femininity & form
Essays by Robin Muir, Becky
E. Conekin; 192 pages, 220 b/w
illustrations, 23 × 28.5 cm,
hardcover, dust jacket
Graphic design: Katja Durchholz

JOSEF SUDEK. THE LEGACY
OF A DEEPER VISION

Josef Sudek, the "Poet of Prague," had a
legendary career spanning almost six
decades. His craftsmanship and
technical virtuosity were unparalleled
among his contemporaries. Faced with
the legacy of Cubism, Surrealism, and
the Czech avant-garde, Sudek sought
his own approach, characterized by a
striking mastery of light.

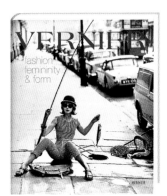

EUGÈNE VERNIER. FASHION,
FEMININITY & FORM

Vernier worked for *Vogue* in London as
a fashion photographer between 1954
and 1967 at the birth of one of the most
exciting periods in British, European,
and American fashion history. For this
book, Vernier has chosen more than 100
of his own favorite images from the
British edition of *Vogue*, which featured
his work during that period.

Eugène Vernier, Beersheba camel market, Israel, July 1962, 30 x 20 cm, fine art pigment print on baryta paper

Eugène Vernier, Tania Mallet, January 1961, 29.8 x 24.5 cm, fine art pigment print on baryta paper

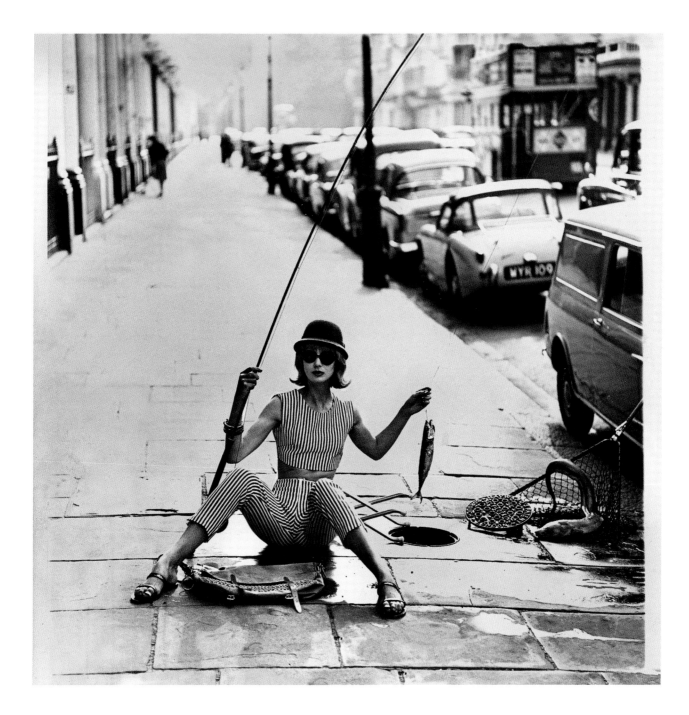

Eugène Vernier, Ros Watkins, July 1961, 29.7 x 29.7 cm, fine art pigment print on baryta paper

Art Cologne 2011
578 pages, 150 color plates,
20 × 25 cm, softcover with flaps
Text: English | German

Regine Marth, Marjorie Trusted (eds.)
Barocke Kunststückh.
Sculpture Studies in Honour
of Christian Theuerkauff
240 pages, 117 color, 28 b/w illustra-
tions, 22 × 28 cm, cloth
Text: English | German

Marion Beckers, Elisabeth Moortgat
(eds.)
Eva Besnyö. 1910–2003.
Woman Photographer. Budapest –
Berlin – Amsterdam
Exhibition catalogue,
Das Verborgene Museum as guest
of the Berlinische Galerie, Berlin
248 pages, 271 b/w photographs,
23 × 28 cm, hardcover
Text: English | German

Jill Lloyd, Christian Witt-Döring (eds.)
Birth of the Modern.
Style and Identity in Vienna 1900
Exhibition catalogue, Neue Galerie
New York City, NY
Contributions by P. Blom,
C. Cernuschi, J. Clair, A. Comini,
G. Howes, J. Lloyd, R. S. Lauder,
C. Weikop, C. Witt-Döring;

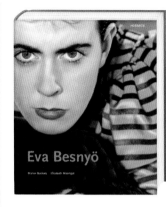

EVA BESNYÖ. 1910–2003. WOMAN
PHOTOGRAPHER. BUDAPEST –
BERLIN – AMSTERDAM

Eva Besnyö was an exceptionally gifted
photographer: she acquired her photo-
graphic skills in the studio of József Pécsi
in Budapest, became aware of the
aesthetics of modern photography in
the early 1930s in Berlin, and became a
respected master photographer in
Amsterdam.

288 pages, 238 illustrations in color
and b/w, 23.5 × 28.5, hardcover
Graphic design: Pandiscio Co./Bill
Loccisano

Gottfried Knapp (ed.)
Christina von Bitter. The Skin of Things
160 pages, 78 color illustrations,
24.5 × 30.5 cm, hardcover
Text: English | German
Graphic design: Rainer Lienemann,
Wigel

Achim Bunz
Buddha in the Yurt.
Buddhist Art from Mongolia
Carmen Meinert (ed.)
Texts by Carmen Meinert, Andrey
Terentyev, et al.; 2 volumes,

840 pages in total, 554 color illustra-
tions, 24 × 28.5 cm, hardcover,
cloth, slipcase
Text: English / Russian

Andreas Blühm (ed.)
Alexandre Cabanel.
The Tradition of Beauty
Exhibition catalogue, Wallraf-
Richartz-Museum & Fondation
Corboud, Cologne
128 pages, 79 color illustrations,
24 × 30 cm, hardcover

Markus Müller (ed.)
Eduardo Chillida
Exhibition catalogue, Kunstmuseum
Pablo Picasso, Münster
224 pages, 260 color, 37 b/w illustra-

BIRTH OF THE MODERN.
STYLE AND IDENTITY IN VIENNA 1900

This publication reveals a common thread running through the
fine and decorative arts of the period: the redefining of individu-
al identity in the modern age. In fine art, decorative arts, and
music, this entails both a dialogue between surface ornamenta-
tion and inner structure. It also explores the new attitudes
toward gender and sexuality that surface in Viennese literature
and psychology at the time.

tions, 22 × 28 cm, hardcover
Text: English | German

Max Seidel (ed.)
Francesco Clemente. The Tarots
Exhibition catalogue, The Uffizi
Galleries, Florence
168 pages, 178 mostly color illustra-
tions, 22 × 28.5 cm, hardcover

Ingrid Pfeiffer, Max Hollein (eds.)
en passant. et al.*
Exhibition catalogue, Schirn
Kunsthalle, Frankfurt
64 pages, 57 color illustrations,
21 × 27 cm, softcover
Text: English | German

Berlinische Galerie (ed.)
Rainer Fetting. Berlin
Exhibition catalogue, Berlinische
Galerie, Berlin
Essays by Guido Fassbender, Travis
Jeppesen, Heinz Stahlhut, Simone
Wiechers; 136 pages, 143 mostly
color illustrations, 23 × 27 cm,
hardcover
Text: English | German

Daniel Blau (ed.)
Lucian Freud. Portraits
Exhibition catalogue, Galerie
Daniel Blau, Munich
Text by Norman Rosenthal

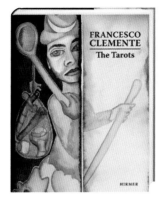

76 pages, 27 color illustrations,
illustrated bibliography,
24 × 28 cm, hardcover
Text: English | German
Graphic design: Peter Grassinger

Christina Strunck, Elisabeth Kieven
(eds.)
**Galleries in a Comparative
European Perspective. 1400–1800**
436 pages, 318 illustrations in
color and b/w, 22.5 × 30 cm,
hardcover
Text: English | German

Suzanne Greub (ed.)
Paul Gauguin. Polynesia
Exhibition catalogue, Ny Carlsberg
Glyptothek, Copenhagen; Seattle

The work of painter Francesco Clemente
has always drawn on many esoteric
traditions. He finds inspiration in a
variety of visual languages, ranging from
the tantric diagrams of India to the
Candomblé ceremonial implements of
Brazil. This book reproduces all 78 of
Clemente's tarot cards; it also presents
12 self-portraits of the artist as the
12 apostles.

Art Museum, Seattle
Introduction by Michel Buillard
400 pages, 200 color illustrations,
24 × 29 cm, hardcover

Stanley Greenberg. Time Machines
Introduction by David C. Cassidy
132 pages, 162 b/w photographs,
26 × 28 cm, hardcover

Xenia Hausner. Damage
Exhibition catalogue, Today Art
Museum, Beijing Pingod
Contributions by Peter Assmann,
Rainer Metzger, Clarissa Stadler,
Xiao Xiaolan; 152 pages, 110 color
illustrations, 29.5 × 27.5 cm,
hardcover
Text: English | Chinese | German

Presented here are more than two hundred full-color images—
selected by the artist's son Ignacio—that form a rich and varied
exploration of the entire scope of Chillida's career. The book
begins with the earliest work in Paris in the late 1940s and
continues on to his return to the Basque Country, where he
moved away from the clay and plaster studies of the human form
and began creating the large-scale metal sculptures for which he
is best known.

Xenia Hausner, INDIGO Z, 2013, 98.5 x 68 cm, oil on Tecco paper mounted on Dibond

LUCIAN FREUD.
PORTRAITS

Lucian Freud (1922–2011) is one of the most widely acclaimed British artists of our time. Plentifully illustrated and with an essay by the celebrated curator Sir Norman Rosenthal, *Lucian Freud. Portraits* brings the artist's lesser-known etchings deservedly to the forefront of our appreciation of his art.

Marc Scheps
Menashe Kadishman.
Sculptures
136 pages, 94 color illustrations, 63 b/w illustrations, 27 × 36 cm, hardcover

Rudi Fuchs
Kiefer, Rembrandt, Kiefer
Exhibition catalogue, Rijksmuseum, Amsterdam
Text by Rudi Fuchs; 36 pages, 24 color illustrations, 24 × 31.5 cm, hardcover; text: English | German
Graphic design: Irma Boom

Markus Heinsdorff.
The Bamboo Architecture
Contributions by M. Kahn-Ackermann, G. Knapp, W. Liese, A. von Vegesack; 208 pages, 157 color illustrations, 25 × 30.5 cm, cloth
Text: English | German

Burkhard Leismann, Verena Titze (eds.)
Andreas Horlitz. Equilibrium
Exhibition catalogue, Kunstmuseum Ahlen
120 pages, 136 color illustrations, 23 × 32 cm, hardcover
Text: English | German

Cornelia Wieg (ed.)
Into One-Another.
Berlinde de Bruyckere in Dialogue with Cranach and Pasolini
Exhibition Catalogue, Stiftung Moritzburg, Kunstmuseum des Landes Sachsen-Anhalt, Halle; Kunstmuseum Bern; Kunsthalle Wien, project space, Vienna
Contributions by E. Blume, G. Böhme, K. Bühler, C. Wieg, and an interview by Hans Theys with Berlinde de Bruyckere; 236 pages, 77 color, 153 b/w illustrations, 22 × 30.5 cm, hardcover
Text: English | German

Niklas Maak
Le Corbusier.
The Architect on the Beach
208 pages, 74 b/w illustrations, 12 × 20 cm, hardcover
Graphic design: Gunnar Musan

Beate Kemfert, Angela Gratzl (eds.)
Line and Sculpture in Dialogue.
Rodin, Giacometti, Modigliani ...
Exhibition catalogue, Opelvillen, Rüsselsheim; Museum für Neue Kunst, Freiburg
96 pages, 100 color illustrations, 21 × 26.5 cm, hardcover
Text: English | German

PAUL GAUGUIN. POLYNESIA

While there have been many biographical and critical studies of Gauguin, few have focused specifically on the extent to which the art and culture of Polynesia influenced his work. Featuring more than sixty of Gauguin's depictions of Polynesian life, this book fully articulates the extent of that influence. Alongside Gauguin's works are an equal number from Polynesian artists that exemplify the dynamic relationship between European and Polynesian art throughout the 19th century.

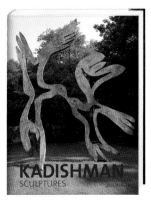

The draftsman, painter, and sculptor Menashe Kadishman
is one of Israel's most important artists who also enjoy
wide international acclaim. His sculptures are found
throughout the world in museums, private collections,
public places, and sculpture parks. This volume presents
his twenty most important sculptural works.

David Teboul (ed.)
Boris Mikhailov.
I've Been Here Once Before
480 pages, 320 color illustrations,
12.5 × 19 cm, softcover
Graphic design: Jérôme Saint-
Loubert Bié

The Pencil of Nature.
William Henry Fox Talbot
Introduction by Colin Harding
150 pages, 24 calotypes,
21.5 × 28 cm, hardcover

Markus Müller (ed.)
Picasso. Linocuts
Exhibition catalogue, Kunstmuseum
Pablo Picasso, Münster
192 pages, 110 color, 23 b/w illustra-

tions, 22 × 29 cm, hardcover
Text: English | German
Graphic design: Eva Dalg

Jürgen Döring
Power to the Imagination.
Artists, posters and politics
Exhibition catalogue, Museum für
Kunst und Gewerbe Hamburg
168 pages, 149 color illustrations,
21.5 × 26.5 cm, hardcover
Text: English | German

Ortrud Westheider, Michael Philipp
(eds.)
Gerhard Richter. Images of an Era
Exhibition catalogue, Bucerius
Kunst Forum, Hamburg; Tate
Modern, London; Neue National-

galerie, Staatliche Museen zu Berlin;
Centre Pompidou, Paris
Texts by Hubertus Butin, Dietmar
Elger, Dietmar Rübel, Uwe M.
Schneede, Ortrud Westheider
216 pages, 167 color, 55 b/w illustra-
tions, 22.5 × 28 cm, hardcover,
dust jacket
Graphic design: Büro Brückner +
Partner, Bremen

Beate Kemfert, Christina Leber (eds.)
Road Atlas. Street Photography
from Helen Levitt to Pieter Hugo
Exhibition catalogue, Opelvillen,
Rüsselsheim; Kunstmuseum
Dieselkraftwerk Cottbus; Kunsthalle
Erfurt; DZ Bank, Frankfurt
Contributions by F. Langer, et al.
192 pages, 150 color, b/w photo-
graphs, 21.5 × 26.5 cm, hardcover
Text: English | German

Christian Ehrentraut, Rupert Pfab
(eds.)
Ruprecht von Kaufmann. 2007–2010
176 pages, 124 color illustrations,
30 × 25.5 cm, hardcover
Text: English | German

Max Hollein, Pamela Kort, Schirn
Kunsthalle Frankfurt (eds.)
Eugen Schönebeck. 1957–1967
Exhibition catalogue,

Le Corbusier has long been recognized
as one of the foremost figures in the
international style of architecture. Yet,
beginning in the 1940s, the famed
architect and urbanist increasingly took
modernism in a new direction that has
until now been insufficiently consid-
ered—and little understood.

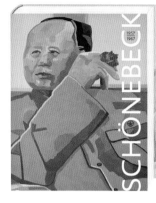

EUGEN SCHÖNEBECK.
1957–1967

Schönebeck's works vary between the abstract and the figurative and feature strange, mutated creatures that seem to oscillate between the worlds of the dead and the living. This book is the first catalogue raisonné to bring together all of his surviving canvases. It also includes around 40 of the artist's works on paper.

Schirn Kunsthalle, Frankfurt
176 pages, 205 color illustrations,
24 × 29 cm, hardcover
Text: English | German

Mariantonia Reinhard-Felice (ed.)
The Secret Armoire. Corot's Figure Paintings and the World of Reading
Exhibition catalogue, Oskar Reinhart Collection "Am Römerholz," Winterthur
176 pages, 94 color illustrations,
23.5 × 28 cm, softcover

Michael Schultz (ed.)
SEO. Personal Cosmos
Exhibition catalogue, Palazzo Bembo, 54th Venice Biennale 2011, Venice

64 pages, 20 color plates,
22 × 22 cm, hardcover
Text: English | Korean | German

Nuit Banai (ed.)
Eran Shakine.
Sunny Side Up
120 pages, 55 color plates,
24 × 30 cm, flexcover

David Knipp (ed.)
Siculo-Arabic Ivories and Islamic Painting 1100–1300.
Römische Studien der Bibliotheca Hertziana, Band 36
338 pages, 49 color, 225 b/w illustrations, 24 × 28.8 cm, hardcover

Turner and the Elements
Exhibition catalogue, Bucerius Kunst Forum, Hamburg; Muzeum Narodowe, Krákow; Turner Contemporay, Margate
256 pages, 260 color, 23 b/w illustrations, 22.5 × 28 cm, hardcover

Fondation Cartier pour pour l'art contemporain (ed.)
Vodun. African Voodoo
Exhibition catalogue, Fondation Cartier pour l'art contemporain, Paris
236 pages, 150 color and b/w illustrations, 24 × 32 cm, hardcover
Text: English | French
Graphic design: Agnès Dahan Studio

VODUN.
AFRICAN VOODOO

In the late 1960s, Jacques Kerchache, an artistic advisor and curator of exhibitions, recognized the aesthetic potency and stunning originality of voodoo statuary and its forms. During his first trips to the birthplace of voodoo, now known as the Republic of Benin, he began to bring together what has become the most significant existing collection of African voodoo statuary.

Susu van Liempt, W.S. [Walter Spies], 2017, 64 x 45 cm, acrylic and charcoal on untreated cotton

Renate Wiehager (ed.)
Ampersand. A Dialogue Between Contemporary Art from South Africa & the Daimler Art Collection
Haus Ruth, Berlin
112 pages, 75 color illustrations, 28 × 27.5 cm, softcover
Text: English | German
Graphic design: superfantastic, Berlin

Helmut Friedel, Annegret Hoberg (eds.)
The Blue Rider. A Dance in Colours
Exhibition catalogue, Städtische Galerie im Lenbachhaus, Munich
264 pages, 257 mostly color illustrations, 24 × 28.5 cm, hardcover

Gabriele Uerscheln,
Stiftung Schloss und Park Benrath Düsseldorf (ed.)
Edward Burne-Jones. Flower Book
Text: English original and German translation

Max Hollein, Vinzenz Brinkmann, Oliver Primavesi, Liebieghaus Skulpturensammlung Frankfurt am Main (eds.)
Circumlitio. The Polychromy of Antique and Medieval Sculpture
424 pages, 360 color, 15 b/w illustrations, 17 × 25 cm, hardcover

Showing a selection of 50 large-format paintings, as well as graphic works and photographs from various collections, this book focuses thematically on the artist's studio and explores its role in his art, whose uniqueness lies in his meticulous and almost obsessive treatment of the portrait and the nude.

Alexander Dettmar.
Painting to Remember. The Destroyed German Synagogues
Exhibition catalogue, Galerie im Stift, Bad Hersfeld
Essays by A. Bergmann, H. Dahlhaus, C. Kahn Strauss, B. Kauffmann, T. Ridder, I. Schorsch, H. Seemann, B. D. Soussan, V. Veltzke; 200 pages, 108 color, 21 b/w illustrations, 24 × 28 cm, hardcover
Text: English | German

Andreas Blühm, Roland Krischel (eds.)
Do or Die. The Human Condition in Painting and Photography; Teutloff meets Wallraf
Exhibition catalogue, Wallraf-Richartz-Museum & Fondation

Corboud, Cologne
Contributions by Andreas Blühm, Bazon Brock, Roland Krischel
160 pages, 121 color illustrations, 22 b/w illustrations, 25 × 21.5 cm, hardcover; text: English | German

Cécile Debray (ed.)
Lucian Freud. The Studio
Exhibition catalogue, Centre national d'art et de culture Georges Pompidou, Paris
Contributions by L. des Cars, J. Clair, P. Comar, E. Darragon, C. Debray, A. Pacquement, R. Shiff, E. Urtizverea
256 pages, 201 color, 43 b/w illustrations, 23.5 × 30 cm, hardcover
Graphic design: Laurent Fétis, assisted by Sarah Martinon

Many of Elfie Semotan's (b. 1941) photographs are famous without the public knowing who took them. Over the last 30 years, she has produced a kaleidoscope of very different portraits from her encounters with other artists, and this book is an opportunity to discover the most fascinating of them. Semotan's "models" occupy the terrain between role-play and exposure. Many of the personalities she sought out years ago have since become international stars.

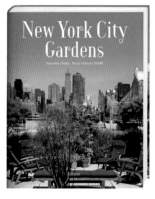

New York a garden paradise? You would hardly think so, but the city on the Hudson is a hidden El Dorado of garden design. The lack of space has meant that gardens designed by imaginative specialists have been drawn upward, toward the light. This book shows some of the best examples of New York's gardens, from the public parks to luxury roof gardens and private oases in the heart of Manhattan.

From Louise Bourgeois to Jeff Wall. Portraits & Studio Stills by Elfie Semotan
Exhibition catalogue, Museum der Moderne, Rupertinum, Salzburg
Essays by Roberto Ohrt, Margit Zuckriegl; 104 pages, 33 color, 51 b/w illustrations, 23.5 × 29 cm, softcover; text: English | German
Graphic design: Albert Handler, moodley brand identity GmbH, Vienna

Rafael Jablonka (ed.)
Mike Kelley. Kandors
78 pages, 56 color, 27 b/w illustrations, 24 × 31.5 cm, hardcover
Text: English | German
Graphic design: Ahrum Hong with Kühle und Mozer, Cologne

Ortrud Westheider, Michael Philipp (eds.)
Modern Life.
Edward Hopper and His Time
Exhibition catalogue, Bucerius Kunst Forum, Hamburg; Whitney Museum of American Art, New York City, NY
Essays by B. Haskell, S. Nicholas, S. Scharf, B. Schulz, O. Westheider, R. Zurier; 2nd edition, 240 pages, 143 color, 93 b/w illustrations, 22.5 × 28 cm, hardcover, dust jacket

Veronika Hofer, Betsy Pinover Schiff
New York City Gardens
240 pages, 178 color illustrations, 24.5 × 30 cm, hardcover
Graphic design: Gunnar Musan

Hans-Michael Koetzle (ed.)
Oberammergau.
Life & Passion. 1870–1922
128 pages, 110 mostly color illustrations, 27.5 × 34 cm, softcover; text: English | German

Thomas Herzog (ed.)
Oskar von Miller Forum. Building for the Future
96 pages, 126 color illustrations, 23 × 30 cm, hardcover
Text: English | German

Agnes Husslein-Arco (ed.)
Anton Romako. Admiral Tegetthoff in the Naval Battle of Lissa
Exhibition catalogue, Belvedere, Vienna
144 pages, 184 color illustrations, 19 × 24.5 cm, hardcover

Sylvia Martin (ed.)
Ted Partin.
Eyes Look Through You
Exhibition catalogue, Kunstmuseen Krefeld, Museum Haus Esters, Krefeld
120 pages, 6 color illustrations, 42 in duotone, 24 × 28 cm, hardcover; text: English | German

In these works, Mike Kelley deals with the imaginary city of Kandor, capital of the planet Krypton and home of the comic figure Superman. The publication presents the group of works titled Kandors and documents the transformation of two-dimensional comic pictures into three-dimensional sculptures.

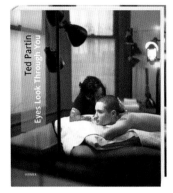

TED PARTIN.
EYES LOOK THROUGH YOU

In his photographic work, Ted Partin devotes himself to the image of the human being, one of the great emotional core themes of photographic history. He creates pictures in which the figures take up a natural pose and the beholder is at once an intimate and a voyeur. An irresolvable contradiction lurks in the photographs—the documentary claim to reality and the desire for a cinematic mise-en-scène.

Agnes Husslein-Arco,
Marie-Louise von Plessen (eds.)
Prince Eugen. General-Philosopher and Art Lover
Exhibition catalogue, Belvedere, Vienna
Contributions by M.-L. von Plessen, L. Auer, T. Baumgartner, C. Benedik, C. Diekamp, L. Hanzl-Wachter, M. Hochedlinger, G. Mauthe, I. Ortayli, K. Schütz, C. E. Spantigati;
336 pages, 345 color, 21 b/w illustrations, 24 × 32 cm, hardcover, dust jacket

Kasper König (ed.)
Remembering Forward.
Australian Aboriginal Painting since 1960
Exhibition catalogue, Museum Ludwig, Cologne
Contributions by R. Bell, E. Joyce Evans, I. McLean, D. Mundine OAM, F. Myers, J. Ryan, F. Wolf
188 pages, 91 color illustrations, 24 × 30 cm, softcover

Agnes Husslein-Arco, Stephan Koja (eds.)
Rodin and Vienna
Exhibition catalogue, Belvedere, Vienna
176 pages, 98 color, 49 b/w illustrations, 23 × 28 cm, hardcover

Richard Hüttel (ed.)
Michael Triegel.
Metamorphosis of the Gods
Exhibition catalogue, Museum der bildenden Künste Leipzig
Essays by H. Damm, R. Hüttel, W. Löhr, R. Reiche, P. Weiermair
224 pages, 165 color illustrations, 24 × 30 cm, hardcover

Max Weiler.
The Nature of Painting
Exhibition catalogue, Museum Essl, Klosterneuburg
162 pages, 116 color, 28 b/w illustrations, 24 × 30 cm, hardcover
Text: English | German

RODIN AND VIENNA

The Secession exhibition of 1901 was the high point of Vienna's involvement with the famous French sculptor. This catalogue looks at the history of the annual Secession shows, Rodin's skillful use of the media and the exhibitions, his influence on Austrian art, and also the masterpieces that have been in the Belvedere Collection since then.

Rita Adolff-Wollfarth. Nanocubism
Contributions by Rita Adolff-
Wollfarth, Lena Rupprecht, Elmar
Zorn; 122 pages, 60 color illustra-
tions, 24 × 30 cm, hardcover
Text: English | German

Esther Schlicht, Max Hollein (eds.)
Art for the Millions.
100 Sculptures from the Mao Era
Exhibition catalogue, Schirn
Kunsthalle, Frankfurt
200 pages, 71 color plates, 58 b/w
illustrations, 21 × 28 cm, softcover
with flaps; text: English | German

Daum Nancy III. Daum Frères –
Verreries de Nancy. 1880–1930
176 pages, 154 color, 24 b/w illustra-
tions, 22 × 30 cm, hardcover
Text: English | German

Lisa Hockemeyer, Gillo Dorfles
The Hockemeyer Collection.
20th Century Italian Ceramic Art
Exhibition catalogue, Estorick
Collection of Italian Art, London
240 pages, 140 color illustrations,
24 × 32 cm, hardcover
Text: English | German

Aris Kalaizis. Making Sky
Contributions by Tom Huhn,
Christoph Keller, Carol Strickland;

conversation between Max
Lorenzen and Aris Kalaizis
132 pages, 125 color illustrations,
catalogue raisonné, 30 × 26.5 cm,
hardcover; text: English | German

Paul von Lichtenberg
Mohn & Kothgasser. Transparent-
Enamelled Biedermeier Glass
528 pages, 762 color illustrations,
23.5 × 28 cm, hardcover
Text: English | German

Ingrid Pfeiffer, Max Hollein (eds.)
E. W. Nay. Paintings from the 1960s
Exhibition catalogue, Schirn
Kunsthalle, Frankfurt; Haus am
Waldsee, Berlin
Essays by I. Pfeiffer, E. Nay-Scheibler,
K. Blomberg; 128 pages, 37 color
plates, 98 color, 18 b/w illustrations,
24 × 25.5 cm, softcover with flaps
Text: English | German

Stefan Weppelmann, Gerhard Wolf
(eds.)
Rothko/Giotto.
The Tangibility of the Painting
Exhibition catalogue, Gemälde-
galerie, Staatliche Museen zu Berlin
198 pages, 30 color, 6 b/w plates,
27 color, 13 b/w illustrations, 1
foldout, 27.5 × 28 cm, softcover
with flaps; text: English | German

Sibylle Weber am Bach
100 Master Drawings from the
Morgan Library & Museum
Exhibition catalogue, Staatliche
Graphische Sammlung, Munich
248 pages, 140 color illustrations,
23 × 29.5 cm, hardcover
Graphic design: Peter Grassinger

Gerhard Röbbig
Cabinet Pieces.
The Meissen Porcelain Birds of
Johann Joachim Kändler
264 pages, 214 color illustrations,
25 × 28.5 cm, hardcover

Peter Volz, Christoph Jokisch Hans
Emblems of Eminence. German
Renaissance Portrait Medals
224 pages, 262 color illustrations,
24 × 32 cm, hardcover

Heinz Mack.
Ars Urbana. 1952–2008
348 pages, 128 color, 83 b/w plates,
34 color, 48 b/w illustrations,
7 diagrams, 24.5 × 30 cm, hard-
cover; text: English | German

Sean Rainbird, Ortrud Westheider,
Michael Philipp (eds.)
Matisse.
People, Masks, Models
Exhibition catalogue, Staatsgalerie

E. W. NAY.
PAINTINGS FROM THE 1960S

The German painter and graphic artist E. W. Nay is best
known for his early works. This publication, however, seeks to
do greater justice to his late oeuvre, which in the 1960s was
generally insufficiently understood or appreciated. The book
focuses on the brief but crucial period between Nay's participa-
tion at documenta III in 1964 and his death in 1968.

Stuttgart; Bucerius Kunst Forum
Hamburg
Essays by I. Conzen, J. Klein,
P. Kropmanns, I. Monod-Fontaine,
et al.; 228 pages, 101 color plates,
58 color, 60 b/w illustrations,
22.5 × 28 cm, hardcover

Sydney Picasso
Paul-Émile Miot.
The Invention of Paradise
Munich gallery Daniel Blau (ed.)
162 pages, 162 mostly color
illustrations, 25 × 30 cm,
hardcover

Monika Kopplin (ed.)
The Monochrome Principle.
Lacquerware and Ceramics
of the Song and Qing Dynasties
Exhibition catalogue, Museum of
Lacquer Art, Münster; Fondation
Baur, Musée des arts d'Extreme
d'Orient, Geneva
Essays by Monique Crick, Patricia
Frick, Soon-Chim Jung, Monika
Kopplin, Dieter Kuhn; 188 pages,
137 color illustrations, 24 × 30 cm,
hardcover

Deniz Erduman-Çalış (ed.)
Tulips, Kaftans and Levni.
Imperial Ottoman Costumes and
Miniature Albums from Topkapi
Palace in Istanbul
Exhibition catalogue, Museum
für Angewandte Kunst, Frankfurt
304 pages, 90 color plates, 23 color
illustrations, 21 × 32.5 cm,
softcover with flaps
Text: English | German

Claus-Peter Haase (ed.)
A Collector's Fortune.
Islamic Art from the Collection
of Edmund de Unger
Exhibition catalogue, Museum
für Islamische Kunst, Staatliche
Museen zu Berlin
132 pages, 125 color illustrations,
23 × 26.8 cm, hardcover

Judith Beyer, Roman Knee
Kyrgyzstan.
A Photoethnography of Talas
224 pages, 29 color plates,
179 color illustrations,
29.5 × 23 cm, hardcover
Text: English | German

Samuel Wittwer (ed.)
Refinement & Elegance.
Early Nineteenth-Century Royal
Porcelain from the Twinight
Collection, New York
Exhibition catalogue, Berlin,
Vienna, New York
488 pages, 465 color,
36 b/w illustrations, 24.0 × 30 cm,
hardcover

Venite, adoremus.
Geertgen tot Sint Jans
and the adoration of the kings
Exhibition catalogue, Oskar
Reinhart Collection "Am Römer-
holz," Winterthur
Contributions by Stephan Kemper-
dick, Harry Klewitz, Mariantonia
Reinhard-Felice, Jochen Sander,
Heike Stege; 96 pages, 55 color,
11 b/w illustrations,
23 × 28.5 cm, softcover

100 MASTER DRAWINGS FROM
THE MORGAN LIBRARY & MUSEUM

The Morgan Library & Museum houses
one of the finest and most renowned
drawing collections in the world. This
publication accompanies the exhibition
by the Staatliche Graphische Sammlung
München at the Pinakothek der Moderne
in Munich and shows 100 master
drawings from the 15th to the 20th
century.

Rita Adolff-Wollfarth.
Partita in Light and Colour
Contributions by Rita Adolff-
Wollfarth, Elmar Korn; 112 pages,
58 color illustrations, 24 × 28 cm,
softcover; text: English | German

Samuel Wittwer
**The Gallery of Meissen Animals.
Augustus the Strong's Menagerie
for the Japanese Palace in Dresden**
360 pages, 220 mostly color
illustrations, 24 × 28 cm, hardcover

Förderverein Stadtmuseum e.V.
Ingolstadt (ed.); Heiner Meining-
haus
Alphonse Knüsel
112 pages, 90 color illustrations,
21 × 29 cm, hardcover
Text: English | German

In 1731 the elector-king Augustus the
Strong of Saxony commissioned the Royal
Porcelain Manufactory in Meissen to
create several hundred life-size porcelain
birds and other animals to adorn the
Japanese Palace in Dresden. By January
1736, 412 birds and 160 quadrupeds
had been delivered to His Majesty.

Wolfgang Steiner
**100 unpublished reverse paintings
on glass, from 1550 to 1850**
272 pages, 222 color, 41 b/w illustra-
tions, 24 × 31.5 cm, hardcover
Text: English | German

Miura Sadatoshi, Michael
Kühlenthal (eds.)
**Historical Polychromy. Polychrome
Sculpture in Germany and Japan**
576 pages, 313 color, 135 b/w
illustrations, 21 × 30 cm, hardcover
Text: English | German

Hans Gottfried von Stockhausen.
**Volume 2: Architectural Stained
Glass**
Contributions by Thomas S.
Buechner, Peter Schmitt, and an
interview by Bert Hauser
224 pages, 196 color,
16 b/w illustrations, 24 × 30.5 cm,
hardcover; text: English | German

Peter Schmitt
**Hans Gottfried von Stockhausen.
Volume 1: The Automous Panel**
152 pages, 96 color, 16 b/w illustra-
tions, 24 × 30.5 cm, hardcover
Text: English | German

Katharina Büttiker
**Daum Nancy II. Daum Frères –
Verreries de Nancy. 1892–1914**
160 pages, 115 color illustrations,
22 × 30 cm, hardcover
Text: English | German

Korinna Pilafidis-Williams
**The Sanctuary of Aphaia on Aigina
in the Bronze Age.**
198 pages, 1400 illustrations
20 × 27 cm, hardcover

THE GREAT MASTERS OF ART SERIES

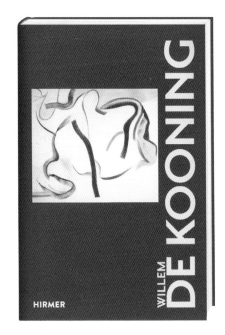

The historic series of artist monographs *Junge Kunst* (Young Art), published in 62 volumes from 1919 to 1933, brought together such famous names as Cézanne, Feininger, Gauguin, Kandinsky, Matisse, Modersohn-Becker, Nolde, Picasso, and van Gogh. At the time, many of the artists were still at the beginning of their careers, others were in periods of creative reorientation, and only a few were viewed in retrospect. Writers such as the still unknown novelist Oskar Maria Graf, the painter Lovis Corinth, and art historians and critics such as Wilhelm Hausenstein, Will Grohmann, and Willi Wolfradt wrote for the series.

In 1933 the *Junge Kunst* series was discontinued under pressure from the National Socialists. In 1937 the defamatory "Degenerate Art" exhibition in Munich displayed 24 volumes of the series, and with the comment "This is how Professor Biermann propagates bolshevism in Germany," vilified not only the artists and their works, but also the writers and their publisher.

Today, these volumes are art-historical treasures. Their "autobiographies," correspondence, essays by the artists themselves, and testimony from colleagues and contemporary witnesses provide an authentic picture of the 20th-century art scene.

A new book series, in which 18 artist monographs had appeared by 2020, is being developed in the style of that historic venture. This series not only looks into the past, it is also devoted to the works of contemporary artists—and for that reason, its name *Junge Kunst* is once again appropriate. In the historic series, women artists were underrepresented. Hirmer is making up for that deficit by including an increasing number of artists such as Marianne von Werefkin and Florine Stettheimer in this new series.

PABLO **PICASSO**

LYONEL **FEININGER**

LÁSZLÓ **MOHOLY-NAGY**

ERNST LUDWIG **KIRCHNER**

RICHARD **GERSTL**

EGON **SCHIELE**

FLORINE **STETTHEIMER**

MARIANNE VON **WEREFKIN**

KOLOMAN **MOSER**

JOHANNES **ITTEN**

PAULA **MODERSOHN-BECKER**

ALFONS **MUCHA**

FRAGMENTS OF METROPOLIS

The architecture of Expressionism represented the emergence of the art of building in the Golden Twenties. In the series *Fragments of Metropolis*, the editors Niels Lehmann and Christoph Rauhut highlight the great diversity within this architectural movement. Each volume is devoted to a particular European region and its different movements, focuses, and protagonists. The books document surviving structures with recent photographs, plan drawings, and maps, encourage on-site inspection, and attest to Expressionism's unconditional will to form.

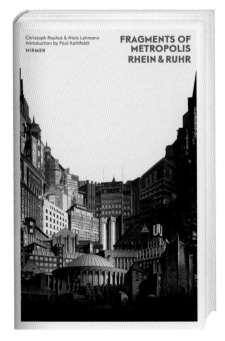

ARCHITECTURE SERIES

The Munich photographer Klaus Kinold (1939–2021) began to focus on architecture early on. In the series of books on architecture he conceived, the publisher was able to draw on his extensive oeuvre. Honored with the German Photo Book Prize, these bibliophile volumes reproduce his pictures in impressive duplex and color printing. The accompanying texts by noted writers discuss the given architects in detail. Printed on high-quality paper and bound as embossed hardcovers with dust jackets, the volumes appeal to architecture and photography lovers alike.

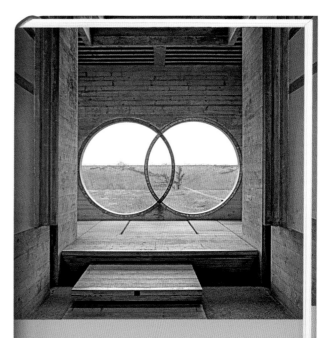

CARLO SCARPA
LA TOMBA BRION
SAN VITO D'ALTIVOLE
FOTOGRAFIE/PHOTOGRAPHY
KLAUS KINOLD

HIRMER

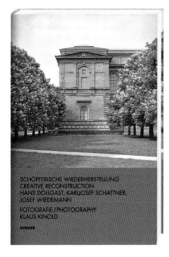

SCHÖPFERISCHE WIEDERHERSTELLUNG
CREATIVE RECONSTRUCTION
HANS DÖLLGAST, KARLJOSEF SCHATTNER,
JOSEF WIEDEMANN
FOTOGRAFIE/PHOTOGRAPHY
KLAUS KINOLD

HIRMER

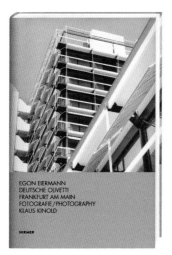

EGON EIERMANN
DEUTSCHE OLIVETTI
FRANKFURT AM MAIN
FOTOGRAFIE/PHOTOGRAPHY
KLAUS KINOLD

HIRMER

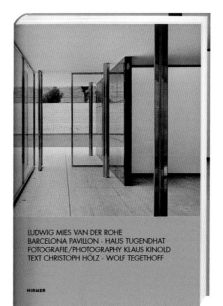

LUDWIG MIES VAN DER ROHE
BARCELONA PAVILLON · HAUS TUGENDHAT
FOTOGRAFIE/PHOTOGRAPHY KLAUS KINOLD
TEXT CHRISTOPH HÖLZ · WOLF TEGETHOFF

HIRMER

SALES CATALOGUE

The publisher's sales catalogue appears twice a year, in spring and autumn, in three separate editions keyed to various worldwide markets. In addition to the print version, which is sent to a selected circle of readers, the digital edition can be downloaded from our website, making it readily available to interested parties at all times. Its contents can also be accessed via the "Edelweiss" platform.

The sales catalogue is distributed to the trade worldwide by our partner Thames & Hudson. In the United States, our partner The University of Chicago Press includes our new titles in its sales catalogue. Some 60 representatives cover the markets on all five continents.

On their presentation in the publisher's sales catalogue, new titles are introduced visually for the first time. Opulently illustrated descriptions of their contents, including information about the authors, related exhibitions, and the book's specifications, create anticipation and interest among potential buyers. These are probably the most beautiful calling cards any publishing house can have, but also the most expensive.

Autumn 2020

Spring 2020

Autumn 2019

Spring 2018

Spring 2019

Autumn 2018

Autumn 2017

Spring 2017

Autumn 2016

Spring 2016

Spring 2015

Autumn 2015

Autumn 2014

Spring 2014

Spring 2013

Autumn 2013

Spring 2012

Autumn 2012

Spring 2011

Autumn 2010

Autumn 2011

2010

FORMS OF ADVERTISING

Thanks to digital options, advertising has changed lastingly over the past decade. Hirmer Publishers advertises its publications on the various digital advertising channels. All titles are presented in detail on our websites: www.hirmerpublishers.com and www.hirmerpublishers.co.uk, with descriptions of their contents, a "look inside" and information about related exhibitions, press notices, and any other accompanying events. In addition, a PDF of the publisher's sales catalogue is included for interested parties to download.

Selected new titles are used as illustrated website banners and advertised in Google Ads. Via Facebook (@hirmerPublishers) and Instagram (@hirmer.publishers), Hirmer Publishers networks with authors, artists, museums, and art lovers, provides exclusive previews of our books, information about events such as exhibitions and book launches, and shares the latest news from the art world.

But Hirmer also continues to use analog means to keep the public informed about upcoming publications. Among the successful promotional products are the print products shown here: advertisements, posters, and pamphlets. Each such item is individually tailored by Hirmer Publishers for the given publication, target group, and advertising purpose in order to achieve the maximum effect. Their visual language, design, slogans, and choice of motif all reflect current trends—and at the same time represent the publishing house's distinctive style.

YOU ARE MY BIGGEST INSPIRATION

EVA & ADELE

DIVINE
GOLDEN
INGENIOUS

ESPRIT
MONTMARTRE
Bohemian Life in Paris around 1900

NEW BAUHAUS CHICAGO

HOKUSAI MANGA

EUROPE AND THE SEA

SOROLLA

The MINI Story

621 AOK

My Life with Alexander Archipenko
by FRANCES ARCHIPENKO GRAY

Website banners

133

Invitation for the
presentation of the
book New West

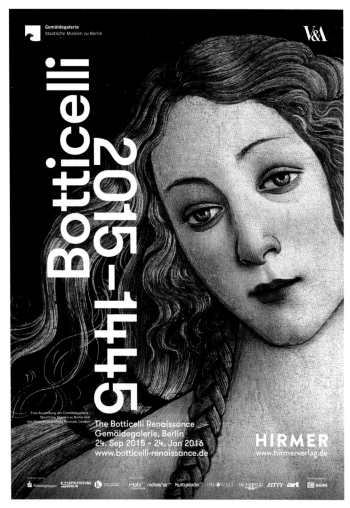

Poster for the book The Botticelli Renaissance

70 years of Hirmer:
anniversary logo

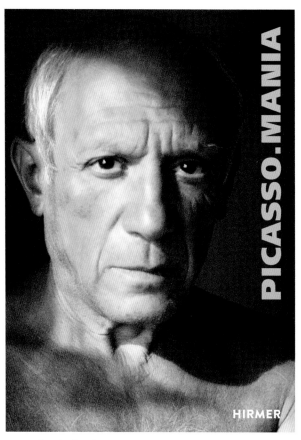

Poster for the book Picasso.Mania

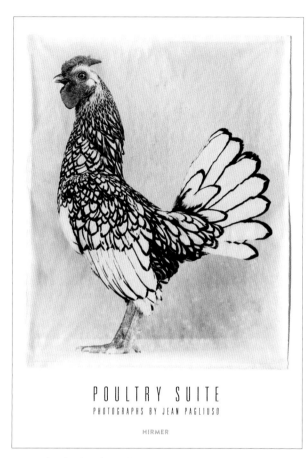

Poster for the book Poultry Suite

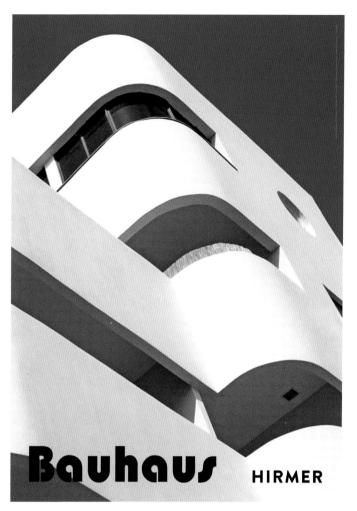

Poster for the book Form and Light

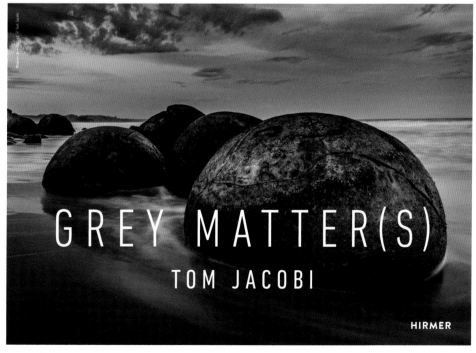

Poster for the book Grey Matter(s)

ACKNOWLEDGMENTS

Thomas Zuhr

My thanks are owed first and foremost to Aenne Hirmer (meanwhile sadly deceased) and to Albert Hirmer for their fascinating contribution to the history of the house from 2013. With their joint text, the book includes contemporary witnesses who with their help and advice accompanied this publishing venture from the very beginning.

Special thanks as well to Gottfried Knapp, Michael Krüger, and Niklas Maak for their eager agreement to collaborate on this book.

I am especially indebted to Karen Angne, Rainer Arnold, Katja Durchholz, and Sabine Frohmader for their engagement and the patience with which they have accompanied this project for so many months. My thanks also go to Russell Stockman for his translations and to Danko Szabó for his meticulous copyediting.

Another special thanks to Alistair Layzell in London, who professionally accompanied the beginning of the English list, and to the teams of our distribution partners, Thames & Hudson and The University of Chicago Press, for their excellent work.

I would like to take this opportunity to express my sincere thanks to the entire staff of the house for their loyalty and commitment in the last few years and decades, without whose dedicated involvement such an undertaking would be unthinkable. In its program management, I mention Kerstin Ludolph. Elisabeth Rochau-Shalem, Senior Editor New York, bears significant responsibility for acquisitions in the United States and Canada. The house's editorial staff and project management are represented by Jutta Allekotte, Karen Angne, Rainer Arnold, Cordula Gielen, Markus Kersting, and Jürgen Kleidt. Book production is handled by Katja Durchholz, Sophie Friederich, Sabine Frohmader, Peter Grassinger, Hannes Halder, and Lucia Ott. Advertising and public relations are the responsibility of Eva-Maria Neuburger, with the assistance of Michaela Döbler and Lilly Burger. Sales are overseen by Renate Ullersperger and Christine Vorhoelzer. Johanna Deininger and Sara Frier take care of our social media presence. Alexandra Bilyk is responsible for accounting and personnel. All daily errands are promptly performed by Roland Zenz. Last but not least, I sincerely thank Rainer Arnold, my "right hand," for his tireless and competent commitment.

INDEX OF AUTHORS AND EDITORS

LIST OF ARTWORKS REPRODUCED IN THIS VOLUME AND RELATED PUBLICATIONS

The works of art shown in this catalogue on the pages listed below are in the possession of Hirmer Publishers.

Helmut Schober, The Energy of Intuition, 2017 (see page 31)
 Related publication: Dieter Ronte (ed.), Helmut Schober. Vortex, Munich 2020 (see page 32)

Benjamin Katz, Dinard, 1977–80 (see pages 38/39)
 Related publications: Hirmer realized *Gerhard Richter at work* (2012), *Georg Baselitz at work* (2013), and *Berlin Havelhöhe* (2019) together with Benjamin Katz (see pages 99, 94, 37)

Michele Melillo, not titled (LC), 2012 (see page 43)
 Related publication: Nicole Gnesa (ed.), Michele Melillo, Munich 2019 (see page 40)

Verena Wolfgruber, Haifischbecken, 2017 (see page 49)
 No related publication

Roland Fischer, Schwimmunterricht mit Gregor Hilde-brandt, 2018 (see page 57)
 Related publications: Hirmer realized *Refugees* (2016), *Tel Aviv. Israeli Collective Portrait* (2016), and *Façades* (2014) together with Roland Fischer (see pages 68, 87)

Stefan Hunstein, Im Eis (In the Ice), no. 3 and no. 2, 2014 (see pages 70/71)
 Related publication: Petra Giloy-Hirtz (ed.), Stefan Hunstein. In the Ice, Munich 2016 (see page 69)

Eran Shakine, A Muslim, a Christian and a Jew at the Tunnel of Love, 2016; A Muslim, a Christian and a Jew Figuring God's Plan, 2016; A Muslim, a Christian and a Jew Knocking on Heaven's Door, 2016 (see pages 76/77)
 Related publication: Eran Shakine, A Muslim, a Christian and a Jew Knocking on Heaven's Door, Munich 2016 (see page 74)

Pavel Feinstein, not titled, 2014 (see page 81)
 Related publication: Kay Heymer, Pavel Feinstein. The Small Format, Munich 2015 (see page 78)

Bernd Zimmer, Wüste/Cosmos, 2002 (see page 85)
 Related publication: Bernd Zimmer. Everything Flows. Painting, Munich 2015 (see page 83)

Tilo Baumgärtel, Nachtgarten, 2011 (see page 97)
 No related publication

Eugène Vernier, Beersheba camel market, 1962; Tania Mallet, 1961; Ros Watkins, 1961 (see pages 102/103)
 Related publication: Alistair Layzell (ed.), Eugène Vernier. Fashion, femininity & form, Munich 2012 (see page 101)

Xenia Hausner, Indigo Z, 2013 (see page 107)
 Related publication: Xenia Hausner. Damage, Munich 2011 (see page 105)

Susu van Liempt, W.S., 2017 (see page 111)
 No related publication

IMPRINT AND PICTURE CREDITS

In the technical realization of this publication, we were actively supported by Reproline Genceller in Munich and by our Italian partner, Printer Trento. A publishing project of this kind would have been a difficult undertaking without their help and cooperation.

Project Management Karen Angne, Rainer Arnold
Translation Russell Stockman, Quechee, VT
Copyediting Danko Szabó, Munich
Layout concept Eva Schlotter
Typesetting & Production Katja Durchholz, Sabine Frohmader
Pre-press Reproline Genceller, Munich
Paper GardaMatt Art 150g/m^2
Typefaces Avenir, Brandon Grotesque, Jenson Pro
Printing & Binding Printer Trento S.r.l., Trient
Printed in Italy
Bibliographic information published by the Deutsche Nationalbibliothek
The Deutsche Nationalbibliothek lists this publication in the Deutsche Nationalbibliografie; detailed bibliographic data is available on the internet at http://www.dnb.de.

ISBN 978-3-7774-2618-1
www.hirmerpublishers.com

© Hirmer Fotoarchiv, Munich
p. 2 Max Hirmer in Egypt, 1955
p. 4 King Seti burning incense before the god Soker, Temple of King Seti I in Abydos, Hall of the gods Nefer-tem and Ptah-Soker
pp. 6 / 7 The king and his train hunting wild asses, from the North Palace of King Ashurbanipal (668–630 BC) in Nineveh, neo-Assyrian, London, British Museum
p. 20 The Temptation of Christ. Christ on the dragon throne flanked by two demons, Plaimpied (Cher), former Collegiate Church of Saint Martin, capital in the nave, 2nd half of the 12th century
pp. 22 / 23 Boys playing ball, from the base of a statue from Athens, late 6th century BC, Athens, National Museum
pp. 118 / 119 Horse's head from Selene's quadriga, from the east gable of the Parthenon on the Acropolis in Athens, 450–300 BC, London, British Museum

© Fotostudio Sahm, Munich
p. 13 Max Hirmer

© 2021 Walter Bayer
pp. 43, 49, 57, 70, 71, 76, 77, 81, 85, 97, 107, 111